How to Paint
Your Show Car

How to Paint
Your Show Car

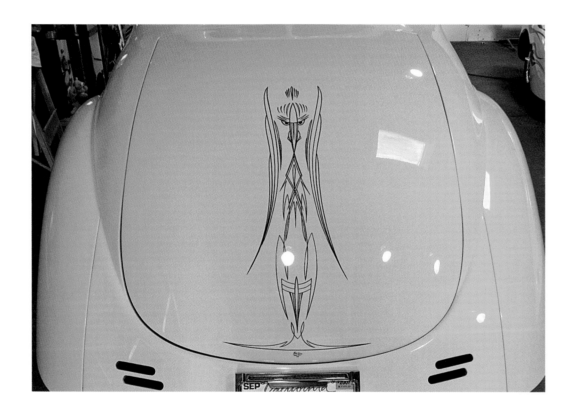

Stefan R. Gesterkamp

First published in 2008 by Motorbooks, an imprint of
MBI Publishing Company, 400 First Avenue North,
Suite 300, Minneapolis, MN 55401 USA

Motorbooks titles are also available at discounts in bulk
quantity for industrial or sales-promotional use. For details
write to Special Sales Manager at MBI Publishing Company,
400 First Avenue North, Suite 300, Minneapolis, MN
55401 USA.

To find out more about our books, join us online at
www.motorbooks.com.

ISBN 978-0-7603-3275-7

On the front cover: This is a piece of art in any form of the
imagination. No over-the-top graphics or screaming colors
needed. If a show car is right, it is right in every color.

On the title page: Classic hot rod-style pinstriping can add
a lot to a project. This Bob Spina design is a great example
of this art form.

On the back cover: Balsawood's combination of length and
flexibility contributes to its unique blocking action.

Editor: Peter Schletty
Designer: Chris Fayers

Printed in Singapore

CONTENTS

ABOUT THE AUTHOR

Stefan Gesterkamp was born in 1965 in Bremen, Germany. Being a car guy all his life and looking for a creative career, he joined the Paint Industry after attending an annual Auto Show. A locally well-known producer of high-end custom paint and restoration work had a breathtaking display at that event. Excited about the quality of the paintwork and the creative use of paint, Stefan started a traditional 3-year apprenticeship at that shop.

In his 26 years in the automotive paint industry, he has worked on numerous restoration projects. From Bentleys, Morgans, MGs, vintage Mercedes and BMWs to classic American Iron, Stefan enjoyed a very thorough education. After moving to the outskirts of Hamburg, he returned to school, graduating from the Fachschule Farben (University of Coatings and Colorants). The following year he was awarded the title of Maler and Lackierer Meister (Master Craftsman) from the Craftsmen Guild in Hamburg, Germany. The "Meister" title is the highest honor given to any Craftsman in Europe.

Prior to his arrival in the USA, Stefan was a body shop manager for two years. In 1994 he and his wife Anette arrived in Los Angeles and he started to work for BASF's Automotive Refinish Division as a field trainer / sales rep and technical advisor to the body shop industry. His in-depth exposure to all sides of the automotive paint industry allowed him to blend old school approaches with the most modern techniques and technologies. From wood to automotive sheet metal, Kevlar composites to the latest metal alloys, as well as substrates like carbon fiber over aluminum honeycomb, he has worked with them all.

INTRODUCTION

Welcome to the world of show car painting. It is a world of big dreams, nice cars and great people. It is also a life of long hours, hard work, total commitment and dedication. The greatest names in custom car design, automotive restoration and hot rod building call this their playground. It is my belief that the best show cars the planet will ever get to see are still to come.

The baby boomer generation is arguably the most car-loving generation ever. This generation grew up with automotive styling that was oblivious to aerodynamics and energy saving designs. The most outrageous concept cars were built during that time when the automobile ruled the world. This generation is about to retire and has the financial ability to create some of the finest cars. The kids are through school and out of the house, leaving many car lovers with plenty of time and extra spending cash. Cars from childhood are likely objects of desire. Building a show car project with a grandchild at your side sounds just like the thing to do, doesn't it?

This car loving generation is already the number one client in this business today.

To prove my point, all you need do is park yourself on the Pacific Coast Highway in California anywhere between Santa Barbara and San Diego on a sunny Sunday afternoon. You'll see that 99% of the highly desirable cars that go by are driven by a baby boomer. Most of this generation has an inherent gene for hot rodding and classic cars. They know what they want and they want the best. Everybody has his or her own idea of what constitutes the perfect car. Simply buying one from someone else— what's the fun in that? All the car craziness and desire for a favorite childhood car were bottled up for years while career and family came first.

Now with time and money on your hands, let's go to work.

And non-baby boomers are more than welcome to join in the fun—somebody's got to inherit the car hobby and keep the fire burning!

ABOUT THE BOOK

When I was approached to write this book, it was of great importance to me that the final product would present value to the craftsman doing the work as well as to an owner who may commission the work on such high profile vehicles. This book will mainly follow three different types of show cars, each being unique in its materials, design and purpose. Each vehicle was done to very high standards and it is my hope that the outlined techniques will be helpful to the car building public.

This book's original concept was a little different from what you hold in your hands. Rather than producing a step-by-step guide or build book, I envisioned a best practices guide that would deal with most situations one might encounter when attempting to perform body and paintwork to the highest possible standard. After numerous conversations with several well-known experts, as well as newcomers to this line of work, I realized that no book had ever addressed the special circumstances in this very unique field. It is an art and a craft that requires careful explanation with lots of photography, and that is the book produced here.

Besides my wish to assist craftsmen that are willing to

go the extra mile, I also hope to motivate young people to consider a career in this exciting line of work. The unfortunate reality is that if we can't get young talented people excited about the world of show car building, this could become a quickly dying art form.

Secondly, I wanted to produce a book that clearly showcases for owners hiring a shop to do the work for them what is truly involved in getting a dream car executed correctly. Producing a perfectly stunning car is not fast nor is it cheap.

Please note that finish criteria may differ across car shows and car-show classes. While this book will always guide you toward an excellent outcome, neither the author nor publisher can accept responsibility if you choose paint products incompatible with a particular car-show class you desire to compete in. Find out the rules before you paint to ensure that your car looks great and meets show and class requirements. Builders restoring for authenticity or originality will have to decide what improvements, if any, are appropriate beyond original fit and finish.

Develop your vision, then let's get going on a premier paint job turning eyesores into eye candy.

FOREWORD by Jay Leno

When I was a kid, I had a '34 Ford and I brought it to a paint guy. He said if you do all of the prep work yourself, I'll paint it for a hundred bucks. That was including paint and it looked beautiful. But it was 1966, when I was sixteen, and times have changed a lot since then. Recently a friend of mine bought his wife a new Lexus, but she didn't like the color and he asked me if I knew somebody that could paint it for about $2,000. And I said: "Keep dreaming." Anybody that thinks you can paint a brand new car, giving it a factory paint job, for $2,000 is either crazy or is trying to take your money. Especially in California with all the EPA and other restrictions, painting is something best left to professionals. My friend really thought he could buy the car in one color and then simply change the color without completely disassembling the car. That shows you how little some people may know about what is involved in painting cars and making them look good.

In this very descriptive book, Stefan creates a realistic picture of what is truly involved in show car painting. The world of show car painting is a world of no compromise, pure excellence and endurance. Giving up and calling it good enough when the project is about 95% done is the most repeated mistake out there. Paint is one of the very first things a spectator will notice when walking up to a show car. A critical eye can easily spot imperfections in the paint finish or surface preparation. Sand scratch swelling, thick paint, tapelines or the minutest ripple in the surface can ruin the overall appearance of your car.

Getting the body and paintwork just right requires a high level of commitment, skill, passion and patience. Owning show cars myself, I am too well aware of what goes into turning a dream into reality. The time and money that can go into a project car is mind boggling at times. In return, looking at a perfectly executed show car is rewarding and never tiring. Following the techniques and processes in this book will guide you through most situations you may encounter during the creation of your show car project.

This book represents many decades of highly qualified craftsmen's experiences. This combined expertise will spare a first time builder or do-it-yourselfer many painful trial and error situations. It is a must-have book for everybody that takes the art of show car painting serious.

Jay Leno and Per Blixt, the full time body and paint expert at the Big Dog Garage.

CHAPTER 1
BEFORE YOU START YOUR PROJECT

Before you start your high-level body and paint project, it is crucial that you do your homework. You will be hiring high-paid craftsmen to spend a great deal of time on your car and to use first class materials. As a result, project costs will add up quickly and be significant. Project cars routinely eat up twice the amount of money originally forecasted and up to three times the amount of time. The average home build car takes three years to complete and that is only possible if the owner is 100% committed. Spending between 1,000 and 3,000 hours in body and paint time alone is not unheard of. In most cases, people will spend more money on the car than it will be worth on the open market. If resale value is on your mind, be advised that only a few lucky ones sell their car at a later time for a decent profit. Unless you own a rare make or model car, start your project for the love of it, not from a desire to make money.

To establish the maximum value of your desired show car project, visit popular auction websites like RM Auction, Barrett-Jackson, or Russo and Steele. Pick the proper site based on the type of vehicle you are planning to build. Not every auction house is necessarily a good choice. They are all unique in their own way. Go with an auction house based on the market segment they are most famous for and most specialized in. Research parts availability and cost prior to the start of the project. Buy new old stock (NOS) parts—those produced at the same time the vehicle was manufactured but never fitted to a car—wherever possible. They fit better in most cases. A better fit can save you countless hours of body and part alterations. If you are not doing all of the work yourself, get a number of estimates from reputable shops that do that type of work. Please keep in mind that nobody can exactly predict the total expenses and labor required to make your dream a reality.

Let's say this is your chosen object of desire. Find out how much a perfect car has sold for at a high-end auction. Deduct all forecasted costs including the purchase price, and the difference is your work budget. If you're unsure how long you will keep the finished vehicle and don't want to lose money, I highly recommend that you find yourself an already done car. Because a no-expenses-spared restoration usually exceeds market value, in most cases it is cheaper to buy a car that is done, just the way you like it, than to undertake the project yourself.

If most of your car looks like Swiss cheese, it is probably not worth the effort! In cases like this, it may make sense to consider buying a donor car body.

Shops that are experienced in show car projects will rarely even consider estimating the cost unless the car has been completely disassembled first. Speaking to many people in this line of work has confirmed my experience that you are best served to add about 60% to your best estimate.

Naturally all of this is a non-issue if the car you are planning to build is a one of a kind custom project, or you are building it for emotional reasons. I have seen cars that have been restored at a cost of three times the vehicle's value, and the owner was happy to do so. Cars that are in the family for generations are a good example where value potential is often meaningless. At that point it is really up to the owner to decide what the final project is worth to him.

Another criteria is the prospective vehicle's condition. Unless it is an extremely rare car, a vehicle with significant rust or accident damage may not be worth the time and money to restore.

Corrosion is the equivalent of cancer to a steel-body car. There is a point when you can no longer justify fixing up all body damage. In cases like this, you can often find a good quality donor car for less money than it would cost you to rebuild the body on hand.

You should also consider your planned direction for the project. Based on the vehicle's type and model, it may not be in your best interest to customize or over restore a car—particularly if it represents a greater value in a close to original condition. A good example would be a right

hand drive, 1970 Barracuda Convertible with a stock 426 Hemi. Boy, can I have dreams or what? But the truth is that this car would be best left alone in an as close to original condition as possible. The difference between stock and modified conditions can be millions of dollars in a car like that. Another example would be old European sports cars. They tend to maintain a better value in stock conditions unless the car has a documented racing history. The bottom line is, make sure you know what you have on hand before you start tearing into it.

CREATING A VISION

When preparing for a show car project, it is extremely important that you create a visual aid. Visual aids are the best way of letting everybody see what you are trying to achieve. Drawing remains the best way to convey what you see in your mind. Besides an actual clay model, sketches or drawings are the most effective way to bring people that will work for you up to speed. The higher the number of people helping you, the more important it is to be on the same page with everyone. Those drawings seem to have a life of their own. They have a tendency to change over the course of the project. New ideas or the discovery of new parts, products, and materials you would like to incorporate are the main reasons for those changes.

Regardless of any changes you may make, the drawing will help you to stay on track with your overall design con-

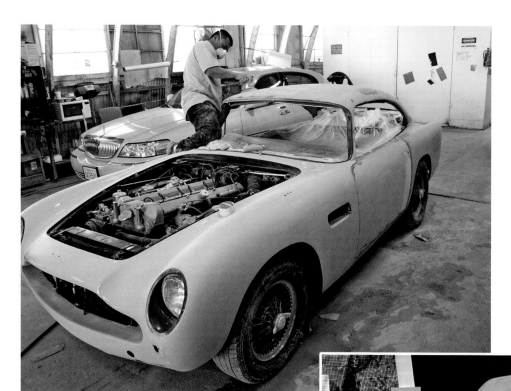

This Aston Martin is a good example of a project car that should be kept close to original condition. Customizing would diminish the vehicle's value substantially. In this case, the car receives only a mild and sensitive exterior restoration, keeping the mechanical components untouched.

When it comes to creating a vision, auto manufacturers have every technology available at their disposal. Naturally, most show car builders don't have those options. A full-size clay model is the best there is, but they are under no circumstances necessary.

cept. Visual aids are a great way to improve communication between different craftsmen. They can be the blueprint for everything from color choices and body alterations to wheel design and more. Good drawing skills are key in producing a meaningful sketch. Hiring a professional is a good investment particularly considering all the work, time, and money you are going to pour into your project. A professional's drawings will usually better approximate the actual car, so each piece of the project gets done to your satisfaction.

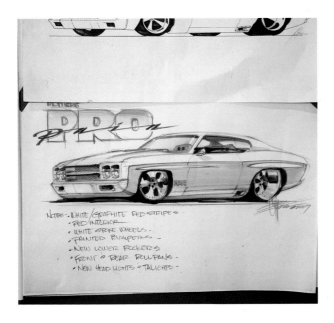

This is a Chip Foose rendering of the Mothers 1970 PRO Pane Chevelle. It proved to be an easy way of getting the design concept across to everybody working on the build.

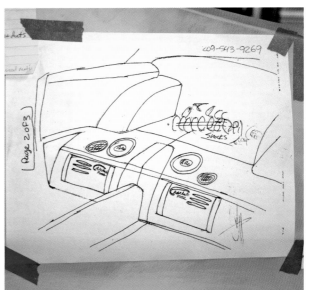

When a change of the bumper design was proposed, a quick drawing gave everybody a clear vision. If everybody knows exactly what the final goal is, many problems can be prevented.

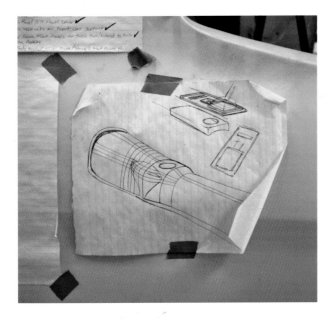

Drawings are also used to help the fabricator. A new drive shaft tunnel will be built, for example, and a clear vision of the final product helps answer many questions.

A quick sketch unveils part of the interior layout. The stereo equipment is taking the place of the rear seat.

CHAPTER 2
FINDING AND PICKING THE RIGHT SHOP

If you are like most automotive enthusiasts, you are probably handy around the car. You know how to maintain your own vehicle, and you are probably also convinced that painting a show car cannot be that difficult. Well, the truth is that most people are probably not entirely qualified to do it right.

With just the right determination, starting a true show car project yourself can certainly be done. The problems usually start when you are not properly qualified, fully committed, or skilled enough. The mistakes made, normally due to the overestimation of your own abilities, can prove very costly in some cases. Having said that, following the procedures outlined in this book will help a highly motivated and extremely handy hobbyist to create a great looking weekend cruiser at a very minimum. And I mean a cruiser you can be proud of. Never say never—if you really want it bad enough, you may just pull it off.

The reality for most of us is that taking the quality level of our work from a weekend cruiser to a true show car finish requires many years of practice. The difference between the two levels of quality is a degree of precision that is, simply put, a very hard learned skill. It requires a person who will not let a good job be good enough and that is a unique character trait many professional paint technicians don't even possess.

A highly quality-oriented, seasoned professional in the body and paint industry should find enough guidance in this book to create a great looking show car. For all others, those who like to maintain sanity and an actual life during the building process, it is probably a wise decision to find a qualified shop to do the work for you. Always keep in mind that hiring somebody to undo or fix unsuccessful work is more expensive then hiring the right professional from the start.

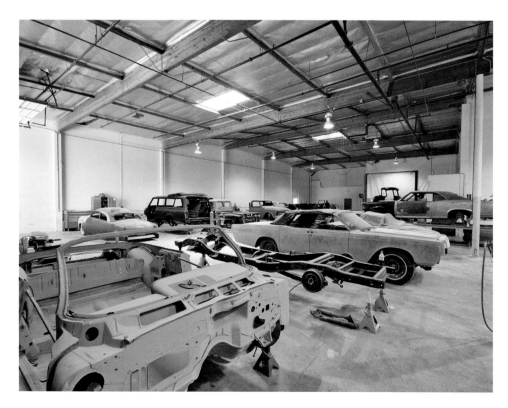

Check out Palmer's Customs for example. Everything is nice and clean with plenty of room around each car.

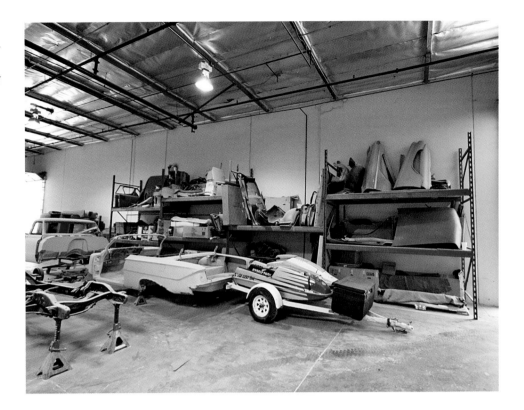

Parts are carefully stored out of harm's way at Palmer's Customs. Yes, there is sanding dust on the floor at the end of a long day, but you can easily see that this shop and the vehicles inside are well taken care of.

Picking the right shop is just as crucial to your project car as any work performed. In most cases, the local body shop or collision repair provider is not a good place to build a show car. The main reason for this is relatively simple: body shops that make a living with insurance driven collision repair work are motivated by factors that are in direct conflict with your needs. Those factors are time and space to be exact.

Today's collision repair providers are set up internally to seek short cycle times. That translates to in and out as fast as possible. On top of that, due to the shrinking profit margins in that industry, every inch of floor space needs to produce labor hours consistently. Any time a vehicle sits on the floor without being worked on constitutes lost profit for the shop. By nature, custom and show cars frequently sit on the shop floor waiting for a part to arrive or a piece that needs fabricating. In some cases the local body shop may be technically capable of doing the work, but they are otherwise ill prepared to deal with all the unknowns that are realities in all project cars. Finding or hunting down rare parts, fabricating unavailable parts, putting the empty car shell on a rotisserie for media blasting or acid dipping are all common procedures that are in conflict with most body shops' daily operations.

The good news is that there are shops that specialize in show car building. The most obvious and well-known choices, thanks to heavy media coverage over the last couple of years are people like Chip Foose of Foose Design and Troy Trepanier of Rad Rides by Troy. Besides the shops that are frequently shown on TV, there are numerous other highly qualified shops all over the nation. These shops are set up and specialize in this type of work.

Finding them is a matter of research. One good way to find a shop is to go to numerous local car show events and speak to car owners that have the quality level you desire. You may also want to contact a car club that specializes in your type of vehicle. If you are serious about finding the best craftsmen out there, attend car shows like the Detroit AutoRama or the Grand National Roadster Show in Pomona. Both shows repeatedly attract the best of the best in the industry.

As big as this country is, it was amazing to learn during the making of this book how small the labor pool for highly qualified craftsmen really is. Many shops temporarily hire freelance craftsmen from all over the country when they need extra help. In this highly specialized world, almost everybody seems to know each other. A home car builder could tap into this market of freelance craftsmen as well. This option would allow the owner of a project car to stay actively involved and at the same time learn many intricate details of this highly specialized trade without running the risk of screwing things up. But I would like

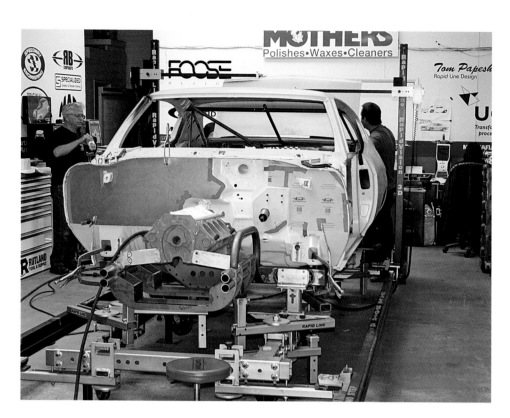

A work stall at Paul Gonzales Custom Cars also demonstrates what a good work environment should look like.

to warn you, these craftsmen don't work for the labor rates you normally pay a guy on the corner of your local home improvement store.

When you pick a shop to do the work for you, it is a good idea to visit the shop prior to dropping off the car. There is a lot you can learn about a shop by simply taking a tour. What should you look for in a shop? For one, a shop should be clean and organized. It is fair to assume that a business that doesn't take care of its own shop environment is probably not taking good care of your car either. Another telltale sign of a good shop is that they usually also have an organized system of storing parts. If you see big piles of parts on the floor, in the corners of the building, or they are all cramped into the car's interior, go someplace else. Having a good parts system prevents them from getting damaged or simply getting lost. In addition to insuring your own car while it is in the shop, make sure the shop is carrying good insurance as well. A security system is one form of insurance, but it won't help if the place burns down. Make sure the car is covered for its actual, as opposed to old-car blue book, value.

Next on the list is taking a close look at the tools and equipment in the shop. Well-maintained equipment is critical to the outcome of the work. If the spray booth is rusted out on the bottom or the filters are all crusted up with overspray, the paint quality may suffer. Shops should

be well lit. If you can't see what you do, perfection may be impossible to produce. There should be enough space around the cars to keep them from being banged up.

I highly recommend that you take a close look at the paint system they use as well. Don't ask for it, simply look at the labels of the product they use and see if the paints and primers are made by the same manufacturer. Businesses that take shortcuts on paint product are very unlikely to admit it publicly. Also make sure that the same company makes the clearcoat. Mixing and matching manufacturers presents big risks. Every paint manufacturer spends millions of dollars in research and development, ensuring that all components work flawlessly within a system. On the other hand, absolutely no research is done to ensure that a product that is manufactured by a competing brand will actually stick or interact correctly. To make matters worse, a number of generic paint products have entered the market recently. They are cheap and cheap for a reason. No serious research and development money was invested in these products. If they have any warranty at all, it is normally a product replacement *only* warranty. Leaving you with the burden and the entire expense of repairing the potential blowup. Building a show car is serious business—it will eat up a lot of your resources—and taking a gamble on the products that are used is one foolish thing to do.

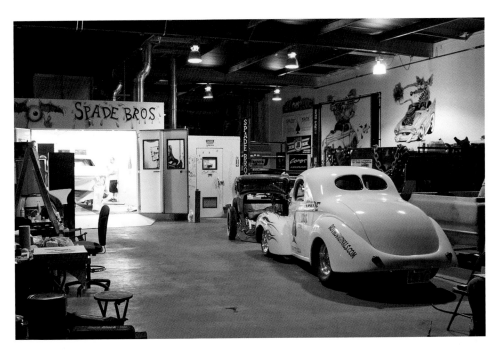

The Spade Bros. is another good example of a nice and clean shop. These shops are good examples of places that are set up and specialized to do work on show cars.

It is vital to find a shop that will share your vision and is passionate about your project. Ideally, a shop provides one-stop shopping. Some shops offer "general contractor" services, taking control of all aspects of the build process. Either they will perform all work in-house or they will arrange to get needed third party work done for you. Why should you be the one worrying about finding the right person for a specific task? These shops are connected in the industry and know exactly which third party provider is the most qualified for the task and will make them look good. Trust me, no committed shop owner would ever take a risk with another business that only provides mediocre work. Anything that goes wrong on your car reflects badly on them. In an industry that is all about referrals, that is not acceptable. Quality shops may warranty their work and sometimes offer active buying assistance. Having the shop involved right from the beginning and asking for their help in picking the best possible car to start out with can cut as much as 20% of possible problems out of the project. A good shop will help in locating parts and services. Locating parts can be a tricky and very time-consuming task on certain cars.

Commissioning upholstery work for you is another important service that you can expect from a good shop. Last but not least, keeping you informed and updated on all progress made to your car is a desired trait you should look for when deciding on a shop. The way I see it, hiring a shop is like a short-term marriage! You have to find people you are compatible with.

DISASSEMBLING THE CAR

For the most part, disassembling the car is something you can easily do yourself. I highly recommend that you take digital pictures of everything before, during, and after disassembly. The more pictures you take, the better off you are. Trust me when I say that this will be very helpful to you later. Many people learned the hard way that they couldn't remember two or three years later where parts go and how it is supposed to look. After each day of shooting with your camera, download the photographs to a computer and place shots in appropriately named folders. This organizational step will help you from getting overwhelmed by the sheer number of photos you take. If you organize them each day, you'll be able to find them when you need them. The alternative, accumulating hundreds of shots in your camera over many days, will produce an organizational chore you may not want to bother with or cause photos to disappear or be forgotten about.

Catalog all parts and use Ziploc bags as much as possible. Attach a printout of the corresponding pictures to each Ziploc or plastic bag. This will make it easier for you to locate everything later. Mark all electrical connections prior to pulling them off. Attaching a piece of masking tape and writing down the purpose and its position is easy to do; figuring out where each and every wire goes years later, on the other hand, is not much fun! If you ever disassembled a car, you probably noticed that not every wire is necessarily attached to something. Wiring harnesses are commonly made for more than one specific type of car. Some vehicles

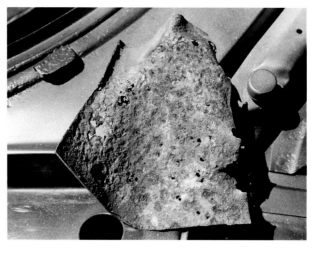

Using bags and marking their contents is going to help in many ways during the build and reassembly process. Show cars are assembled and disassembled several times during a build. Anything you can do to help find the right hardware and not lose any of it is a plus.

This piece was cut out of a media blasted car. You can clearly see that the rust on the inside remains an ongoing problem. Cavity corrosion protection was not on early American car manufacturer's minds.

use all of the wires, others don't—it depends on how well the car is loaded with available features or options. Don't expose yourself to the risk of spending hours, if not days, under the dash, wondering where this darn wire is suppose to go, only to find out that it wasn't attached to anything in the first place. (A factory service manual's wiring diagram can greatly help with such tasks too.)

Make sure you list all the parts that need replacement or repair at this stage of the game. The sooner you can start the hunt for all necessary parts the better off you are.

PREPPING THE BODY FOR A HIGH QUALITY BUILD

Once you completely disassemble the car, it is time to make an informed decision about the method of corrosion removal and the stripping process you would prefer. Starting a complex show car project should be done with a clean slate. Leaving any old paint or bodywork is not advisable. You will spend too much money and time on a car like this to take any chances. The most common method is media blasting the body. Media blasting will remove all coatings, body filler, and corrosion from accessible surfaces. The downfall of media blasting is that all corrosion on the inside of body cavities will remain unchanged like a timebomb waiting to burst through your expensive metal work.

Shops use all kinds of different types of media to remove coatings and corrosion today, from old-fashion sandblasting using several natural minerals, to ground up rocks and crystals, to man-made products like plastic beads. Soda

blasting is another option that has become more popular lately. Using soda blasting as a stripping method requires you to pay more attention to surface cleanup afterwards. Soda has a tendency to leave a hard-to-see residue on the surface that will interfere with the adhesion of a following primer. Using a good surface cleaner, one with a light acidity to it, in combination with a Scotch-Bright pad is your best bet. One product that does a good job and is acceptable in most environmentally regulated areas is Glasurit's 700-1 cleaner.

You may want to use a flexible optical tool to investigate the cavities' condition prior to determining what approach you would like to take. Not every car is necessarily in bad condition and taking the more aggressive approach of acid dipping has its downsides too. If all you find inside the cavities is light surface rust, you may want to consider a thorough application of linseed oil after all of your paintwork is completed. This approach will surely beat the risks of acid dipping. Linseed oil is a neutral balanced oil that will never dry or harden. While it can't completely stop the corrosion inside your car, it will greatly slow the process down. Rust requires water and oxygen for the process to continue; exposure to both can be minimized with a good coat of this oil. There are also synthetic products out there that claim to do the same thing, but I personally prefer the natural option.

There is absolutely no question about the fact that the professional custom and show car community is divided about the best approach for corrosion removal. Go and

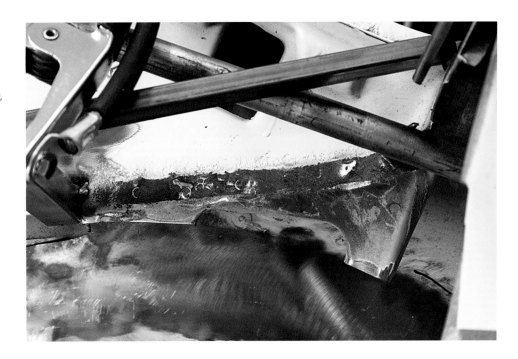

This picture shows an area that stayed unaffected by the acid dipping process. If pinch welds are really tight, the acid may not get the job done. For best results, you want to remove all sheet metal that is being replaced or removed for other reasons prior to acid dipping.

ask ten experts and you will get ten completely different answers. It is your dream car after all and I recommend that you do what feels best to you.

Acid dipping will remove most if not all of the corrosion inside and out but can produce its own future problems.

I really can't stress the fact enough that only the most experienced individuals should do the acid dipping for you. This process can be the best or the worst thing you can ever do to your car. Acid dipping is a controlled multiple step process that requires the car to be extracted out of the acid tank a few times during the process to ensure that every problem area is taken care of. All acid residue needs to be removed completely from the car. In my professional career, I found that the acid removal process was the step with the most problems. The body is then baked to dry out all cavities.

After the acid dipping process is completed, the car should be phosphated. Phosphate will restore some level of corrosion protection and gives you enough time to safely transport the vehicle back to the shop for additional applications of corrosion protection. If the process isn't done right, or the acid dipper took some shortcuts, corrosion may reappear quickly. Again, the biggest possible problem here is leftover acid residue. Undetected, it could interfere with the following coatings, exposing you to severe adhesion problems and acid induced corrosion. In the event that your project car has heavy corrosion damage, it is advisable that the body be braced prior to the dipping process. This is of even greater importance if you are working

on a convertible. There have been reports of cars collapsing when they got pulled out of the tank. Believe it or not, but even rust will give the car some structural support.

Please do your homework and talk to as many people as you can prior to shipping your car off to be acid dipped. Everything you do from here on out, the values you receive for every penny spent, every hour invested, depends on the quality of the work performed at this stage. Please don't misunderstand my intentions here; I don't want to scare you to a point that you would dismiss the acid dipping option. After all this is the most reliable corrosion removal technique available today, but I want to make sure you don't jump into something blind sighted. I have seen a number of cars over the years that were acid dipped and started to rust out of pinch welds and other hard to reach areas almost immediately. This is the most obvious sign that the process wasn't done correctly. You may have to go out of state to find the right guy for this highly critical job.

Before you ship your car body off to get media blasted or acid dipped, you should take pictures of every part you send. Mark each part for easy identification and catalog all of them. Attaching engraved metal tags with wires to each part is the preferred method to identify your parts because they will stay with the components throughout. As soon as the parts arrive at the blaster or the dipper, have the list signed by the shop. I have heard many stories about lost and damaged parts. The only way you can stay in control of a third party provider is by being proactively prepared. Pictures give you proof of the condition of every part at

This picture shows a good example of proper bracing techniques. The bracing on the Mothers Chevelle was put in place due to the floor panel removal and the extreme modifications required on this car. The same techniques would be used to brace a car weakened by corrosion.

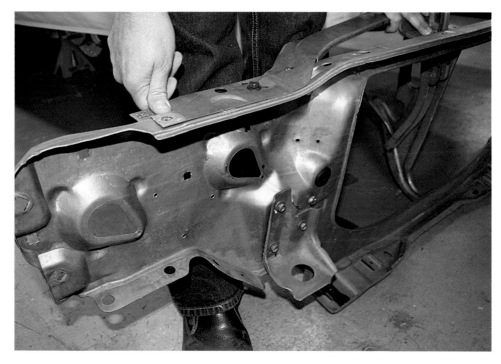

This radiator support shows the final finish after it was acid dipped and phosphated.

the time of arrival and the signed catalog of parts proves that they have received every single item. All in all, this is little effort with big benefits.

As soon as possible after media blasting or acid dipping, the car body should receive a couple of coats of Epoxy primer. Powder coating is another option. This coating offers good corrosion protection and a wonderful foundation for all bodywork that follows.

One reality of building a show car is ongoing fabrication and bodywork; both procedures will expose bare metal on a frequent basis. Keeping up with corrosion protection during the entire time of construction is a must. Never lose sight of the fact that rust is the equivalent of cancer to your car and it will continuously eat away on your dream. While protecting bare metal is essential, do so with care: cleaning all surfaces thoroughly before applying

primer or powder coating. Any hand or fingerprints on the bare steel surface will become future problem areas; likewise, grease or other contaminants can cause problems later. Use a strong solvent-based cleaner for this operation. Stay away from water-based cleaners as they may start a new cycle of corrosion. I highly recommend that the car body be handled with gloves only until a protective coating is applied.

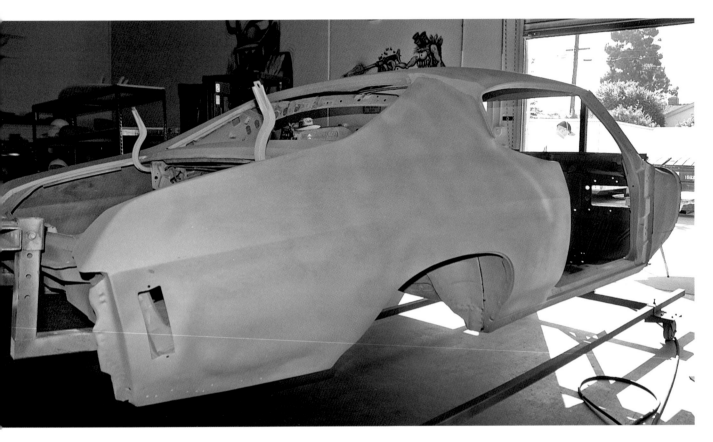

Above: *The Chevelle body was both acid dipped and media blasted. The body is attached to a rotisserie for epoxy priming.*

Right: *Using a good quality Epoxy primer like Glasurit 801-1552 or 801-1871—the chromated version (801-1871) if local regulations permit—gives you optimum corrosion protection and a quality substrate to work on. Please allow the Epoxy primer to dry properly prior to doing any bodywork on top of it. For best results, allow the primer to sit for about a week.*

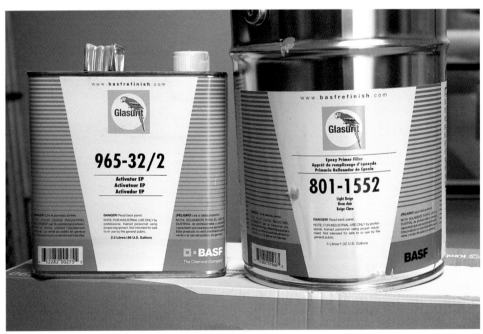

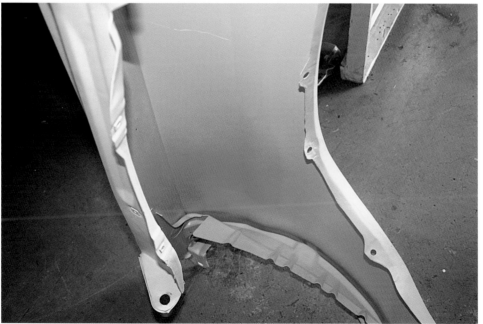

Above: Prime all body panels off the car. The Epoxy primer will help to keep fingerprints off the metal during fitting and fabrication processes as well as providing excellent corrosion protection. This is particularly important if you need to store the parts for a long time.

Left: Pay the same amount of attention to interior surfaces. Applying Epoxy primer to every inch of surface area is a crucial step in producing a long lasting show car finish.

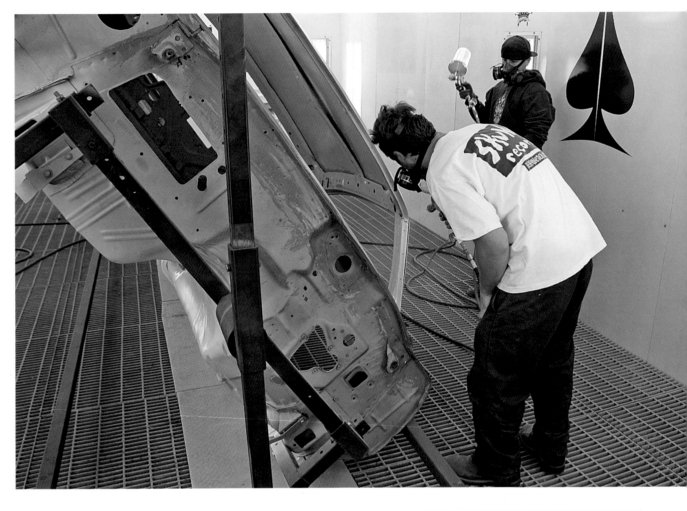

Above: Epoxy primer is applied to every surface. Using the best product available is key. You don't want to invest 1,000 hours or more in body and paintwork over a questionable foundation.

Right: Every reachable cavity is carefully primed. Use a brush if you need to.

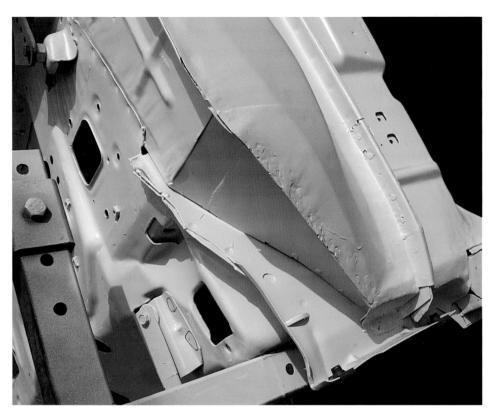

Left: *A nice clean body that was properly prepared makes all following work easier. The best paint jobs in the world cannot overcome poor prep.*

Below: *As soon as the fabrication and welding processes are done, apply Epoxy primer to the bare steel. This is the only way to keep new sheet metal corrosion free.*

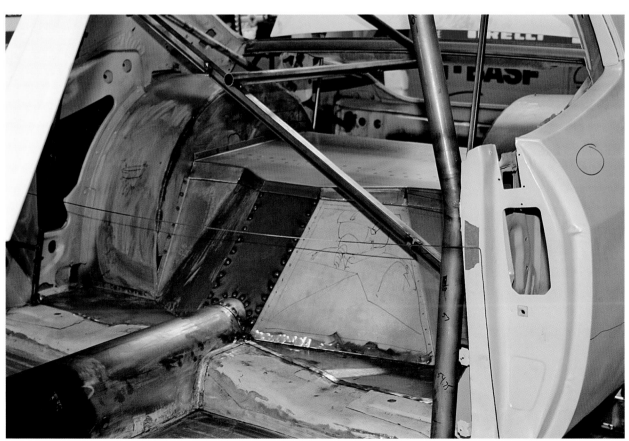

CHAPTER 3
BODYWORK

WHAT TO DO WITH LEADED SEAMS?

On older cars, lead was used to finish joints between body panels. It is commonly found where the roof and quarter panels join. If the lead is in good condition, you may simply want to leave it alone. If it stayed on the car for 30 years or more without deterioration, it shouldn't be a concern of yours. In the event that you do need to remove lead, keep in mind that it is toxic and wear proper protection.

If you need to replace a lead seam, I recommend SMC filler. Oh boy can I hear the purist cry already: "Lead has to be replaced with lead! This is the only way to do it correctly." Well, for the most part, lead can no longer be used in most states. Lead is bad for you and the environment. On top of that, adhesion to lead has always been an issue. In comparison to lead, SMC is a much better choice. SMC is used to bond Corvette bodies together. SMC cures into a very hard film, but it remains flexible enough at the same time to be a good choice for this type of repair. The surface should be bare steel and cleaned well. It may be a good idea to run a small grinder with a P80 grit disk over the surface prior to cleaning. This will help with the overall adhesion.

The secret to a successful repair is applying multiple thin coats rather than a single thick one. Thin applications with extended dry times in between will keep the joints from mapping at a later date. Mapping describes the reappearance of a repair area or the texture of a composite material long after the car has been painted. It is usually due either to product shrinkage or it can be the result of greatly different rates of expansion and contraction between two joining materials. The classic example for this is body filler work over old paint. When the car heats up in the sun after it has been repainted, the paint film expands more than the now sandwiched layer of body filler. Over time, the inconsistent movements of these layers will cause an outline, also called a bullseye, to appear in the paint around the body filler spot. The same problems can arise when you use too thick a layer of body filler that has not thoroughly dried before painting. Ideally, the body filler should be cured for at least two hours prior to any application of a coating. Most paint experts will not recommend applying filler over old paint finishes. While some body filler manufacturers have said that certain glazing putties can be safely applied in this situation, for long

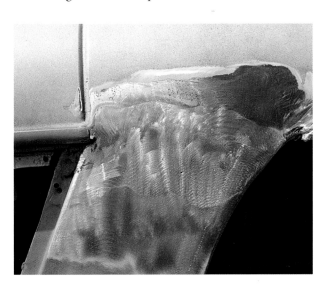

This is a typical lead seam of a car built in the fifties. This seam shows minor signs for concern and will likely be removed.

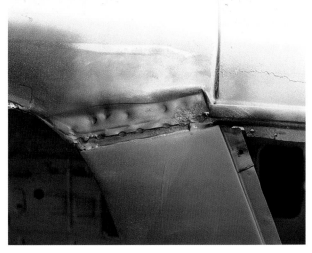

This is the look of the seam with the lead removed. Please remember that lead is a dangerous product and you need to protect yourself while working with it or removing it.

If the lead was removed, clean off all Epoxy primer that may be on the joint.

Blow off any loose particles to ensure great adhesion between the metal surface and the SMC.

term peace of mind it's better to go back to bare metal. Whatever time you save leaving old paint below body filler is vastly outweighed in the show-car context by the prospect that a superb finish coat could develop flaws.

Just as it is the case with all multiple component products, mixing SMC thoroughly with its hardener is very important. Poorly mixed products generally perform poorly. Take your time and mix the product correctly without losing sight of the usable application window. SMC, just like body filler, will kick off rapidly, usually within 5 to 6 minutes, depending on the temperature. That also means that you shouldn't mix up more than you feel can be comfortably used during that time frame.

Use a good, strong solvent cleaner like AM900 to clean off any contamination prior to filling the seam.

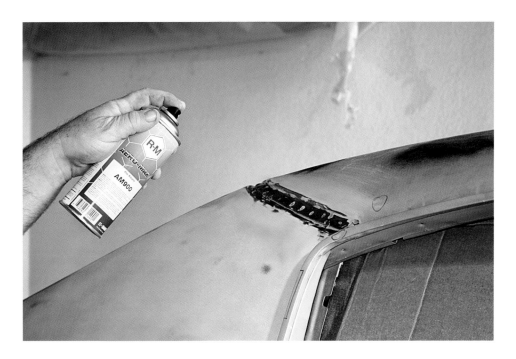

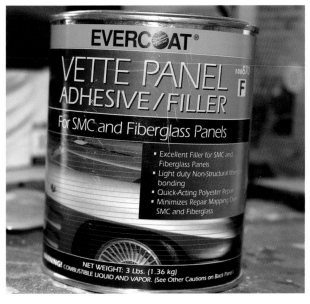

SMC filler is a good choice to fill the joint. Don't plan on filling the gap all at once. SMC will hold up better if it is applied in multiple thin coats.

BODY ALTERATION AND FABRICATING

While body modifications are not this book's focus, I bring up the subject because almost all custom show cars are highly altered vehicles. Many of those alterations directly affect the body and paintwork. In a perfect world, all fabrication and alterations are done in timely fashion and the paint department gets the car for a reasonable period to do its job. The unfortunate truth is that every project I have ever been involved in had a definite deadline. With the paint department being one of the last stops during the construction process, delays and other lost time always needed to be made up for right here. The paint department usually gets the short end of the stick when it comes to time. As a result, fabricating and bodywork overlapped frequently on those projects.

Proper prioritization is very important in a situation like this. If some of the alterations are improperly done or they are not made at the ideal time, the paint crew may not be able to get the perfect finish you desire. I have seen and worked with the best of the best in the world of paint & show car building and you can easily call some of them magicians, but there comes a point when you simply run out of time to get things right. That would be the time when you should extend a project's deadline. Nothing truly spectacular has ever come out of rushing it beyond the practical point.

Some of the most popular changes to a show car today are engine and drive train modifications, smooth firewalls, lowering the ride height by measures other than suspension changes as well as body alterations to fit the desired wheel and tire sizes.

Other alterations like shaving door handles and locks, relocating the exhaust system and removing the drip rail on the roof will also affect the paint end of the building process. Good fabricating work is as important to a show car as the paint itself. All goes hand in hand and a skillful combination of both worlds is what makes most cars great.

Stir the product thoroughly prior to catalyzing. The contents may have settled and it is important for overall durability that you have the product in a consistency the manufacturer intended.

Below left: Apply the appropriate amount of hardener paste and mix very well. If you still see any hardener colored streaks, keep mixing. Even though you need to mix it well, you don't have much time. The chemical reaction between polyester-based products starts the moment the two components meet.

Inset: Multiple thin coats will be applied to fully fill the seam. Do not apply layers more than 1/8 of an inch thick at a time. Allow to fully cure in between applications. I recommend a day. Sand and clean prior to the next coat.

When drastic cuts are made to the body, a support frame needs to be welded into place prior to the cut. This will protect the body's integrity and dimensions. If this is not done, then later in the process you may not be able to align your panel fit and gaps—both are absolute essential components of a show car finish.

The Mothers Chevelle required extreme alterations to the floor and wheel tubs. To fit the custom built racing frame and large size tires, Paul Gonzales and his crew cut out most of the floor and the wheel tubs. This type of alteration requires that a support frame be welded in place prior to cutting.

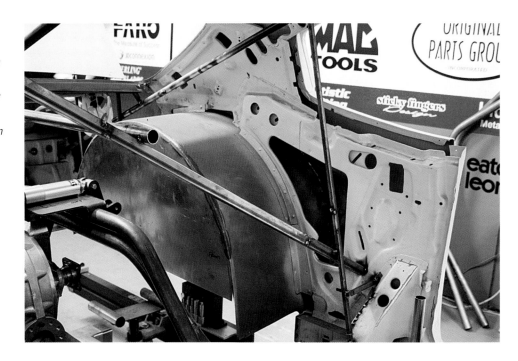

To achieve a smooth firewall, a complete custom fabricated panel was welded to the body. Engine compartments are as important to a custom show car as the exterior and required the same level of attention during the body and paint process.

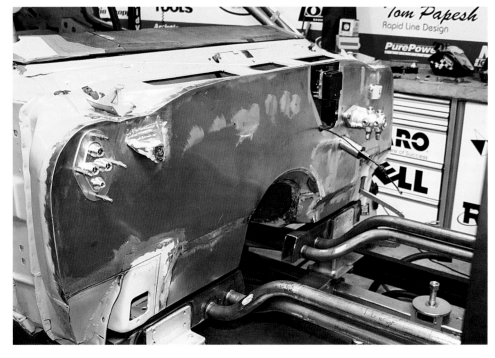

If the design calls for altering the body's exterior, the necessary welds must not warp the sheet metal. A skilled fabricator will carefully choose the proper welding method for the task on hand. The side effects of MIG vs. TIG welding for example are different and applying the proper method can help minimize later bodywork. If you're adding panels, as was done on the Mothers Chevelle, consider several factors. In this case, Chip Foose's design called for a slip-on rocker-panel cover. This cover will also house the exhaust tips. A slip-on cover requires an attachment rail. This rail has to be welded in place in a way that does not interfere with the surface shape. Warping the rockers or the lower parts of the quarter panels in the process would create big time problems.

This type of modification does not allow for much body filler. The cover itself not only has to fit perfectly, it also has

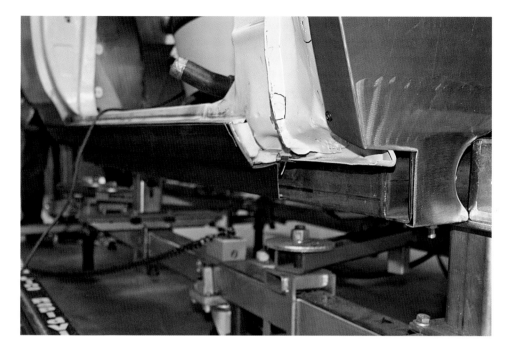

Chip's design concept called for rocker extension panels. They will provide a lower ride height and help cover up frame sections as well. In this picture you see the newly fabricated inner panel and the attachment lip that will allow the outer panel to slip into place.

With the rocker extension panel in place, it is easy to see how such fabrication leaves little room for error. Only a very small amount of body filler could be applied to help perfect the upper edge.

to hug the body shape dead-on. There is no room for errors if you want the car to live up to show car standards. Simply looking at the slip on covers, you probably think, "what's the big deal here?; there is not much to it." The reality is different, though. Fitting perfectly requires that the fabricator and painter communicate well all the way through the process. The painter must check all the fabricated parts beforehand and advise the fabricator on how much clear-ance he has to build into the panel fit. This is important to allow for the thickness of the total paint film at the end. If the final gap on the painted panel is not precise or any of the edges are not straight and of equal thickness, a show car finish will be impossible to achieve. There are a lot of different, highly specialized skills a good fabricator should possess and they make all the difference in the world to the painter's ability to produce that flawless look.

BODYWORK

UNDERCARRIAGE AND FRAMES

Show Cars are normally frame-off restorations. The body is removed from the frame and commonly hangs on a rotisserie. Rotisseries give you perfect 360-degree access to the car body. Temporary attachment points may need to be welded to the body in an effort to allow for a quick exchange on and off the rotisserie. On average, a project car that receives heavy customization to the frame, the belly pan, wheel tubs and more is moved on and off that rotisserie about 6 times. Spending some engineering time on making this task easy is worth the effort. A forklift is routinely used to move the body on or off the rotisserie. Spending some extra time ensuring that the forklift is not damaging anything makes good sense.

Unless you replace the original frame with a new or custom made one, the frame should be media blasted prior to any alterations. For this application, acid dipping does not offer any true benefits above and beyond a thorough media-blasting job.

The most popular refinishing option for a frame today is to have it powder coated rather than painted. A true show car frame is treated identically to the car body. The welds are ground and every imperfection is addressed prior to the painting or powder coating process. All dents and waves are treated with body filler just like you would do with the car shell. Unnecessary drill holes are welded up and ground flat; any new drill holes that are required by

Above: Joining the inner and outer fenders requires a very skilled welder. If this process is rushed, the sheet metal could warp to a point that you may need an extra 50HP to make up for the body filler weight.

Right: Accessing the floor pan is easy while the car is hung on a rotisserie. Achieving truly beautiful cars is close to impossible without them.

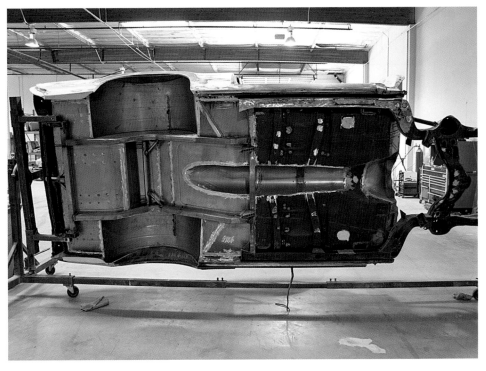

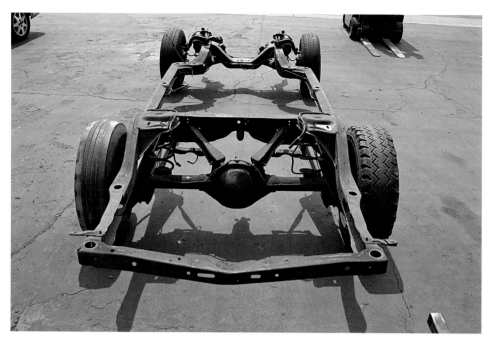

Frames are commonly rusty and greasy. Attempting to clean and prep them by hand is in general a poor choice of labor utilization. The time it takes to prep them right is worth more money than the cost of a professional media-blasting job.

In the case of the Mothers Chevelle, a custom built frame replaced the original. The old frame was discarded.

added or relocated hardware should be drilled prior to coating of the frame. In the event that the frame would have to sit for an extended period of time in bare metal after it has been media blasted, go ahead and powder coat immediately. Powder coating really makes for a good substrate to do body work on. At the end, you are by far better off to powder coat the frame twice than let the rust settle back in.

It is not unusual for show cars to be fitted with custom frames. In general, the stock frame will not allow for the desired wheel and tire choices. The original frame is frequently not strong enough to handle the additional power most people want in their cars either. With engine changes at an all time high in the world of dreams, careful planning is required. OEM manufactured "Crate Motors" have become the latest craze and are popular choices in these









Right: Engineers designing this type of frame-rollcage combination need to consider everything. The engine will be mounted to the frame with solid motor mounts. This will send a lot of vibration through the frame and rollcage. To minimize vibration intrusion into the cabin, the body needs sufficient clearance around the cage.

Below: The floor pan is prepped to accept the rollcage. Because the cage and frame are going to be permanently joined, no mistakes can be made that would require the body to come off the frame again.

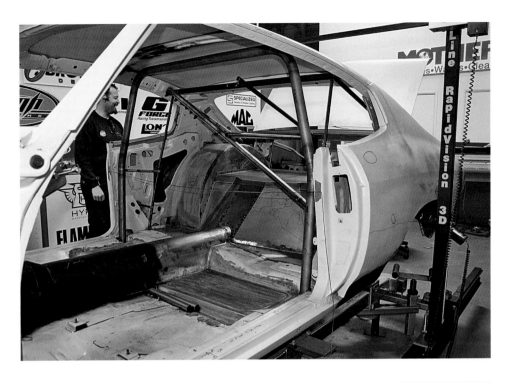

Another important decision needs to be made with a frame like this. The durameter rating of the bushings and blocks will play a big role in the level of vibration transmission into the passenger compartment. The goal is to find the optimum stiffness with the best vibration absorption.

types of cars. HP ranges in excess of 700HP are getting easier to come by. A 1000HP compressed gas engine will power the Mothers Chevelle—turning this car into an alternative fuel vehicle, or an eco friendly Hot Rod that rocks if you will. The power that this engine produces called for a completely custom build frame. Paul Gonzales and his crew got the call to make the frame. They have a real racing-world fabricating background and were up to the task. The engineering process of this frame included the fabrication of a rollcage that will be directly welded to the frame. The finished frame is then powder coated to achieve good durability and chip resistance. A nickel colored flat finish was chosen for a clean industrial appearance.

The undercarriage can be treated in several ways. Based on your desire to utilize the vehicle in a certain manner, you can pick from three popular options.

Painting is by far the most beautiful method of refinishing the undercarriage. The downside is that it is also the most sensitive coating you could apply to the car's belly. Despite the sensitivity of paint, for show cars that are going to be trailered around most of the time, painting is the way to go.

Powder coating is a good-looking, durable coating that is a perfect choice for the careful weekend users. Powder coatings are hard and generally scratch resistant. The color choices are really good these days, but black is still the most frequently used option on project cars today.

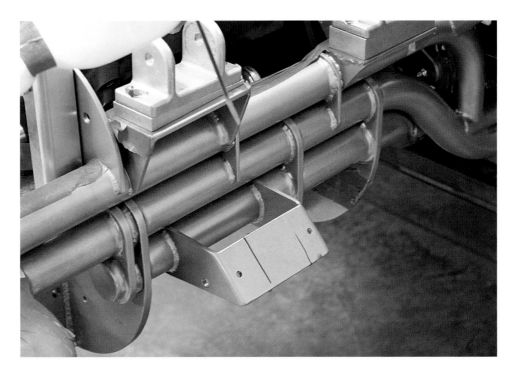

The satin nickel color of the powder-coated frame will be carried into the exterior paint scheme.

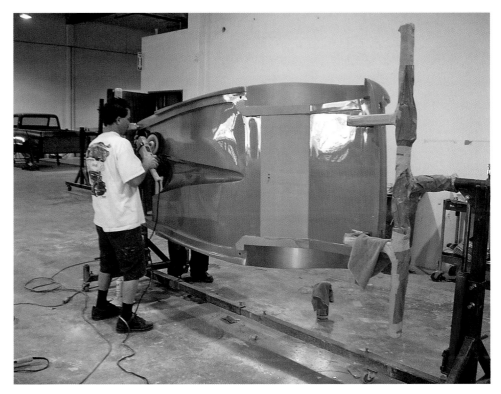

A painted show car belly is a beautiful sight. Meticulous bodywork is required to make this look as great as the upper body. This type of work is for the most committed in the show car world.

If you are planning to use your show car on a regular bases and you plan on using it hard, Line-X texture coatings—often found in truck beds—are the way to go. This coating is nearly indestructible and can be applied at different texture and thickness levels. Its physical properties make it a better choice than conventional undercoating. The Line-X coating, which must be applied by a skilled technician, is a two-component product that is applied heated. It cures almost instantaneously.

These coatings are unlike any other coating most people

The same flawless prep and paintwork is going into a painted frame. If it is done right, it can be breathtaking.

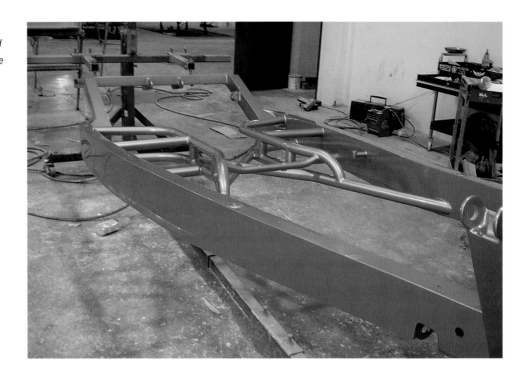

The belly of this Chevelle is prepped for the Line-X coating. The previously powder coated frame is carefully wrapped in aluminum foil.

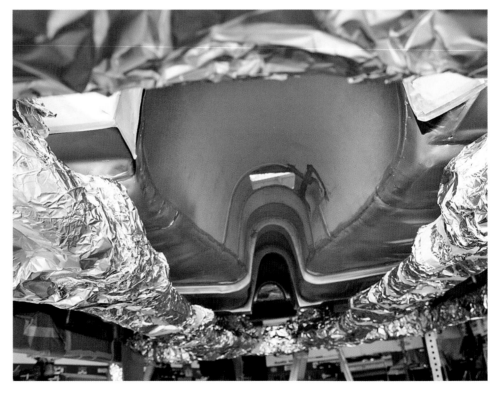

have ever sprayed. You need to find a technician with 20-20 vision and a passion for detail. Nothing can be missed and the texture and thickness has to be precise. A 60-mil layer is an ideal thickness for the belly and 20 to 30-mil is a good choice for the interior. (One mil is 1/1000 of an inch.)

With these coatings, some sound deadening effect can be expected as a bonus. Overspray onto unintended surfaces should be avoided at all cost. Once the coating attaches itself to a surface, it is extremely difficult to remove. To mask off components like tubular frames and suspension

Not only will the belly be coated, but the floor of the trunk and passenger compartment as well.

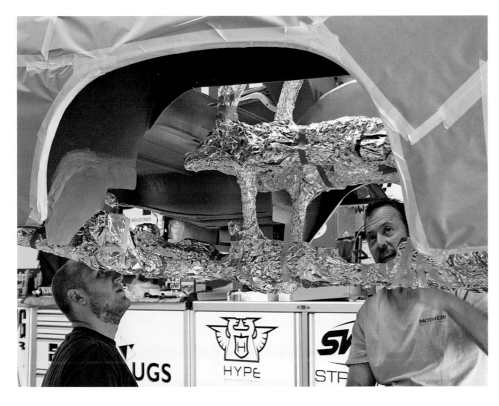

Masking is a very critical step. Any Line-X overspray will attach itself tenaciously and is a pain to remove.

components, aluminum foil is a great choice. It can be wrapped tightly around tubing without much masking tape. It also comes off rather quickly. Any seams that need sealing should be taken care of several hours prior to spraying on the Line-X. Seam Sealer that never properly dried will remain soft forever and could create a problem down the road. As when applying any other coating, clean the surface to be sprayed thoroughly beforehand. Blowing off or vacuuming off any debris prior to solvent wiping is a good idea.

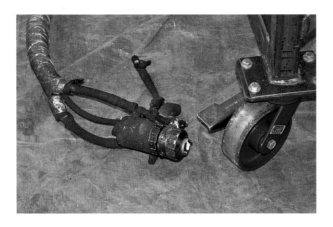

This strange looking device is the applicator gun. It mixes the two components right at the tip, the instant before spraying.

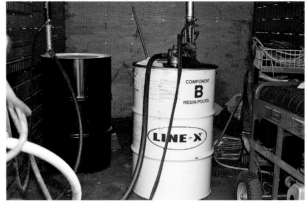

The components are pumped out of those drums and heated up in a machine.

Right: For best results, the technician needs to have a passion for detail. Missing a spot or applying too little can result in premature failure later.

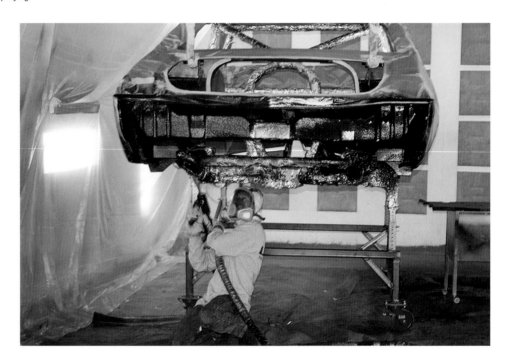

Below: The heated material is pressurized to 2000 PSI. The two components are still separated from each other at this point.

PANEL PRE-FITTING

Pre-fitting all of the bolt-on body panels is a must prior to handing the car over to the paint department. The heart and soul of a show car paint job is the combination of panel fit, surface flow and the precision of all gaps. Handing the car body over to the painter with good general fit can take weeks out of the painting process. All of the fitting processes on panels and gaps have to be done with a fresh set of rubber bumpers and seals in place. Be prepared to buy two sets of seals and bumpers. One is likely to be damaged during the process of perfecting the body. Spending the extra $300 is a good investment and the final appearance of the project will reward you for it.

Cleaning all surfaces prior to application is critical. Note that the edges are taped off. The thickness of the coating would interfere with this part's proper fit later. Address those considerations well in advance.

The final finish is an easy to clean, super tough and highly professional looking coating. Be aware that this coating has the ability to fill in smaller drill holes or alter the shape of openings.

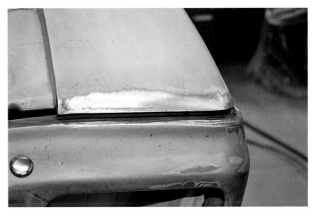

Additional metal is welded in place to tighten up the gap between the bumper and quarter panel.

Drilling small holes through hinges and panels to mark their proper position is a common practice. Try to drill the holes in areas that are not too obvious later. Also, please restrain yourself from drilling these marker holes too early. In many cases, it is often a better idea to wait until the painter has done 90% of his panel shaping and gapping. One reason for that is that highly altered bodies are known to sag in the early stages of their transformation. The second and even more important reason is that the painter will remove and reinstall doors and fenders multiple times during the bodywork and primer stages, altering the pan-els and moving them around, each and every time. Markings made too early in the building process may not be accurate later. Drilling new holes every time you think you have it right can easily be confusing by the time the car is ready for painting.

Precise and consistent gaps are one of the biggest and most obvious differentiators between a good paint job and a show car finish. As a general rule of thumb, the smaller the gaps, the better the car. On the flip side, the tighter the gap, the harder and more difficult it is to get them perfect. To tighten up the gaps to a predetermined size, welding

The painter and fabricator discuss the alignment of the deck lid. Finding the least invasive way of properly gapping is vital.

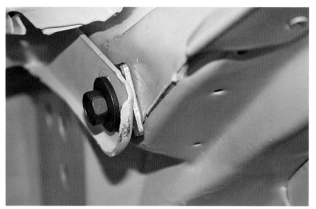

Shims are used to find the proper alignment of the bolt-on panels. They are used to move the panel up, down or outward.

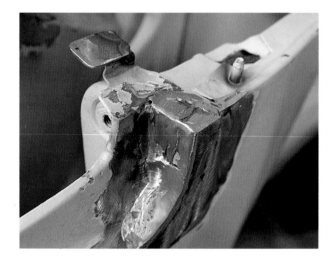

Additional metal was also put in place on the front fender. The factory gap between the fender and bumper on a stock Chevelle is almost an inch on some cars.

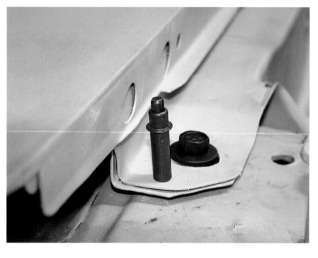

Cleco fasteners are used to temporarily secure mounting points. This method is very helpful if the proper alignment of surrounding panels depends on this part not moving.

additional metal into place is often necessary. When determining the gap size for your project, consider the future use of the car. A show car that is moved by trailer from show to show and hardly ever drives under its own power can be gapped very tightly. One-eighth inch or smaller will really make the car look spectacular. Some Ridler Award contenders have been gaped to watertight gaps in certain areas. Watertight gaps are extremely cool looking, but obviously only practical on areas that don't move. In the example of the Mothers Chevelle, most gaps have to be bigger than 1/8-inch. The car will be driven hard and often. The 1000 HP engine will be more than capable of twisting the body under hard acceleration. To be safe and allow for enough body flex, the gap size is set at 3/16″ for this project.

Aligning all the parts and surfaces is another fun game during panel fitting. Knowing exactly which part or what area to secure first and what surface to align to is a matter of experience. Using common sense and considering every part and panel that could be affected by your choices is a good way of staying out of trouble. Cleco fasteners are commonly used to keep mounting points lined up correctly, while shims are mainly used to secure proper panel fit. Skillfully adding them can move a panel up, down or outward. As soon as you have all surfaces aligned properly, document the position and the thickness of each shim prior to disassembly. As mentioned before, the vehicle will be assembled and disassembled several times in the process. Having a good record of the position of all shims

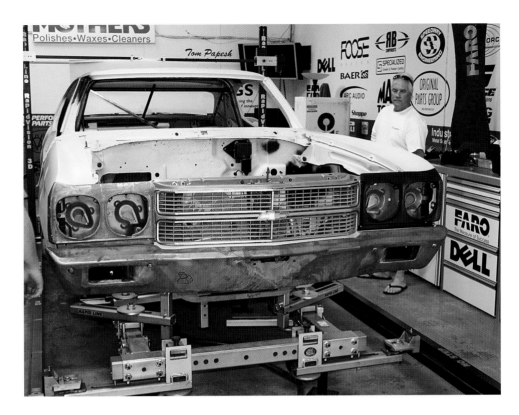

After the body was married to the new frame and most major fabrication work to the body was completed, body and panel fit is rechecked.

Paul Gonzales evaluates the best possible mounting points for the new struts that replace the old twisted spring. Obstruction-free operation as well as clearing future upholstery are primary concerns.

prevents you from reinventing the wheel. Store all the bolts and shims for each panel in its own separate, clearly marked, Ziploc bag.

If your modification plan calls for replacing the original trunk lid springs with pressurized gas struts, install them prior to paint and bodywork. Struts can affect the fit of the trunk lid. Due to the struts' internal pressure,

they are known to push the hinges upward. Making the proper adjustments after the car was painted has proven to be challenging. Also, if you are shaving off the door handles and lock cylinders on the car, engineer a temporary mechanical device that lets you open and close all locks easily. To get the perfect panel flow, the painter has to have the locks, strikers and seals in place.

CHAPTER 4
PAINTING PREP AND MORE BODYWORK

PAINTING OF CHROMED BUMPERS AND PARTS

Painting any chromed bumper or molding is challenging to say the least. Chrome is not a suitable substrate for a quality paint finish. Even the most advanced adhesion promoters today are doing a mediocre job at best. If your show car design calls for painted bumpers, please do yourself a favor and get the chrome stripped off the part. Sanding the chrome off the surface is a painstaking endeavor and not a very practical use of your time. There are two good options to remove chrome: media blasting and chemical stripping. Reversing the process of chroming itself is often used to remove the chrome during the chemical stripping process. The stripped part can have a strange look to it. Once stripped of its chrome, the part is well suited to powder coating, which leaves a tough, chip resistant coating for temporary storage and later makes a great foundation for body work.

SETTING UP YOUR WORK AREA

Setting up your work area is an important step in the bodywork process. This is even more important if more than one person will work on the car at the same time.

Having to look for tools or materials is frustrating. Set up your work area in a way that makes sense to most people. Dedicate areas for materials, mechanical tools and bodywork tools. The likelihood that you will wear the proper safety equipment also decreases if you have to search for it. Nobody likes to work in a dirty environment, so put plenty of trash cans all over the place.

Keeping your work area clean improves the quality of the work and really helps to keep up morale. Have a number of tables available to set up tools, materials and to temporarily store parts. Make sure that fans or other methods of proper ventilation are available. The other key factor is lighting. Perfection will never happen if you can't see properly. Have plenty of extension cords and air hoses on hand. Air tools are in general more effective than electrical power tools. Make sure that the compressor is up to the task.

BODY FILLER WORK AND STRAIGHTENING THE BODY

This segment is the meat and potatoes of bodywork. If you envision a perfectly metal finished and body filler free car, stop dreaming. I shouldn't say that it couldn't be done,

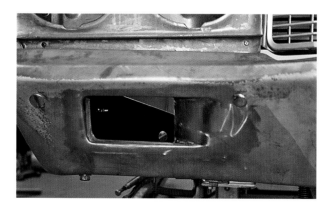

A chemically stripped bumper looks strange. Note the changes made to the turn signal opening. The opening is redesigned to be a functional brake duct.

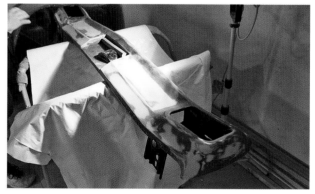

The rear bumper was also stripped of chrome. The license plate opening was greatly reworked prior to powder coating. The good news is that powder coating makes a great substrate for bodywork. Sand the bumper with P120 or P80 grit paper prior to the bodywork.

Set up worktables that are specific to tasks. The body filler table for example should have plenty of spreaders in different sizes, as well as cleaning solvents and rags. Gloves, dust masks and other essentials should all be found in the same location. Clean, restock and reorganize the table a couple of times a day.

Have several stands on hand. Wrap the stands with a soft padding to protect the parts' surfaces.

Have all essential body tools easily available on one table. You are going to use them all the time and having to look around the shop to find them can break your concentration. Return them right away after you are done.

but it certainly wouldn't be practical. Trying to metal finish any car to show car perfection is not only impractical, it probably would cost you about a million bucks. In the world of show car painting, there is no panel straight enough to be simply sealed and painted. A skim coat of body filler is going to be applied pretty much everywhere at one point or another. I know that body filler has a bad reputation. This reputation was earned during the early years of product development and improper use. The quality of modern, high-grade body filler is so good today that its presence is no longer a concern. As long as it is used to the manufacturer's specification, correctly mixed

and applied to a substrate that is properly prepped, body filler constitutes no quality problem.

You will spend most of your time sanding and applying body filler. Based on that fact, it is important that you pick the right products and sandpapers for the task. The good news is that today's body filler sands better than ever. Picking a high quality, lightweight body filler will make all the difference in the world. Using between ten and twenty gallons of body filler during the making of a show car is not uncommon. Considering the amount you may use, spending a premium on body filler products makes good sense. For the "first timer" to the show car world, don't be

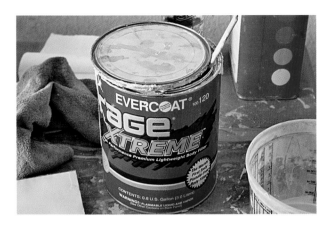

The choices of high quality body fillers are great. Rage Xtreme from Evercoat is my current favorite. Body filler is a fast evolving segment of body materials. Consult with your local paint supply store to stay on top of this technology's evolution.

Sandpaper comes in all shapes and sizes. The same grit is made in different quality levels and is purpose driven. Picking the right paper makes a big difference. Sandpaper is the most used tool during the bodywork phase and it deserves your full attention.

alarmed when you hear that you may need twenty gallons of body filler. As a rule of thumb, at least two-thirds or more will be sanded back off during the shaping process. For the most part, not much more than about an eighth of an inch will remain on the car when it is done. When purchasing body filler, look for attributes like easy sanding, none staining and shrink resistance.

SUPPORTING PRODUCTS AND TOOLS

Sand paper choices are equally important. Oh, did I mention that sandpaper just like everything else today is really expensive? I perfectly understand that money doesn't grow on trees, but everybody who works in this field for a living agrees, you get what you pay for. Buy the highest quality sandpaper available. You will spend 90% of your time sanding and a lower grade paper can easily add hours, if not days to your project. Mirca and 3M are not the only quality sandpaper manufacturers, but in my opinion, they have worked the best. Paper from 3M is probably the most innovative and widely available choice today. Keep in mind that manufacturers produce different quality levels of product, for different purposes, under the same brand name. Educate yourself prior to purchasing.

One other under-appreciated tool is masking tape. The same holds true for tape as it does for sandpaper. The most expensive thing you can do is try to save money on it. You want a tape that sticks when it counts, but will come off the surface completely if you need it to. Some of the cheaper tapes I tried over the years have left glue residue on the surface after you removed it or simply came loose

Have plenty of masking tape on hand at the time you start the project. Buy it by the box. You are going to mask the car several times for different purposes. Having to run to the paint store to get more interrupts your workflow. Have different tape sizes on hand.

all on its own after a few days. The nature of a show car is that you do many different things to it at separate times. As a result, tape stays on surfaces for days on end and you have to be able to rely on it without checking it every day. Tape is in many cases the best product choice to protect work already performed. A good example for this would be any primer or Line-X overspray landing on your freshly powder-coated surfaces. Tape not only protects surfaces from damage, it is also a very useful tool. It is used to mark bodylines while you shape contours, or it can cover a gap while you apply body filler. Tape is used to attach

small parts temporarily and functions as a guide. There are countless uses for tape during the body and paint process and you need to be able to count on it.

ROUGH SHAPING THE BODY

Rough shaping the body removes all dings and dents prior to fine-tuning the surfaces and gaps. This process is about 90% of the bodywork the car will receive. Even if it is 90% of the work, it will only take 40–50% of the time required in perfecting the body. The last 10% is where the separation from a simply nice car to a true show car is made. Half of the time you are going to spend on bodywork is spent on that last 10%. It is also the moment when the separation between technicians and true craftsmen becomes apparent. The amount of time it takes and the level of com-

mitment that is required to get all of the vehicle's body surfaces right is overwhelming to many people.

This bodywork stage is a messy business. Sanding dust is produced by the truckload and product overspray or accidental material transfer is a constant risk. Protect all sensitive surfaces that have already been finished with either plastic or masking paper. Protect any open vents from excessive dust intrusions or buildup. Tape off the underbelly and the inside of the passenger compartment to protect it from contamination, dust buildup and overspray. When taping off the passenger compartment and other openings, tape them in a way that will not interfere with your ongoing work. As an example, tape the door openings in a manner that allows you to install or remove the doors without having to re-mask them every time.

Spreaders of all shapes and sizes are used to create the perfect body. This particular spreader was originally designed for drywall work.

A wide selection of sanding blocks is a must on every project.

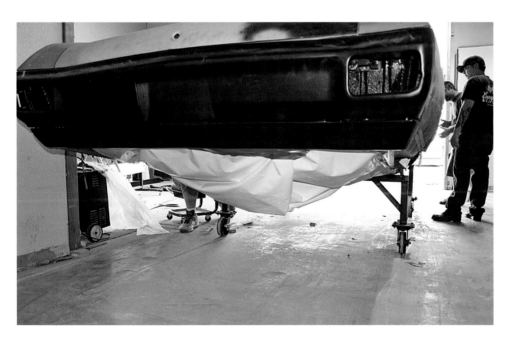

The belly and wheel tubs are masked with heavy-duty masking paper and strong duct tape. This will help to protect the Line-X coating from tool damage, body filler transfer and primer overspray.

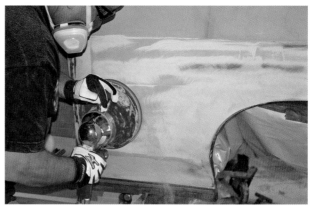

The door openings are covered by cardboard. This leaves enough room to work on the jambs and remove and install the doors as needed.

Wear the proper safety equipment for the job. No show car is worth more than your health.

Clean and sand all surfaces to achieve maximum adhesion for the following body filler. The sandpaper of choice for this operation is P80–120.

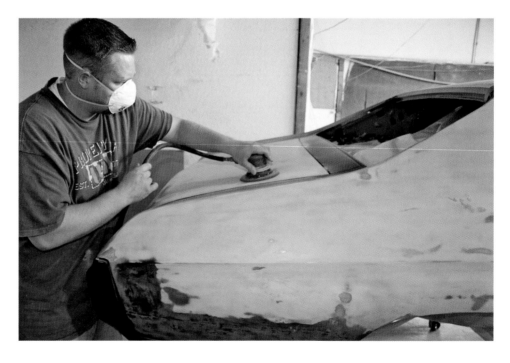

Have personal safety equipment on hand. Dust masks, Latex gloves, ear and eye protection are the minimum equipment you should have available. As exciting as show car work can be, protecting yourself should always be on the forefront of your mind. It is an ongoing observation of mine that the combination of high profile work with young talented people almost always translates into lower protection levels. The higher the car's media attention and the younger the men or women working on it, the less likely it is that they will use proper safety equipment. I know that we all have been young and careless at one point in our life, but we should all work on making this a safer place. You may not look extremely cool wearing a dust mask or rubber gloves while working with your buddies, but having serious health issues like compromised lungs is a lot less cool—and a lot more permanent.

Before you start applying body filler, clean all surfaces with a good strong cleaner like RM 900 Pre-Kleano. As soon as all of the fingerprints and contaminations have been removed give the epoxy primer a good scuff. Well-cured epoxy primer has a hard to scratch surface. For best results, sand it with some P80 or P120 sandpaper. Sanding the primer too rough will remove too much of your corrosion protection; sanding it too fine can result in adhesion problems for subsequent coatings. Breaking through the primer cannot always be avoided; it is even

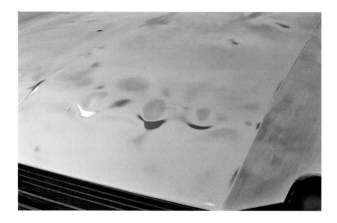

Sanding the epoxy primer will reveal high and low spots.

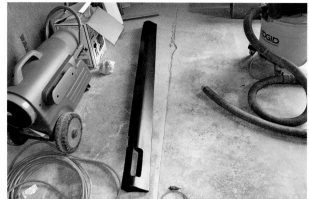

A small movable heater can help overcome slow curing body filler issues. Increased use of hardener can lead to future problems.

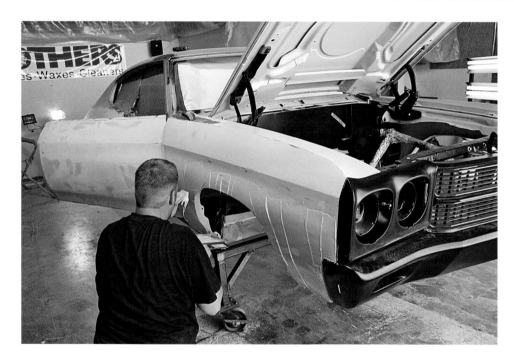

Dave Young is applying the first coat of body filler to the lower part of the right fender. He is paying close attention to the shape and the contours.

helpful in some instances. Should a panel have too many dents, breaking through the primer can show the true scope of the surface condition.

Applying body filler properly can cut a lot of sanding time out of the day. The smoother you apply body filler and the more precisely you fill in low spots, the less sanding you have to do. Modern body fillers have nice flow and leveling characteristics that can be used to your advantage. Controlling the temperature is a key factor in body filler's performance as well. In a cold environment body filler may cure very slow. To speed up the cure time, craftsmen may increase the amount of hardener they apply. But the hardener pastes used in polyester resin products are peroxide based.

Excess peroxide that is not completely used up during the chemical curing process has the ability to slowly migrate through the paint film and bleach the color pigments. How fast this will happen depends on many variables.

The bottom line is that peroxide staining is unsightly and hard to repair. Storing the body filler in a climate controlled room and not allowing the metal temperature to drop too low is the best way to avoid this problem. Preheating the vehicle's surfaces during cold weather is another option. On the flipside, during high temperature days, body filler may cure too fast. The natural response is to leave out some hardener. Should the hardener level drop too low, however, the body filler will not cure properly

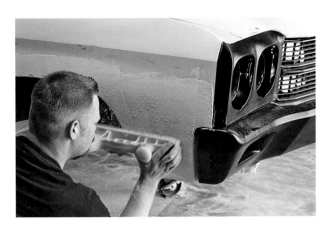

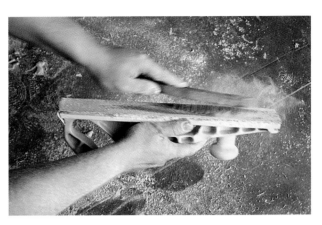

Starting the sanding process just at the right time makes shaping easier. The second upside is that you don't produce as much fine sanding dust. The particle size is too big and it easily drops straight to the floor rather than floating through the air.

Sanding body filler at its earliest possible stage will load up the paper. A wire brush helps extend the sandpaper's lifespan.

and will stay soft or even sticky. Future problems are likely in a paint job applied over questionable body filler. The correct fix to combat heat-accelerated curing times is to mix smaller, more manageable filler amounts that you can apply before it cures.

To minimize unnecessary work, don't simply start slapping on body filler; take a moment and read the shapes and contours of the part's surfaces. Knowing the exact flow of the surfaces, the contours and style lines helps you apply body filler in the most beneficial way. Rather than applying body filler to three or four smaller areas next to each other on the same panel, cover entire surfaces. Achieving the optimum surface is many times easier that way because it gives you a surface of uniform hardness to sand. A panel surface with areas of metal, epoxy primer, and fully cured body filler will be difficult to make perfectly straight because the different hardnesses will sand at different rates. Err on the side of covering more area with filler and start sanding early (though not too early). Shaving and carving lines and surfaces requires less physical strength that way. Trust me, you will need a lot of your energy during the making of a show car; wasting any on something unnecessary is just plain foolish.

Sanding body filler at an early stage tends to load up the sandpaper, though. Using a wire brush can help extend the paper's life span, but don't try too hard! Change your sandpaper as soon as it loses bite. The labor cost outweighs the cost of sandpaper any day of the week. In the big picture, nursing a tired piece of sandpaper along just to save a buck is counterproductive. Never lose sight of the fact that about 80% of what you are going to do during the prep

work is sanding. To most people, sanding isn't exactly fun anymore after the tenth day and if you can help yourself be more efficient, do it.

After sanding the first coat of body filler, clean all surfaces prior to applying the second coat. Cleaning off any lose particles is a must to guarantee flawless adhesion between coats. Use a brush or vacuum to contain the dust in your work area as much as possible. As soon as the majority of the dust is removed, use a compressed air blower to free the surface of any remaining particles. Inspect the body filler surface closely for any small hidden air pockets. Open up any pockets prior to the next coat of body filler. Trapped air will expand and harm the finish when the car is painted and exposed to the sun. The best defense is to mix the body filler in a way that air is not going to be trapped in the film in the first place. A little attention and awareness goes a long way and can easily prevent future headaches.

While you work your way around the car, mark any low or high points you are aware of. This practice is particularly helpful if you don't plan to work on the same surface for some time to come. Also, marking them can help you find them easily if you have some leftover body filler you wish to use up. The bottom line here folks is that this is the best and most uncomplicated insurance policy I know of to help you remember problem areas at any given time. You are likely to work on several areas at once and staying on top of everything that is going on can be challenging, but is also very crucial. To make your marks, use a pen or pencil that will not soak into the body filler. Chalk is another option, but the problem with caulk is that you may blow or wipe it off accidentally. Using a Sharpie can have

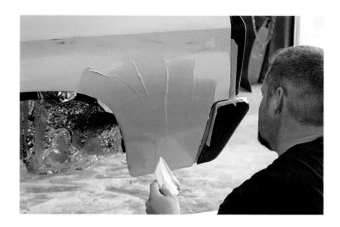

The next coat of body filler is only applied over a clean and dust-free surface.

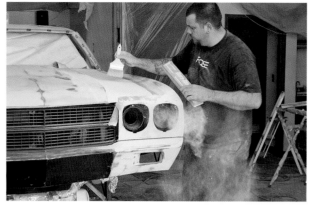

Rather than blowing the sanding dust all over the place, use a brush or vacuum to get it cleaned up neatly.

Placing leftover body filler is easy and effective when you mark areas that still require additional fill. Use a pencil that will not soak into the porous body filler.

The most important tool during the shaping process is a good long board.

unwanted side effects too. Not completely removed, the markings made with a Sharpie tend to bleed through the following coatings.

With the rough shaping on its way, more attention is being paid to the edges as well. Having perfectly shaped and only factory thick edges are a must on any show car. The thickness of the edges is a dead giveaway about the presence of body filler. The trick is to do whatever necessary to get the perfect shape and panel flow without leaving any signs of body filler. The finished car needs to have the look and feel of being metal finished. For example, adjusting a door's edge to align perfectly with the fender, even if it means that the complete door surface needs to be covered in body filler, is well worth it. Not committing to perfect edges with factory radius and thickness is where many show car attempts fail. It doesn't take an industry expert either to point that out. Painfully proving this

The ongoing effort of keeping the workspace clean is well worth it. Any particle you remove cannot accidentally find its way into your products.

Keeping the factory radius and thickness of every visual edge is paramount in the pursuit of perfection.

Pay a great deal of attention to aligning surfaces. Make adjustments in a manner that maintains edge thickness at factory level.

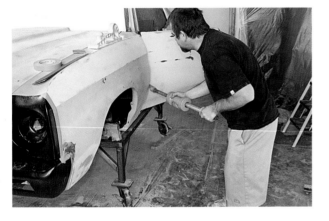

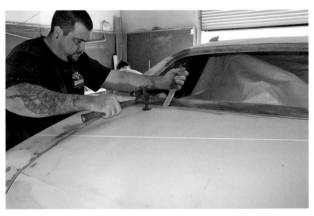

To improve the alignment of the panel's surfaces, Chris Guinn is pulling the fender edge outward with a slide hammer.

Jake Baily carefully adjusts the edges of the trunk lid to match the surrounding surfaces

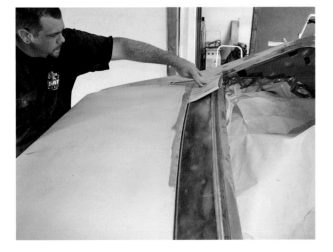

Even a sleeve of sandpaper can be just the perfect tool at times. Lowering the lid with the sandpaper in-between gently lifts up the edge.

point all the time is my wife. Anette never worked in the industry, but she has a very observing eye. Taking her to car shows can be very embarrassing. She can simply walk up to just about any beautifully redone car and point out the smallest defect in a New York minute. One day it took her an astonishing 15 seconds to find the first flaw on a Pebble Beach winning car. One thing is for sure, you know a car is done right if she can't find a reason to complain.

Larger dents are best fixed by working the metal as well as possible before you apply body filler. Working on fully disassembled cars is great; it gives you excellent access to most of the inner panels. Pushing and massaging the metal with an assortment of different tools from the inside and the outside is the best option if you have access to it. A different choice is to temporarily weld small metal studs (also called nails sometimes) to the outer surface of the dent. Attach a slide hammer to the stud to pull the surface carefully

This small welder is used to attach the metal rods to the surface. Attaching them just in the right spot is an art that requires some practice.

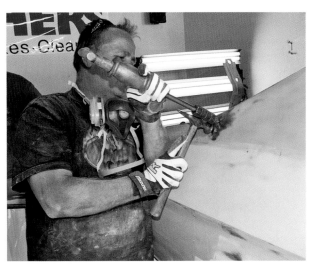

Above: Kerry Jennings is carefully working out a low spot on the quarter panel by pulling the surface outward and controlling the outer perimeter with a hammer at the same time.

Left: It is not easy, but you can see the poor flow of the lines and surface on the door and front fender of this Chevelle.

back into its desired shape. Where to attach the studs and how many to attach is a learned skill that requires some practice. It is not overly complicated to do, but if it is done wrong, it can easily create a bigger problem.

Undoing factory flaws and returning the body to a shape the original designer of the car would be proud of is the ultimate goal. Manufacturing standards in the '60s and '70s were particularly bad. Manufacturing and stamping processes are mainly to blame for the quality shortcomings. Put any car from this era that is still in original condition up on a lift and take a close look at the quality of the surfaces. Using the reflection of a light on the paint as a guide unveils the ugly truth.

To achieve a mirror perfect reflection in your final paint finish, almost the complete car has to be coated with body filler and re-sculptured. This process is going to require multiple applications of body filler followed by skilled blocking. Watching this process unfold is hilarious to an outsider. "Didn't you just do this?" is a question I have heard so many times in my career. To assist the straightening efforts, different colored body filler is often used. The color difference can help to prevent you from shaving off too much of a particular layer of body filler and to guide you on filler depth as you shape specific areas. Color difference is especially important if one layer is to serve as a reference point for other areas. The color difference

To undo the manufacturing flaws, Kerry needs to apply several layers of body filler followed by a skilled blocking procedure. Layering different colored body filler reveals a panel's contours graphically and allows you to shape them perfectly to your needs.

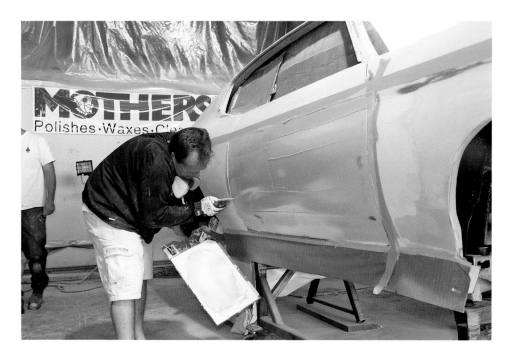

Most paint supply stores carry blue, white and red hardener. Used properly, they can be a great help.

A straight edge unveils the flat spot on the fender. The straight edge is used that way all over the body.

is achieved with different colored hardener pastes. But a word of caution is in order. Only use multi-colored body filler with a particular purpose in mind. If you are simply lazy and grab any color hardener paste that is closest to you, you can easily wind up with an optically confusing surface. Besides colored fillers, there are other tools that are not necessarily on people's minds when they do bodywork—tools that offer great value to the overall quality of the project. One example is an assortment of straight edges. Straight edges can function as a measuring tool for how much block sanding or fill is required. A couple different sizes of straight edges are a must in every show car painter's toolbox.

Let's switch gears here for a moment. Considering the fact that the majority of show car owners are of the baby boomer generation, there is an increased likelihood that the car you are working on is a classic American muscle car. One notorious problem area on many muscle cars of the '60s and '70s is the fenders. Fenders on Camaros, Chevelles, Chargers, Barracudas and the like left the factory with a flat spot right over the wheel wells. These flat spots are a side effect of the tooling of its time. To find out how bad the flat spot really is, take a straight edge with its wide flat side to the fender and follow the natural curve of the body. You will see how the fender bows in rather than following the natural shape in a consistent line. Repairing the flat spot is

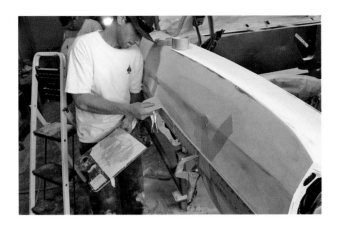

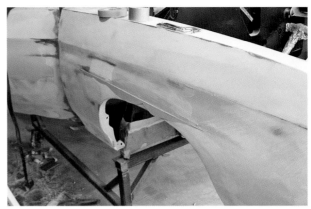

After the inside of the straight edge was taped up and it was attached to the fender, Ryan Spade squeezed body filler in-between the two surfaces.

After the straight edge is removed, a perfect bodyline appears. This line functions as a guide to build up the surrounding surfaces

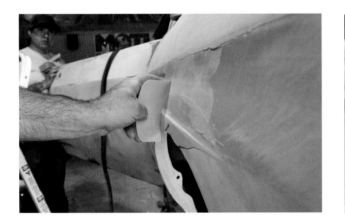

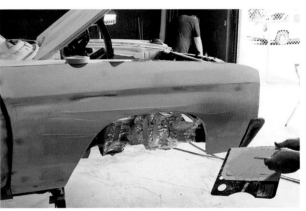

You can easily see how this procedure takes the guesswork out of recreating the perfectly shaped fender. Remove any sharp body filler edges before you start applying more.

Following the ridge as a guide, bring the surrounding areas up to the right height. This would have been a perfect time to use different color body filler.

critical to perfection. Chris Guinn, one of the best craftsmen in his field that I have met, tries to return his cars' fit and finish to what the original designer of the vehicle envisioned. If you have ever seen a production car next to a full-scale clay model or prototype, you clearly see what was lost due to modern production techniques and tooling. Undoing these flaws is part of any true show car project.

Not only is the straight edge used to unveil the problem; it can also be used to repair it. Once again attach a straight edge to the fender in a way that it will recreate the shape in a consistent line. Securing the straight edge at strategic points prevents it from moving around during the following procedure. This is going to be a big part in your success. The flat spot should be clearly visible behind the edge at this point. To protect the tool from damage, I recommend you prep the straight edge with some tape.

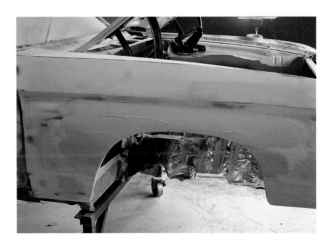

After the first blocking was done and a second coat of body filler is applied, it becomes clear how improved the fender profile looks.

Kerry has marked the backbone with tape. Before he starts concentrating on the line he verifies that the surface is correct using that straight edge again.

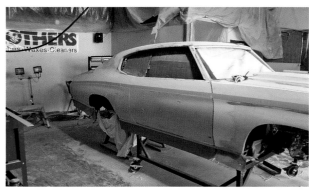

Different color body filler is applied right up to the tapeline. The tape helps to create a clean break and the color difference makes it easier during the block sanding process.

Killing two birds with one stone, creating the backbone and finalizing the fender shape at the same time. Kerry applies body filler over the fender right up to the line.

As soon as the body filler is applied, Jake is using the straight edge as a spreader, keeping the hard-fought-for fender shape true.

Taping up the straight edge completely on the inside allows you to squeeze body filler behind it without making a big mess. Mix up some body filler and squeeze it behind the straight edge. As soon as the body filler sets up, remove the straight edge. This approach leaves behind a perfect guide, or "splining," as Chris Guinn calls this process. After you remove any sharp edges, this body filler ridge is used as a guide to fill in the surrounding low spots. Using different color body filler allows you to maintain the integrity of the perfect spline. Simply stop sanding as soon as you break through to the original body filler color. It is likely that you have to apply body filler over this area several times to get everything just right. Emphasizing and recreating shapes, contours and bodylines is what show cars are all about.

As soon as most surfaces are close to their desired shape,

it is time to start concentrating on the bodylines. The Chevelle has two major lines that are of the outmost concern. One is the leading edge that travels from the top of the fenders through the doors into the roofline and the other is the backbone. The backbone is the lower line that runs along the whole side of the car, from the front of the fender all the way through the quarter panel. To make a show car stand out, those lines have to be emphasized. They need to be perfectly straight and crisp. Applying body filler to a taped line is, in some cases, the easiest way to achieve the perfect lines. Perfection really boils down to one thing and that's repetition. The perfect show car finish is created by applying body filler and then sanding it straight. As soon as you are done blocking it, you pretty much start the process all over again 15 more times. Not really, if you know

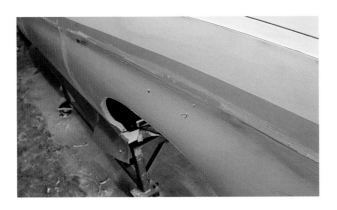

Using this technique leaves you with a great and easy-to-block-sand surface. Try not to do this alone; it is much easier with two people.

A must have product for a project like this: 3M's powdered guidecoat.

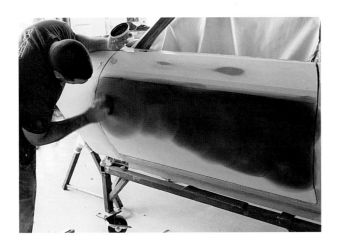

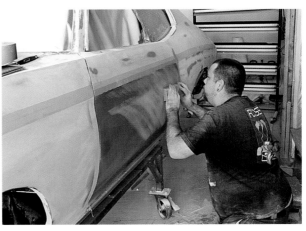

A generous application of the 3M guidecoat unveils surface and line imperfections in a hurry.

Blocking a guide-coated surface takes the guesswork out of this operation. High and low spots are clearly visual that way.

what you're doing, but you will do it many times to get it just right. It simply isn't feasible to spread putty to show car standards on the first go. It takes multiple applications and careful sanding to move the panel to the exact shape required. This degree of care, patience and precision is what separates good enough from perfect and the capable accident repair shop from the qualified show-car builder.

At this stage of the game, though, don't bother to take the lines past about 80% perfection. This is still the rough shaping process after all. Please keep in mind that it makes very little sense to work on perfecting those lines if the surfaces around them still need help. Straightening surfaces has a tendency to move the lines all over the place. After you have done your second show car you learn. Trust me. Parts continue to come off and go on and you constantly refit

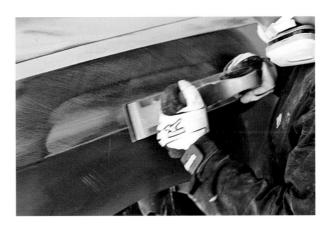

The shape of the surface as well as the line stands out thanks to the use of guidecoat.

The door jambs are as important as the rest of the car. They have been almost completely covered in body filler. Every surface, contour and edge is perfected and the radius of those edges was tightened up. The final product will be like no other Chevelle.

It is clearly visible how easy it was to greatly improve the shape of the door's inside jamb—nice clean crisp edges with arrow straight surfaces.

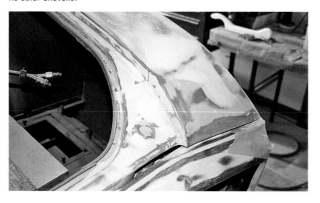

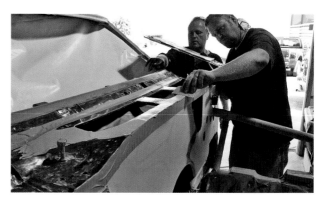

The trunk jamb is treated with the same respect. Every line and surface gets a makeover.

Perfection means doing the right thing, even if it is hard to see later. No stone remains unturned. Dave is giving the firewall his full attention.

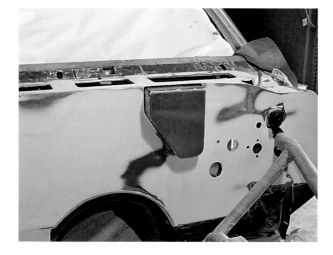

Paul Gonzales fabricated a new windshield wiper motor cover. It is immediately test fitted to the new firewall. Any required modifications have to happen now.

everything. Perfecting one element of the car usually triggers reworking other segments too. Changes made to a door could easily force you to rework the entire side of the car. It is a game of passion and patience. Panel fit is everything and cannot be rushed. In the quest to shape the perfect line, 3M's powdered guidecoat is a lifesaver. This guidecoat greatly improves your ability to see the progress you make. Once the line is properly accentuated and just right, it will be one beautiful thing to look at. Applying the first coat of primer and seeing the reflection of light bouncing off a perfect line is highly rewarding after all that hard work.

Show car projects require as much attention on the inside as they do on the outside. Hours are spent just perfecting the door jambs. Show Car Judges frequently pay equal or more attention to the door jambs, trunk lid inside and engine compartment as they do to the outside. Taking a

close look at a factory jamb exposes plenty of opportunity for improvement. Weeks can be spent in the engine compartment alone. Smooth firewalls are a big hit today. Welding new pieces into place, relocating components and refitting holes for custom steering components give you plenty of reasons to bring the good old body filler back out. It has to be right and it should be better than new.

FINAL SHAPING OF THE BODY

Final shaping of the car's body is truly where a painter earns his money. This is also the time when all gaps are tightened up to a predetermined size. All surfaces are matched up to each other. The lines are going to be finalized and final preparations are made for the first time a primer is applied. In order to do this task right, the body needs to be set up correctly. At the present state, the Mothers Chevelle body sits on a rollable frame. All its weight is supported in the center of the car. To line up all surfaces and gaps correctly, the car needs to be hung at its suspension points and the final weight load has to be duplicated correctly. It is important that you know the exact weight of the engine, transmission, interior and full gas tank. Rather than obstructing free access by installing a mockup engine and a full gas tank, use sandbags. Sandbags are cheap and can easily be moved around.

Hanging the body at its suspension points with all its weight load in place seasons a new frame and settles the body into the same stage it will be in when completely finished and reassembled. Failure to do this step correctly can throw off all your gaps and panel flow when you install the actual components. Naturally, this will only become apparent after the car is painted and nothing short of heroic ac-

tions will lead to the proper corrections. As a rule of thumb, the longer and heavier the car is, the greater the impact of this exercise. On top of this, some cars have a more unbalanced engine than others, and components' weight distribution is either in front or behind the front axle, resulting in greater body flex and weight pull at the nose. You may see a body settle by an eighth of an inch or more. All your hard work can be compromised if you don't prepare for this in advance. To ensure that the perfect panel flow can be achieved, make sure that a fresh set of rubber seals and rubber bumpers are installed for this procedure. This is also the right time to re-verify all panel fit and mark the final position of all bolts on panels and hinges. Placing small drill holes in strategic places allows you to put everything back together the exact same way over and over again. You will take the doors, hood, fenders and trunk lid off many more times for various primer and paint applications. Knowing exactly where they go is key from here on out.

Many hours are ahead of you creating the perfect lines. It is a ballet of taping, sanding and thin body filler applications. The lines should be crisp and more pronounced than on the original vehicle. When preparing the lines, try to shape them to a sharp and pointy edge. The sharp edge greatly improves your ability to see just how accurate they really are. The most important lesson I have learned about lines is this: don't break the pointy sharp edge to create a natural looking metal radius until you are ready for primer. Everything has to be in place, the surfaces have to be right, the gaps need to be precise and all bolt-on parts must be completely aligned before you break the edge for the final radius. Doing this too soon can washout the desired "made from one piece" look.

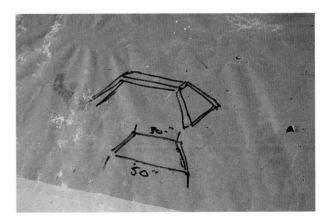

Measurements are taken to build proper stands that allow the car to be hung at its suspension points.

A quick sketch is made to discuss the shape of the stand. It has to fit right and needs to tolerate the weight of the loaded car as well as the movements made during sanding and shaping.

The new stand is put in place prior to the weight load. Cushioning material is wrapped around the stand to prevent it from damaging the powder-coated frame.

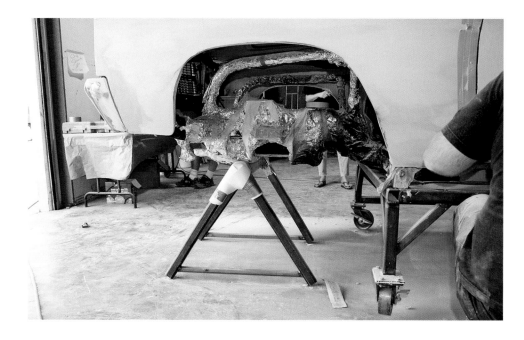

The original support frame is now freely hanging below the car, weighing just about what the interior is going to weigh.

Sand bags are strategically put in place, used to duplicate the weight load of the engine, transmission and gas tank.

Improving and enhancing the factory lines is serious business. It requires that you work it one surface at a time. Again, tape is used as a guide, helping you to make the final corrections.

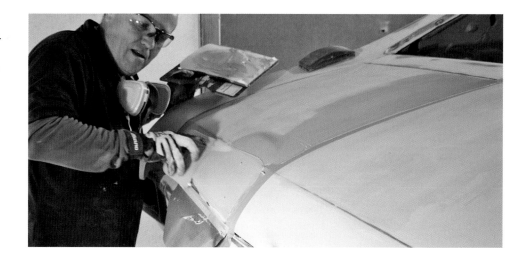

Don't break the nice clean sharp edge of any bodyline until you are absolutely sure you are done.

Enhancing the trunk lid and lining up the lines with the quarter panels is done one surface at a time.

GAPPING

Gapping is another process critical to the overall look of your project. Fine show cars not only have uniform gaps around each panel but equal gaps across panels. Let's recap gapping basics. When making this decision, consider how you will use the vehicle. While smaller gaps look better, you can't go as small on a car you will use to transport family and luggage as you can on a show-only vehicle. Likewise, cars with extremely powerful engines require bigger gaps because of the flex and twist they induce.

Most cars are gapped at around an eighth of an inch. That is a happy medium for a car that will be driven but not abused. Three sixteenths of an inch is a good choice for cars with more than 600 HP engines. The torque of a large engine has the ability to twist the body enough that gaps that are too small could backfire on you. Perfecting the gaps is a combination of welding additional metal to strategic areas of the gap and closing them up with body filler in other areas. Thin edges like a door's cannot be built up with body filler and require welding. On the other hand, adding to the quarter panel side of a door jamb can safely be done with body filler. But not every gap that is off is too large; sometimes you may have to cut off part of an edge to create that perfect gap. Be prepared to re-weld the edge after it is shortened.

Whatever it takes, it has to be done. Closing up gaps can have widespread consequences. As you will see in the following pictures, changing the gap size may also require you to change the shape of the affected parts to make everything look natural and correct. The front bumper on this Chevelle is a perfect example of the domino effect the gapping procedure can have. The fender as well as the bumper required reshaping to get the look of this segment true to the design concept. Guess what?—the headlight buckets were affected as well. Changing the bumper required changes to the buckets. This type of domino effect can roll around a car and never stop.

For the most part, gapping that requires welding should ideally be completed prior to body filler work. Consider a rough gapping stage (welding) early on in the project and a fine gapping stage (body filler) close to the end. During the fine gapping stage it is important that you allow room for the thickness of the paint. Using multiple layers of tape is a good way to mock up paint thickness. How much tape depends on the type of paintwork! The exact allowance for paint varies between single stage, basecoat clearcoat, and multicolored finishes. There are also heavy graphic situations that call for a boatload of clear on top. The basecoat itself is a relatively thin coating and doesn't build that fast. Consider one layer of tape for the total film thickness of a single-color basecoat. Two layers if you are planning on laying out several different colors with at least three or more overlapping each other. Single stage paint and clearcoats are higher build products and require about one layer of tape for every coat of product applied. For paint jobs that have extreme graphics, additional considerations are required. In general, this type of paintwork asks for several additional layers of clear to help cover up substantial tapelines. When you are faced with this scenario, please don't count all layers of clear that will be applied. Heavy color sand and buff is also a reality on paintwork like this. Most of the extra coats are ultimately removed during the color sand and buff process. Consider about four layers of tape for the final clearcoat finish, six if you are planning to re-clear the car for a second time.

Rough gap the car early in the project. Chris Guinn inspects the condition of this door gap with the body lines properly aligned.

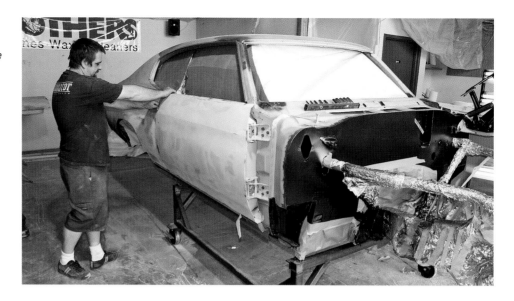

Fine-tuning all body lines and gaps is tedious work. A wooden mixing stick keeps the bottom gap aligned.

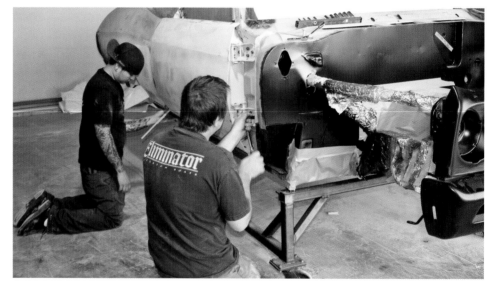

After the door is perfectly aligned, it is clear that the gap widens on the upper portion.

To improve the upper gap, metal is TIG welded to the door edge. Note that the seal and bumper are in place during all fitting operations.

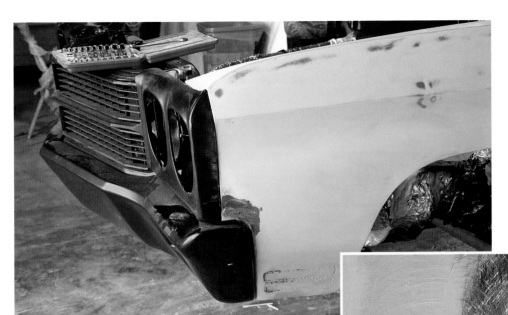

To achieve the crisp and tight look this project calls for, metal was welded to the fenders and the headlight buckets were lengthened.

Below: Using the mixing stick as a guide, Jake is perfecting the gap with a small grinding tool.

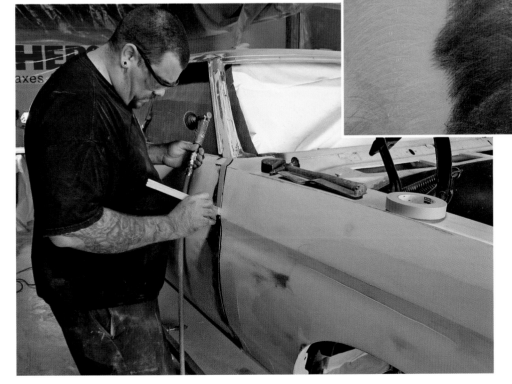

Above: The copper color of the silicon bronze used for the TIG welding makes it easy to see how much metal was added to the door edge.

Aligning the surface height after you altered the gap is very important to keep the edge thin.

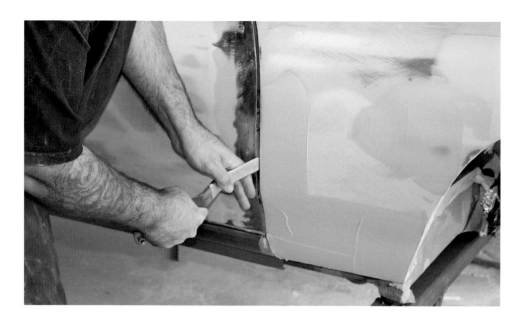

Improving the gap between the trunk lid and the quarter panel required removing metal from the lid. Tape is used as a guiding line.

After the grinding process, the gap is checked with the mixing stick. Tape was wrapped around the stick to create the correct thickness.

Careful grinding leaves a nice even gap. In situations like this, practical adjustments can really only be made to the lid.

One possible side effect of grinding the edges is that you may break through. Repairing this problem simply requires more TIG welding.

Skillful welding and grinding leaves nice fitting, clean, strong edges.

The long edge of the trunk lid required an even more aggressive shortening.

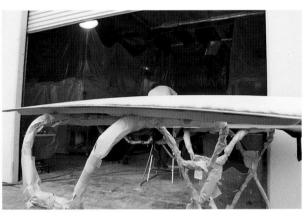

The grinding process produced large-scale surface separation—this work is not for the faint of heart.

After the lid is completely welded back up, it looks like new but fits better. Well worth the effort.

In this picture you can see how a metal rod was welded to the door, carefully starting on the top surface and then swinging outward. The rod greatly improves the line of the edge and adds needed length to the door as well.

The process of fine gapping requires body filler in conjunction with dragging tools. Drill bits are a great choice for a dragging tool. They come in any desired size, making it easy to improve the gap. Tape up the cutting end of the bit to avoid potential injuries. Also tape off any surrounding surfaces that need to be protected from unnecessary body filler and then squeeze the body filler into your gap. Immediately drag your tool along the thinner edge of your panel, opening up a perfectly sized gap. The drill bit should be one size smaller than the gap size you desire. That leaves you with enough excess product to sand flat. Don't expect the gap to be perfect the first time around.

Three applications seem to be the norm. This is another body filler application in which multi-color hardeners can be useful. Apply the first squeeze in red and follow with blue. Apply the second color body filler as soon as the first coat starts to kick off. Drag your drill bit once more. The moment the body filler cures about 50%, clean up all unwanted body filler from the surrounding surfaces.

Breaking through the blue into the red body filler during the sanding process gives you a warning sign to stop sanding. You know that you are going to take off too much body filler if you break through. This is a very effective technique and should help you keep the gap precise.

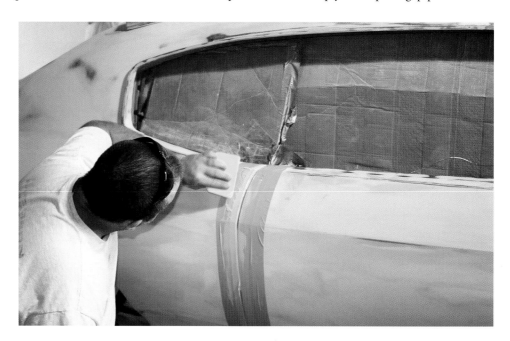

After taping the surrounding surfaces, Chris squeezes body filler into the gap with a plastic spreader.

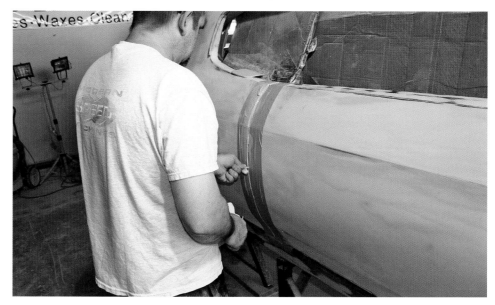

Take your drag tool and stick it into the gap at the lowest portion you filled. Drag the tool upward using the door edge as a guide. You may have to do this a few times as the body filler tends to move around.

A drill bit is a great tool to use for dragging. Use the smooth part of the drill and tape the rest.

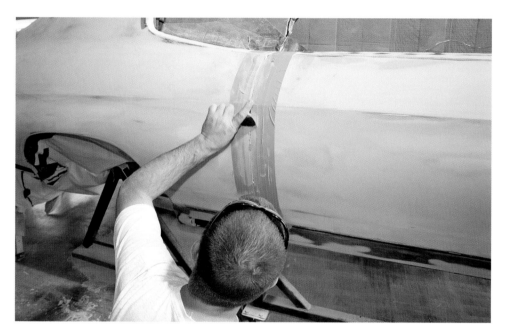

As soon as the first layer of body filler starts to kick off, apply the second squeeze in a different color.

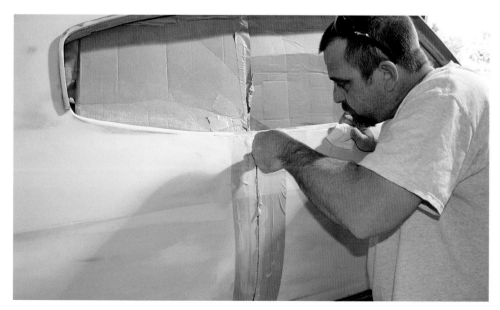

Repeat the dragging procedure. Try to work the inside body filler edge to be as smooth as possible.

Before the body filler can cure completely, clean out the jamb. Cleaning up excess body filler is easiest while it is still rubbery.

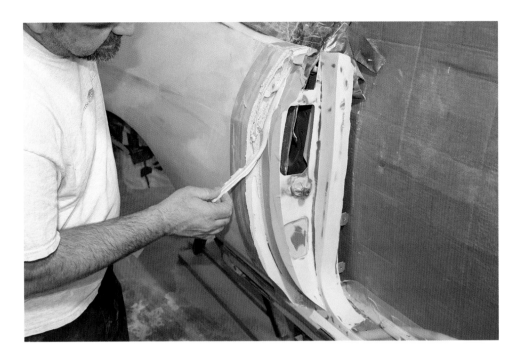

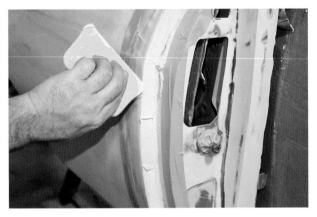

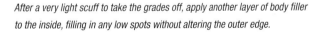

After a very light scuff to take the grades off, apply another layer of body filler to the inside, filling in any low spots without altering the outer edge.

The final result is a perfect gap. The red line is the only reminder left of a former poorly fitting OEM gap.

Using a drag tool is just one of several options to improve the gapping. In the design studio world, sheet wax is frequently used. Sheet wax comes in a variety of different thickness levels and it is conveniently covered with an adhesive on one side allowing you to secure it to your panels. Although sheet wax is not necessarily an inexpensive way to achieve the perfect size gap, it is a very convenient and highly professional way. Simply pick the sheet wax that is the exact same thickness as your desired gap, then cut it to size so it will fit the body closely and attach it firmly. If the surface you attach the sheet wax to is too small to give you adequate adhesion, you can supplement with masking tape to give it that extra support. Once the sheet wax is in

place, squeeze body filler into the remaining gap. Try to push the body filler as far down as you can, without moving the sheet wax out of position.

Creating a perfect gap around the bumpers of a 1970 Chevelle is hard work. The gap sizes are all over the board on these cars, but nothing is as bad as the fit of the original bumpers. Looking at a number of Chevelles revealed varying bumper gaps as wide as an inch on some cars. Clearly, that is not acceptable for any show car. Perfecting gaps like the ones found on the stock Chevelle can require changes to much more than just the fenders and bumpers. Headlight buckets and bumper mounting points are likely altered during this procedure as well. Luckily for the

Sheet wax is another option in the gapping procedure. This product is commonly used in automotive design studios and is a bit expensive. Dragging a tool is not always the best choice and having both options available is ideal.

Left: A close look at this gap reveals some problems on the quarter panel side.

Right: Sheet wax is used to create the perfect gap here. The sheet wax is attached to the trunk lid, reaching all the way down into the jamb. The trick is to keep the angle right.

Left: The sheet wax is positioned just right and is secured with some extra masking tape. Securing the sheet wax keeps it from moving much during the body filler squeeze.

With a plastic spreader, Shaun Spade squeezes the body filler as far down as he can. Don't apply too much force though. Moving the sheet wax would be a bad thing.

PAINTING PREP AND MORE BODYWORK

Mothers Chevelle, the design concept called for painted bumpers, which unlike chrome can be modified invisibly with body filler. Making adjustments to a bumper that will be chromed later requires significantly more effort. Luckily a skilled fabricator would be able to knock that out for you in a couple of days.

For this particular project, the bumpers have already been shortened in width for better fit and the original front bumper flat spot at the nose was reshaped to a pointy configuration. These alterations really helped to bring the look back to what the clay model must have been like. Why GM thought it would be an excellent idea to flatten out this spot just to fit a license plate and the hood release mechanism right there will forever be a mystery to me. The rear bumper was also reworked and has a tight fitting license plate box now and much cleaner lines. All the changes made improve the appearance of the Chevelle without being obvious and right in your face.

This is the typical look of the bumper fit on a stock Chevelle, sporting wide unattractive gaps with the bumpers extending outward past the fender surfaces.

66

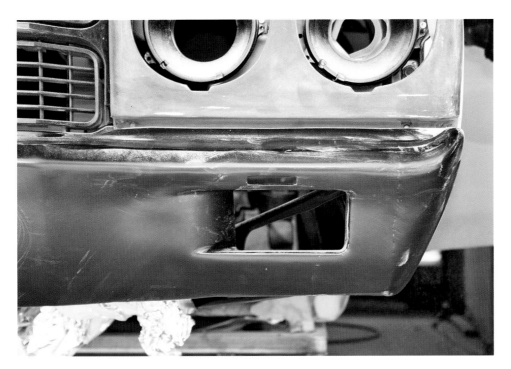

In an effort to improve the overall fit and to tighten up the gaps, the headlight buckets were lengthened. Then the bumper width was shortened to improve its fit with the fender surfaces.

This is the look of a stock 1970 Chevelle bumper gap.

The same drag tool technique shown on the door gaps is also used to improve the fender-to-bumper gap. Both the fender and bumper surfaces are matched up to each other as well. Still a work in progress, you can clearly see the dramatic improvement already.

Repeat the same technique on the back bumper. As always, masking tape protects surrounding surfaces from unwanted body filler.

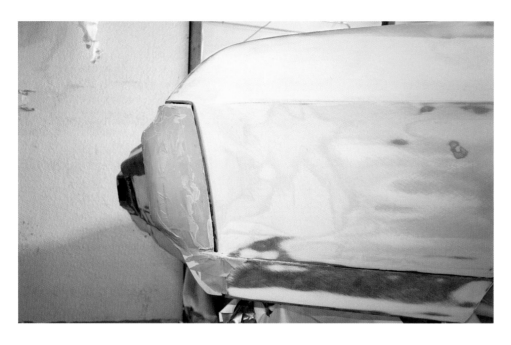

PANEL FLOW

Panel flow and gapping is time consuming work. When talking about panel flow, I mean lining up all the surfaces of the car in a way that the whole body appears to be made out of one solid piece of steel (with lines scribed in for the doors, hood and trunk openings). To create that look, you must apply body filler in a very skillful, well thought through way.

A few words of caution are in order here. To create perfect panel flow, your block sanding must overlap the panel gaps. It would almost be impossible to get a flawless surface flow throughout the car if you block sanded each panel separately. Make sure that every panel is installed in its final position and that they have not moved since you marked or drilled them. Recheck that all rubber seals and bumpers are properly seated. Any changes to the seal fit after you finish blocking the car may throw off the panel flow.

Ideally, if it is practical to do so, block sand the whole side of the car in one single operation. It is a great way to perfect seamless surface flow. As important as it is to line up all surfaces just right, please don't lose sight of panel edge thickness. Having the most perfect panel flow, with thicker than factory door edges, is just as wrong as poor panel flow. Both criteria have to be worked simultaneously.

Matching the style lines on the bumper to the car is critical as well. Visually verifying a correct radius in body filler can sometimes be challenging. Changing colors, textures and sand scratches make verifying a shape by looking at it difficult.

A strip of masking tape can help to unveil the true shape of a radius.

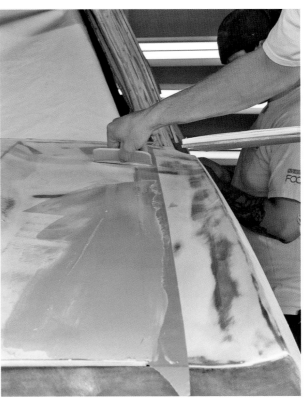

After you determine each panel's final position, drill small holes to mark alignment. Those holes are a guide to guarantee that each panel can be reinstalled in the exact same position over and over again.

To create perfect panel flow between the hood and fender, the gap is taped off and a layer of body filler is applied to the hood. It is important that the body filler overlap the gap halfway onto the 2˝ tape.

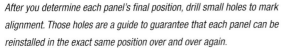

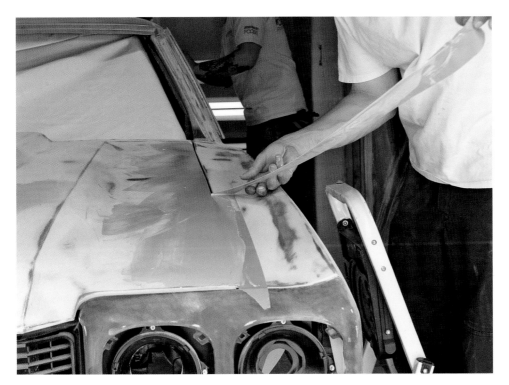

After the body filler is applied to the hood, pull the tape while the body filler is still wet.

Don't sand the body filler just yet. Tape off the hood, covering the gap in the opposite direction.

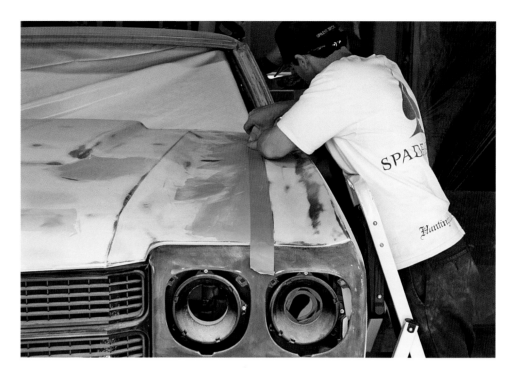

Apply the second coat of body filler to the fender edge, again overlapping the gap onto the tape.

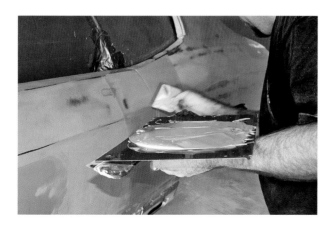

Above: Both top surfaces are now block sanded simultaneously, leaving them at exactly the same height. This process has to be repeated several times in most instances to get everything just right.

Left: With the door jambs taped off, apply body filler over the door and quarter panel at the same time.

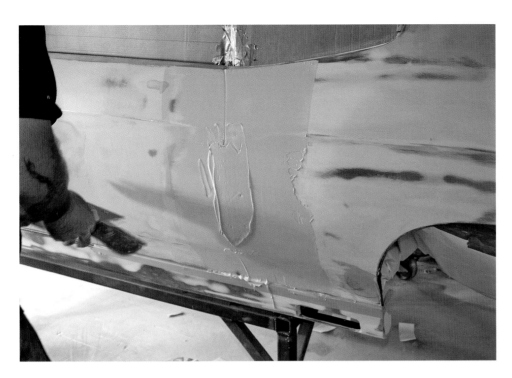

A generous layer of body filler extends into both panels. This is important to create the one-piece look.

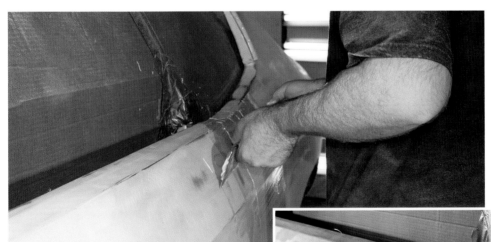

Using an extra wide metal edge spreader, work the surface of the body filler to a close-to-final shape.

This technique really helps to create the illusion that the car is sculpted from one single piece of metal.

When the body filler cures to about 50% hardness, cut the gap between the door and quarter panel open with a sharp knife. Make a single cut right down the center of the gap.

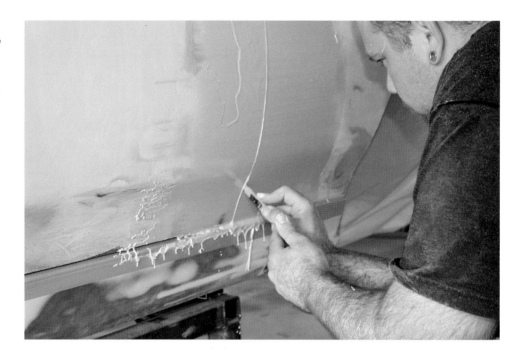

As soon as the body filler is sandable, block the surfaces of both panels as if they were one.

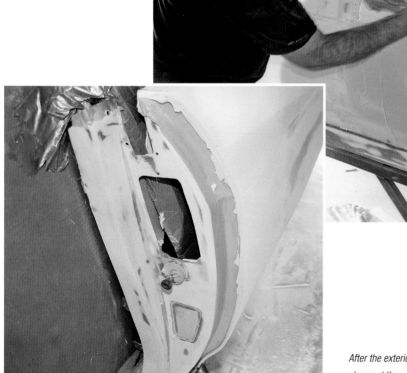

After the exterior surfaces have been block sanded, open the door and clean out the gap and jamb.

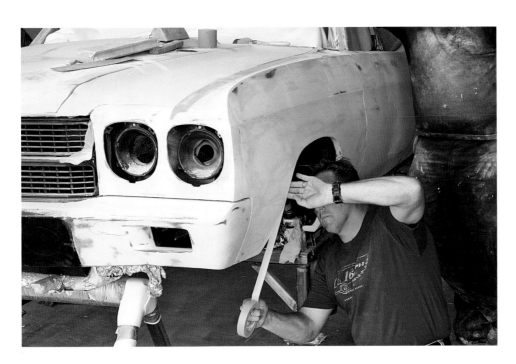

Chip Foose's critical eyes could not live with the factory wheel openings.

The excess sheet metal is marked for trimming. The cut line should follow the natural curve of the fender opening.

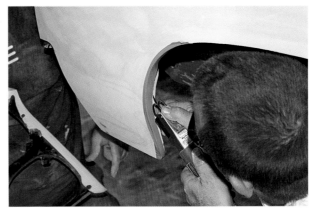

The excess metal is carefully trimmed, following the taped line.

TRIMMING EDGES

Perfecting the overall look of your project car could require you to trim off unwanted sheet metal. Those cuts should be made in a way that a spectator would never know that you made them. One area that commonly calls for some trimming is the wheel opening. Guide any cuts you make with a taped line. Tape is the perfect tool to help you stay on course during the cutting operation. The final look should be a swooping line. Other examples of areas that may get cut are inner fender extensions. Heavy engine compartment modifications are the leading reason to cut portions of the inner fenders. In general this is done to make room for new components.

DON'T FORGET THE LITTLE STUFF

There are always the little things that are easy to overlook that could spoil the fun if not addressed. Take a very close look at everything on your car; other people certainly will. Show cars are efforts at perfection, which their owners pursue uncompromisingly with lavish spending. Thus, it is human nature to eagle-eye them in search of flaws. You've done it to others' cars, so rest assured they will do it to yours. When you look at your project, you must be as critical as you are of other people's show cars. Nothing that could be interpreted as a flaw should catch your attention. If your eyes are getting stuck at a particular spot or they wander back for a second look at something, the

73

This is a perfect example! Many people may have missed this. A low spot in the drip rail is easily overlooked but that is not acceptable on a car of this caliber.

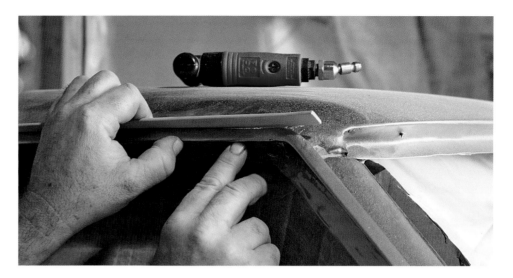

In an effort to make room for the new frame design, the inner fender lip was shortened. The cut was made in a manner that would be OEM like and draws the least amount of attention to the alteration.

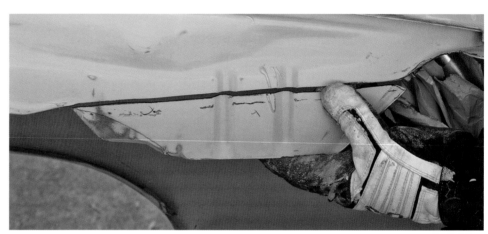

likelihood is that it is not right. Don't tell yourself to let it go. Figure out what makes it perfect, and do it.

FITTING THE HEADLIGHT BUCKETS

Fitting headlight buckets is one of those small tasks with big payoff. Nobody does this better than Chris Guinn. He is known for his watertight seams and he spends a significant amount of time on this task. Watching him do that is a treat for anybody who strives for perfection. A different version of the body filler squeeze technique is used to get the watertight seams. If done correctly, both the fender and the bucket will match up perfectly. With Chris's technique, there is no concern about the longevity of the paint finish later. Both surfaces meet up just right, leaving no pressure points or possibility of paint rub due to vibration. Short cutting this procedure on the other hand could damage the paint. But there is more to fitting these headlight buckets than just the seam.

Headlight buckets are not manufactured any better or worse than the rest of the car. The lines and contours re-

quire the same improvements and enhancements as the other components. As you will see, correcting those shortcomings creates another domino effect. The lower corner shape of the headlight bucket for example is mirrored in a separate line on the upper bumper surface. Getting both perfectly harmonious is just another one of those things. You move and improve on one line; the second one has to follow. Then there is the fact that the left and right side are probably not identical from the factory—but they must be on your show car. Producing a template is the way to go on situations like this.

After you've successfully performed the body filler squeeze and the headlight bucket is in the shape you want, it is time to repeat the exact same method on the fender side. It is not good enough to do this to only one of the surfaces. Trust me, it may appear to be total overkill, but it has to be done for this to work. You will likely find yourself performing a body filler squeeze five to six times per headlight bucket.

In preparation for the body filler squeeze, the fender edge is first taped off.

Right: Then the headlight bucket is installed, but not tightened. This leaves a space for the body filler to be squeezed into.

Below: Squeeze the body filler deep into the gap all around the edge. Pull the headlight bucket outward to assist the squeeze.

Tighten up all the screws prior to the cure of the body filler. The filler has to be soft for this to work.

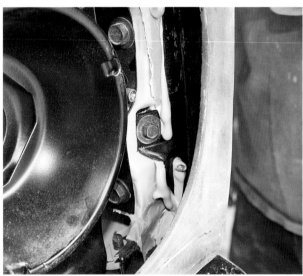

To save your sanity, clean up any unwanted body filler right away. You are going to spend hours on this the way it is, don't make it worse.

Above: If done correctly, body filler will come out of the seam on both sides. As soon as the body filler sets up, loosen the screws and give the bucket a gentle wack. This will release the bucket from the fender.

Right: A plastic spreader with sandpaper attached to it is one tool of choice to clean up the surfaces. Repeat the squeezing process again until everything is nice and straight.

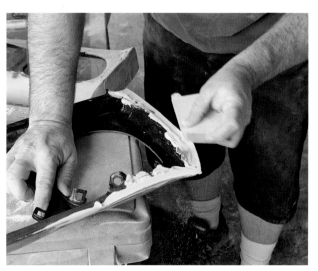

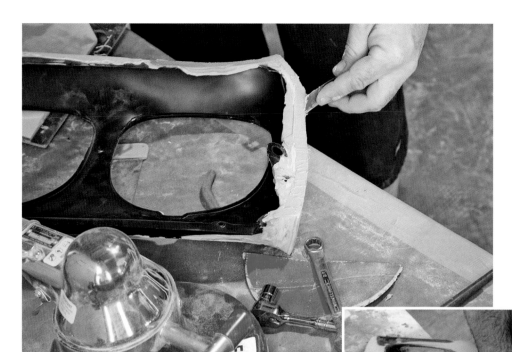

When you are happy with the surface on the bucket use a small metal edge spreader for some detail work.

Right: Performing bodywork to the leading edge of the bucket is important to enhance the overall look.

Below: Now with the reshaped contours and improved fit of the headlight buckets, the corrected bumper in place and tightened gaps, it is time to match everything up.

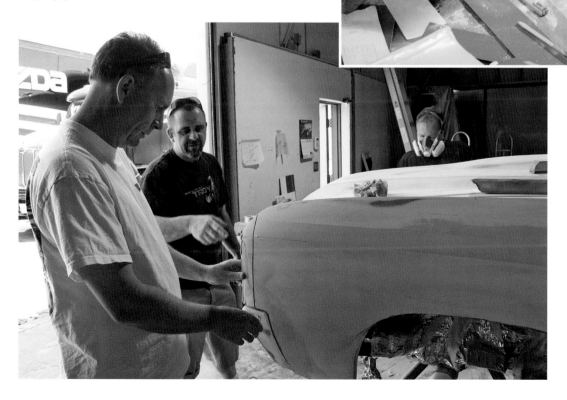

Make a template from tape. This template shows the exact shape or outline of the bottom edge of the headlight bucket. Using this template allows you to reproduce the changes made on one side exactly on the other side.

Above: A pencil that has been ground down to half its thickness can be used to precisely outline contours.

Above: Dragging the half pencil along the outer edge of the headlight duplicates the exact shape of the bucket on the bumper's surface. Thanks to the shape of the half pencil, the fudge factor is gone and the lines are very precise.

Left: After the headlight bucket is removed, the pencil line dictates the needed changes to the bumper. Every piece depends on another. Failure to line everything up would be a disaster on a high dollar show car.

CHAPTER 5
PREPARING, MASKING AND CLEANING

GETTING READY FOR POLYESTER SPRAY FILLER

After many months of sanding, blocking and working the body filler, getting to the point of finally applying primer for the first time is highly rewarding. To untrained eyes, the car probably has not changed much during the last six hundred hours of torture. A knowledgeable observer on the other hand can clearly see the incredible improvement since the start of the project. But the true scope of just how well you did is going to be revealed with the first coat of primer. All of the confusing signals the eye receives from a dull, multi-colored surface are eliminated in one single pass. Looking at an even colored car after all this time is like starting an entirely new project. It is amazing how motivating this simple procedure can be. The hard part is restraining yourself from rushing into this stage. Trying to hide anything under a thick layer of primer will come back and bite you in the butt. Unfortunately that always

seems to happen after you painted the car. I am convinced that the nasty little flaws know exactly when you short cut a procedure and they are determined to make you pay for it—the hard way of course.

By the way, did I mention that no show car should *ever* see single component putties? They are a thing of the past. With the exception of a UV cured putty, they simply do not work with modern paint products and they should stay where they belong: the trash. Swelling, cracking, shrinking and lifting are all attributes of what is commonly called Combi Putty.

Before the Chevelle is primed, the entire weight load is removed and the car is lowered back onto the casters for easy movement. Now remove all of the masking paper and thoroughly clean the entire vehicle inside and out. Spend a good amount of time blowing out any sanding dust. Wipe down all surfaces before you re-mask the car for primer. Tape sticks much better to clean surfaces and you don't

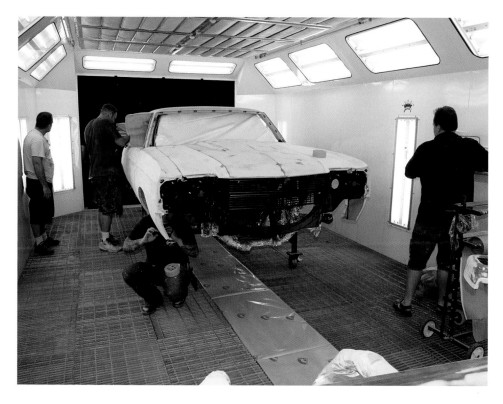

After the car is clean, masking should take place in a well-lit area. Because it is about 11 at night at this point, the booth is not used for anything else anyway. I call that the perfect crime.

All jambs are taped off meticulously. Polyester spray filler overspray has a tendency to travel deep into any opening. Spending extra time now is well worth it.

want any polyester spray filler overspray anywhere else other than the exterior surfaces. Polyester spray filler is probably one of the greatest products ever invented, but if it attaches itself to a surface you didn't plan to paint, good luck. Don't rush the masking process. An extra couple of minutes spent masking can save you hours of cleaning. You don't need to use the highest-grade paper for this primer application either; lint is not a big problem with this product. OK, maybe not the LA Times, but 3M's gold paper would be overkill. The tape on the other hand should be first grade quality.

After the car is all masked up and the surface blown off once more, it is time for the final wipe down. No surface can ever be cleaned too much, but you need to follow some rules. Depending on where you are in this country, you have different cleaner options. In highly environmentally regulated California, the choices are entirely different from let's say North Carolina. Regardless of where you are, you want to use the best possible cleaners. Did you notice that I said cleaners, as in more than one? The truth is that a single cleaner will probably not remove all contaminants. The cleaner the surface, the better the adhesion. A proper cleaning job is done with a combination of solvent and water based cleaners.

During the bodyworking process various contaminants will accumulate on the car. They will be either water soluble or solvent soluble. To ensure that you remove both types prior to applying any paint, wipe it twice. Start with the solvent based cleaner and final wipe with a waterborne

cleaner. Highly absorbent paper towels are key to a successful cleaning job; otherwise you simply move the contamination from one side to the next. The solvent based cleaner removes any oils or grease from the surface, while the waterborne cleaner removes particles like salt for example. Salt you say? How in the world would salt get onto my car? It is really simple actually. For one, I have never been involved in any show car project where the team is not served french fries at one time or another. But even if everybody is washing his or her hands after the frequent 2:00am all-nighter snack, sweat is an equal opportunity offender. No solvent based cleaner in the world will effectively remove that type of contamination completely. Oil will affect the primer's ability to adhere to the surface and creates nasty little craters. Those craters are commonly called fisheyes, which alert you to some contaminant like oil or silicone.

Salt on the other hand is like a silent killer. At first you don't know that salt is present. In the beginning, you may not even see those pesky little salt crystals below your paint. As time goes on, the car will get exposed to water. After ongoing exposure to water, salt crystals tend to grow below the paint surface and create tiny unsightly bubbles or blisters. I know it is hard to believe, but paint is not entirely watertight and therefore allows the salt just enough exposure to do its thing. Sometimes I get that frantic 911 call from a puzzled painter after a customer complained about what looks a bit like white colored solvent popping, with the white layered in-between the basecoat color and

The moment everyone involved is waiting for—spraying the first coat of primer.

Right: *If you are in a highly environmentally regulated area, strong solvent-based cleaners are commonly packaged in aerosols. The solvent inside this aerosol can of AM900 is identical to the RM 900 Pre-Kleano in gallons the rest of this nation is using. This is an excellent cleaner most painters can't live without.*

Far right: *My favorite choice for water based cleaner is 700-1. You're going to be surprised by this water based cleaner's strength.*

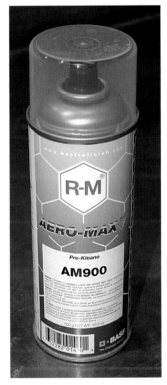

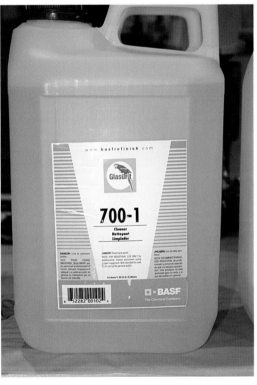

the clearcoat. This is most noticeable on black paint jobs, of course. Closely examining the pattern of those tiny bubbles routinely displays a perfect full or partial handprint. Usually you find that type of problem on the top of a fender edge or anywhere a technician would support himself during sanding operations. The only remedy to

this problem is removing every layer of paint down to where the salt is.

You can see why solvent wiping alone is not an option. The main reason I ask you to wipe with the water based cleaner last is that water based cleaners have an anti-static property, which keeps dust from clinging to the surfaces of

Kimberly Clark's X80 towels are among my favorite. They produce only a small amount of lint but are highly absorbent—the number one concern during cleaning operations.

Latex gloves are the most often found gloves in a body shop. Nitrile gloves offer a bit better protection against a wider variety of chemicals. Make sure you read the product's MSDS prior to choosing your personal protection equipment. Keep in mind that not a single product you will get in contact with during this project is going to be good for you. It is your health and your responsibility to protect yourself.

your car and in return ensures a cleaner paint film.

Allow all cleaners to evaporate completely from the surface and out of the body filler. Keep in mind that body filler is porous and absorbs liquid like a sponge. Rushing the primer could trap cleaners inside the body filler and create problems later. You should let the car sit for about twenty minutes after you wiped it all down. Longer times are needed in cold and humid climates.

POLYESTER SPRAY FILLER

Polyester spray filler (Glasurit 1006-23) is one of the greatest products ever invented for painters who are in the business of making surfaces straight. It is a guilt-free primer—the only primer you can apply heavy handed without any unwanted side effects. Polyester spray filler can safely be applied to 18 or 20 mil thickness. In comparison, urethane primers are designed for 4–6 mil applications. It is a widespread and common mistake made by many craftsmen to use and abuse urethane primers for heavy fill. Abusing urethane primers is risky business. Shrinkage, loss of gloss, blistering and cracking are all possible side effects of primer abuse. As with most paint problems, they wait until you completely finish the car before they appear.

Glasurit's 1006-23 is an easy sanding primer that sticks well to epoxy, body filler or bare steal. As with any polyester-based product including body filler, it doesn't adhere well to an acid etch primer. Polyester spray filler is a dry-sand only product and needs to be re-primed with a polyurethane primer in order to be paintable. Block sanding and shaping this primer is a delight. The ideal sandpaper choice for this product is P120. What makes this product great besides its ability to be applied thick is that it will not shrink on you later. Once 1006-23 is fully cured, it is not going anywhere. What you see is what you get. It is the ideal product to lock in all the different layers of bodywork.

One little hint: buy your polyester spray filler fresh when you need it. This technology has a short shelf life and you don't want to maintain excess stock. Have the paint store put it on a paint shaker before you take it home.

BLOCK SANDING POLYESTER SPRAY FILLER

Polyester spray filler dries nice and hard but still sands rather easy. To create that mirror perfect paint reflection a show car so desperately deserves, block-sanding skills are key. Remember the good old long board that helped you shape the body filler just a day ago? You can retire it now. Balsawood sanding blocks are taking its place. These sanding blocks are all home made and custom fit to the sanding requirement of each panel. All kinds of different shapes and sizes of balsawood is purchased in an arts supply house and customized as needed. The balsawood tools allow for a gentler, yet more precise blocking action. Rounding up the leading edges on you custom made balsawood block can be just one example of what is required to help create the perfect cut of the primer. For the most part, from this stage forward, balsawood tools are the only blocks used through the completion of the car.

The mixing ratio is simple—one bottle of 948-22 hardener for each can of 1006-23 polyester spray filler. Make sure that both components are mixed together well.

Applying polyester spray filler requires a large fluid tip on your spray gun. Bring your bazooka to the party. The tip size should be 2.2 to 2.6 depending on the gun manufacturer. Sata, the maker of some of the nicest spray guns on the planet, makes a special gun just for this product. The KLCP has a tip marked P for polyester. Be advised that this gun is not legal in all 50 states.

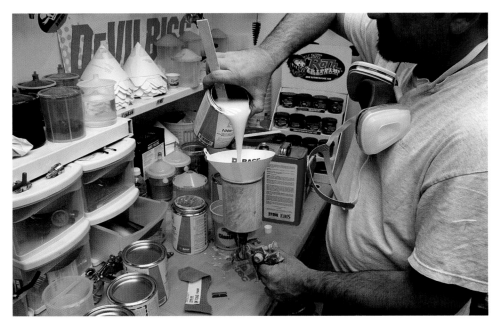

In California, the Sata polyester spray filler gun is off limits, leaving us with a big tip HVLP KLC primer gun.

Many painters have started to use disposable cup systems on their guns. Because 1006-23 is a very heavy-bodied primer, disposable cups are not ideal; the original ventilated aluminum cup supplies the best flow rate. Only mix one quart at a time. Ask a friend to mix you the next batch while you spray. Polyester products have a short application window and they can rapidly harden in your gun as you spray.

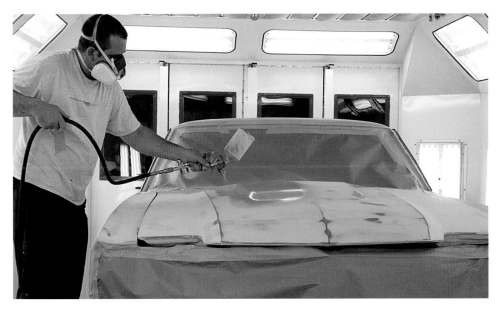

A momentum changing moment for any project is the first coat of primer. Glasurit's 1006-23 is a perfect choice for the job.

Pile on 4 to 5 coats of polyester spray filler depending on the fill you are looking for. Think of this product as sprayable glazing putty.

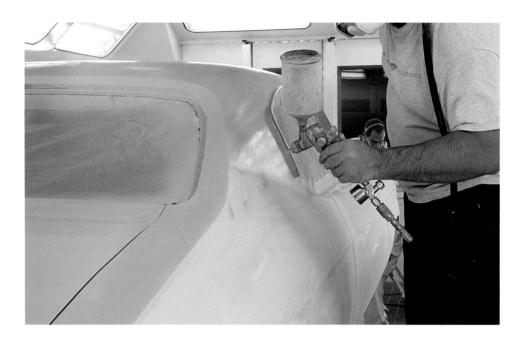

To simulate the final body sag, the car is only supported at its suspension points with its entire weight load back in place. Flawless panel flow cannot be achieved otherwise.

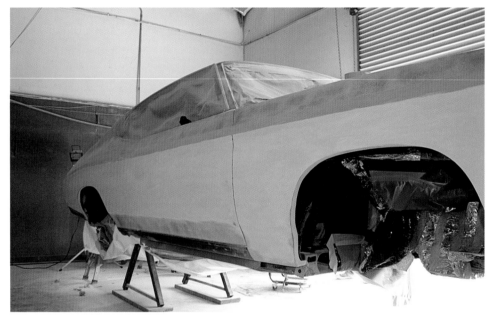

Before you start blocking your polyester spray filler, the weight load has to be put back in place and the car should only be supported at its suspension points. Panel flow is and remains a key concern.

Should you feel the need, you can pre block sand the polyester spray filler with P80 grit sandpaper. Stepping it down to P120 or P150 on the second cut. Guide coating the primer for each individual cut is highly recommended. Doing so will ensure proper visibility and helps to avoid any missed 80 grit scratches. Trying to cover up a P80 grit scratch with urethane primer is never a good idea. Bring better than 20-20 vision and your most sensitive touch to this game. It is a must to get every ripple and imperfection taken care of. Don't be surprised if you still find areas on the car that you don't like. Bringing out the body filler a couple more times is normal and a reality on show cars. Even applying polyester spray filler for a second time is quite normal. Remember I said earlier in this book that it isn't quick or cheap to build a show car? If you want your show car to be beautiful for a long time to come and not slowly deteriorate over time, everything has to be corrected with these types of products, not with urethane primer.

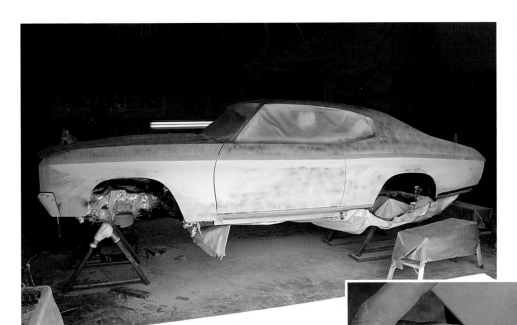

The polyester spray filler has been pre cut with P80 grit paper. For this application a sprayed on guidecoat is used.

Right: Balsawood of all shapes and sizes are the blocking tools of choice.

Below: Zone blocking is the method of choice. Clearly define the zone by taping it off and than blocking up to the tape. Just like the body filler, don't shape the actual line until all surfaces are perfect.

A long balsawood block is used to perfect the upper zone and create superior panel flow at the same time. Only balsawood and foam blocks are used from now on.

Right: Balsawood's combination of length and flexibility contributes to its unique blocking action.

Below: If the blocking process reveals any low spots that are too deep to be blocked out, bring back the body filler.

Almost perfect—no stock Chevelle has looked that tight. Ultimately every bodyline, surface and edge will line up correctly.

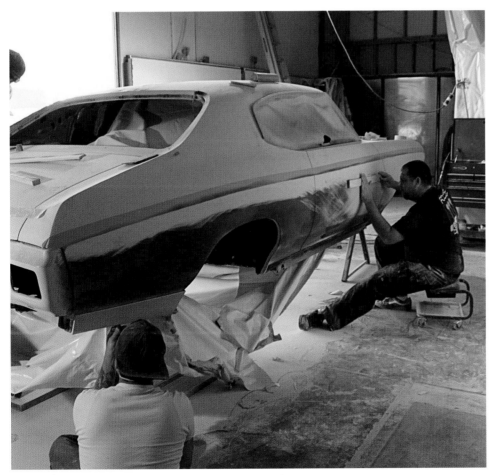

A layer of 3M powdered guide coat is applied for the second cut with P150. The generous application of guidecoat will reveal any leftover P80 scratches as well as any surface imperfection.

Tape is layered onto the molding to simulate the paint thickness. It also helps to protect the molding from damage.

Not what you like to see on a show car. . . . The window opening has to be corrected to fit the molding.

Above: The very familiar body filler squeeze is the saving grace, leaving a perfect fit for the molding.

The stripping process removed the factory sealer in the drip rail. Resealing the drip rail is important; it restores the integrity and look to this part of the car.

A lot of fine-tuning occurs during this stage, such as verifying the fit of the window moldings. It is extremely likely that you will replace the moldings with new ones—do not assume that they will fit perfectly. Install the moldings with tape layered to simulate the thickness of the paint. Failing to duplicate the paint thickness could cause paint damage during the reassembling process. Body filler squeeze techniques are used to fix any imperfections between the window opening and the molding.

Another important part that needs your attention is the drip rail. During the stripping process, the factory sealer was removed and replacing it is important. There are plenty of choices in product offerings for this procedure. I highly recommend that you go with a two-component product. The durability is so much better than conventional caulking products.

After blocking your surfaces, visual checkups are necessary—you will reach a point when you can no longer rely on feel alone. Once you reached that certain level of straightness, your fingertips are going to fail you. You lose the ability to feel the imperfections. Wiping down the surfaces with a wet solvent rag or simply spraying solvent onto the surface is the next step. Checking the consistency of

Two-component products are the way to go. They come in different drying speeds and can be chosen based on physical properties.

A special applicator is required to apply the two-component sealer. The product is mixed as it travels through the tip. The tip is a one-time use item and any leftover product requires additional tips for future use.

We picked Fusor 122EZ for its self-leveling and fast cure characteristics.

Using 900 Pre-Kleano as a visual aid for straightness works really well. You want a solvent that stays wet long enough for you to see properly.

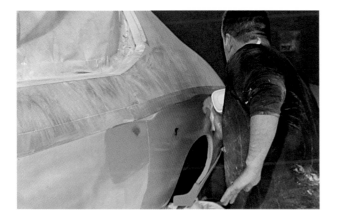

Wiping or spraying solvent onto the surface allows for a close look at your blocking progress. There is a point when you can't feel the flaw anymore.

The hood is by far the most critical panel on the car. It is right in your face all the time. There is no hiding anything from anybody on this panel. I watched Lance Nabors spend days on this part alone.

Very unusual shapes of balsawood are employed to get every inch perfectly straight.

Line up everything just right—style lines, gaps, shapes and radiuses all have to coexist in perfect harmony.

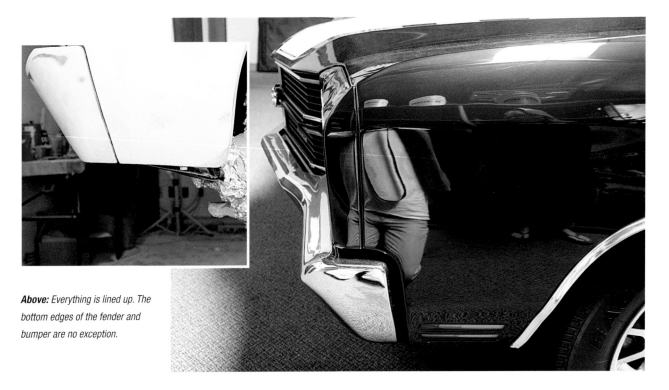

Above: Everything is lined up. The bottom edges of the fender and bumper are no exception.

The reworked fenders and bumper greatly improve the look of the project compared to the OEM configuration.

object reflections in the solvent glare and seeing how the reflections travel over the surfaces of the car as you move allows you to gauge your progress. If you see any sign of a wiggle, the surface is not straight. The closer you get to the final painting stage and the finer your sandpaper choices are the more you need to rely on sight.

Comparing the before and after pictures gives you a greater appreciation for all the changes a show car goes through. If you saw the Mothers Chevelle by itself, simply sitting there, painted in a very bland or boring color, you would still notice that this car is different and special, but most people wouldn't be able to pinpoint why. Everything about it is inherently Chevelle, just at a level of precision the original designer would have wanted. That is really the essence of a show car. If your vehicle can capture attention without screaming here I am due to a flashy color, fancy rims, a spoiler as high as the sky or a deafening exhaust note, mission accomplished.

CHAPTER 6
CHOOSING YOUR PAINT

PICKING A COLOR

Unless you already made all of your color choices prior to the start of the project, now would be a good time to start finalizing this stage. Personally, I hate to make color choices too early when it comes to my own cars. Many times it is easier to commit to the color after you've worked on the project for a while. Picking a color or color combinations can be one of the hardest decisions you may have to make. It is a highly personal choice and it can get confusing at times. Asking too many of your friends for their opinion is a terrible mistake. For every person who will support your vision, there will be another with opposite opinions. Listening to too many people can stir you off course and away from a perfect choice you already made. On top of that, many humans have a hard time envisioning colors or color combinations in the first place. It is your project and at the end, your opinion is the only opinion that counts (unless, perhaps, your spouse hates your first choice).

Inspirations for colors and design can be found almost everywhere you look. The most obvious choice would be custom car magazines. The problem with going that route is that you run the risk of getting a "me too" look that way. So much time and money is being invested into that project, why would you want to replicate something already in existence? Some colors go well together and some don't and you don't need to rely on cars as your models. Try walking through clothing stores, furniture stores; take a stroll through a museum or art gallery. If there's a good art school or program in your area, check out their students' work—you may see wonderful color combinations. An art student with good color sense who can draw might be just the source for a fresh approach, along with the means to help you picture it. Colors are also splashed across TV and movie screens, sports jerseys, cyclists' and runners' shirts, pants, bikes, shoes. Take your digital camera and go color hunting.

Many of my personal ideas came from looking at magazine advertisements. It truly is amazing how much creative energy can be found in advertising. You really never know what may trigger your mind. Simply looking at a tooth-

The scarf in this picture is the color choice for a vintage Aston Martin. The ColorMax Solid tool helped identify just the right color shade for the car.

Options on specialty pigments for your paint are phenomenal these days. It is very hard not to find the answer to your quest.

Above: *Color Scanners can help you find a match to a painted surface you wish to reproduce.*

Right: *Color correcting lights can assist you during night hours or rainy days. The 3M Sun Gun reproduces sunlight when it is not otherwise available. Picking a color under fluorescent light can result in a disappointing choice. Some colors appear much different under artificial light compared to daylight.*

paste carton design, seeing the background color scheme in a computer ad or a cosmetics advertisement, all could help your inspiration. Seeking inspiration out of the non-automotive sector is an excellent way to come up with something new and fresh.

It is very tempting to get crazy with paint. By the same token, it is very easy to ruin a perfectly fine show car with a paint job as well. As a rule of thumb, the higher the qual-ity of craftsmanship, the nicer and straighter the body, the simpler the color can be. Overdoing the paintwork can take away from the elegance and beauty you so care-fully crafted into the bodywork. Of course, if you must, you can always custom-paint the snot out of your car. It's yours after all!

Looking through paint-color books is an option, but the endless variety may be as confusing as helpful. It may

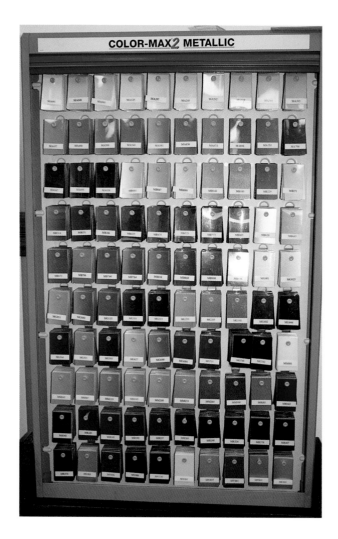

COLOR-MAX2 METALLIC

The greatest color tool in the world today.... The ColorMax2 is the only color tool on the market manufactured by actually spraying the paint onto the chip, giving you the best color reproducibility. Color chip books are commonly blade coated. Blade coated chips are a good rough representation of a color but not precise.

be easiest to arrive at some color scheme ideas beforehand through the above suggestions and then use paint jobber books and charts to home in on the perfect shades. In my personal opinion, the best color tool you could possibly use is the ColorMax. The ColorMax comes in solid and metallic versions. There are way over eight thousand chips in the metallic tool alone and the tool is constantly updated with new colors as they become available. To make an informed color choice it is critical that you can rely on the accuracy of the chip. ColorMax is currently the only color tool I am aware of that is actually made by spraying automotive paint onto gigantic sheets of treated cardboard. It is then cut into the proper size and fitted into the tool. The importance of this is that the tool was made with the same materials and the same techniques you are going to use to paint your car. Why would that be important to you? Simple: it allows you to reproduce the exact look of that chip over and over again. In comparison to the ColorMax, regular color books are commonly made from printing inks in a blade coating process. They are a good representation of the color but not exact or precise. Their purpose is to identify what color is on an OEM manufactured vehicle in the event that there is no color code found on the car. They are a great tool for what they are designed for, but not the best way to pick a color.

Should time permit, make all color selections on a sunny day. Cloudy and rainy days are not the best start to a great color selection. If you must make a choice under poor conditions, use a 3M Sun Gun. This tool creates almost perfect sunlight. Having said that, don't rely on sunlight alone. There are colors in the world that don't look as good as you would hope under florescent light or in the shade. Make your initial pick in sunlight and then verify that you still like your choices in other lighting situations. This approach leaves no surprises.

There are over eight thousand chips in this tool covering every color family. The shades between the chips can be minute and you should easily find just that shade you desire.

The interior is often part of the painting process on a show car as well. Specialty decks exist for all sorts of applications.

The ColorMax tool comes in metallic and solid colors. Being able to see exactly how the color will look is critical in the decision-making.

OEM color identifier decks come in many different shapes and sizes. Keep in mind that this type of color tool is not as precise as the ColorMax2.

Above: Chris Guinn and Chip Foose are discussing the color sample made for the Mothers Chevelle Project.

Right: After Chip made his original color choices out of a ColorMax tool, Chris painted a master or sample panel. Everything that follows is compared to the sample panel. The blob of gray is a possible accent color in debate. Interior colors, pin striping and powder coating colors are all checked and matched to the sample. The greatest thing about working with a designer is that they never seem to lose sight of the smallest details.

The paint industry never ceases to come up with new technologies and effect pigments. Jumping on the latest hip thing can be risky. Chrome-like coatings appeared a short time ago and they opened up completely new opportunities for custom painters. They are great coatings as long as you know and understand what you may get yourself into. This type of coating for example can be very touchy in its application and when it comes to durability.

MIXING COLOR

After you've made your color choices, the paint is mixed up using a paint mixing bank. Paint mixing machines have an array of different color tints that have to be mixed together precisely. Any mistake made during this operation can affect the final outcome. Buying your paint from a source you can trust is important. Heaven forbid you have to repaint parts of your car and you have no leftover paint. Being able to reproduce the exact same paint again is critical at that moment.

Above: All components are poured into a can using a scale to weigh each toner. Following the paint formulation correctly allows you to easily reproduce the same color.

Left: A typical mixing machine holds all the tints needed to make your paint. The tints require frequent mixing for consistency.

CHAPTER 7
PRIMING

APPLYING POLYURETHANE PRIMER SURFACER

After you have finished sanding the polyester spray filler, clean and re-mask the car body following the same techniques used during the first product application. This time around you may want to pay more attention to dust removal. Polyester spray filler is a bit more forgiving than any coating following from now on. When it comes to paint products, the surface can't be clean enough.

Polyurethane primer surfacer is the first coating you apply that is considered paintable. Polyester based primers are too porous and have other attributes that make them a poor substrate to paint over directly. Applying a nice and hard polyurethane primer on top of the polyester spray filler is the ideal process to get the surface to a paintable stage. Polyurethane primer is a high build primer that is designed to be applied between three and four coats thick. That equals roughly 4–6 mil of dried product film. A Sata KLC primer gun with a 1.7 fluid tip is a good choice for applying polyurethane primers. I know I shouldn't have to say this, but real life has taught me otherwise. Please don't use the oldest gun in your toolbox to spray the primer! Over and over again I see painters handing a worn-out spray gun down to the primer guy. Let's be perfectly clear here: any gun that is not good enough for painting anymore is certainly not good enough for priming. If your

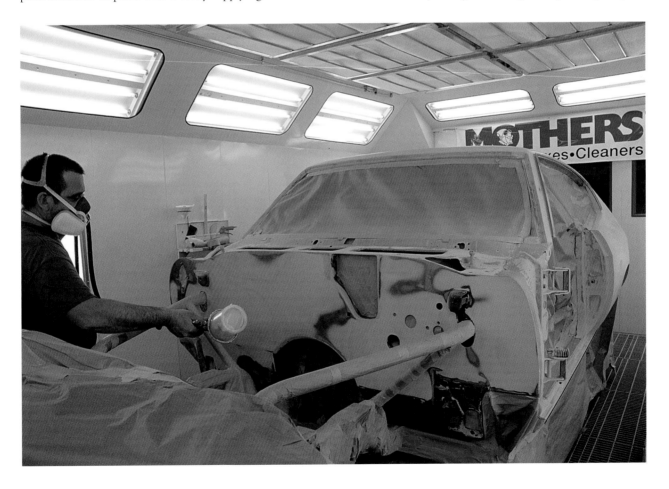

Prior to the DP200 polyurethane primer surfacer, all bare steal is carefully coated with a thin coat of epoxy primer.

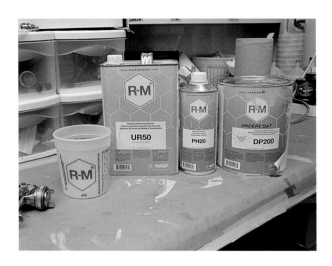

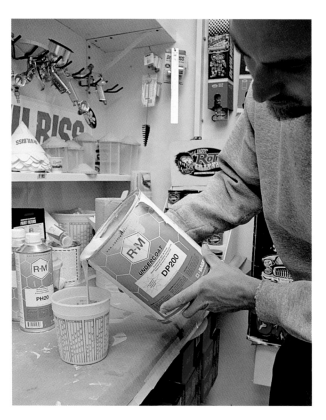

Above: *The Mothers Chevelle will receive RM DP200 polyurethane primer. This 2.1 VOC primer provides you with a strong coating that will give you excellent holdout and gloss retention for the following paint.*

Right: *All catalyzed products have a mixing ratio that isn't really up for debate. Millions of dollars are spent every year to ensure the best possible product performance. DP 200 has a mixing ratio of 4:1:1 as a high build primer surfacer and 4:1:2 as a wet-on-wet sealer.*

gun's spray pattern is not perfect, you could easily create problems. Solvent popping, striping, runs or high and low spots are just a few problems you could get yourself into. At the very least, you will create more work for yourself. Old paint spray guns usually don't come with a 1.7 fluid tip either. If the tip size of your spray gun is too small, you may not get the recommended film thickness either. Come-on folks, this is not rocket science, simply use the right tools for the job. If you don't have the right equipment, go and get it. After all, this is not an "I paint any car in any color for just $299" kind of deal.

Apply three to four coats of the polyurethane primer, depending on the fill you require. Should you have any bare metal exposed, apply one thin coat of a corrosion protecting primer prior to the polyurethane primer. I know there are direct-to-metal primers out there, but "direct to metal" refers in many cases to adhesion, not necessarily corrosion resistance. While you technically could use a thin coat of an acid etch primer, I strongly recommend that you stick with an epoxy primer. Epoxy is still the best corrosion protection money can buy. Allow for the proper flash off time before you proceed. Don't rush to spray the polyurethane primer, either. Giving the primer enough time to flash between coats will reward you with a stronger, better coating. Rushing the primer application creates

the risk that you may trap solvents in the film. The trapped solvents will force their way out, leaving behind tiny holes called solvent pops. This happens when the chemical cure is faster than the solvent evaporation speed. Trapping solvent in the primer film can also lead to adhesion problems between the substrate and your new coating. Ensuring that each individual application of polyurethane primer dries to a flat finish in between coats is the easiest way to avoid future problems.

Good quality polyurethane primers all have one characteristic in common: they dry to a hard finish and don't sand easily. You may not be the biggest fan of the sandability during the wet sanding process, but trust me, seeing your car years later without any sign of shrinkage in the paint will reward you for the extra effort. Very easy sanding primer surfacers have a tendency to come back and bite you in the you-know-what.

I have seen one problem over and over again: painters everywhere have a tendency to gravitate to the fastest product combinations available. Picking the proper hardener and reducer combination for the size of the car and the ambient conditions can shave hours out of the sanding process. In most cases, slowing paint products down makes you faster overall.

A critical component of any spraying application is the

Polyurethane primer is applied to the body. From this point forward, all parts are removed for all spray applications. The bolt-on parts are primed separately. I promised you that you would take them on and off many more times. Isn't that fun?

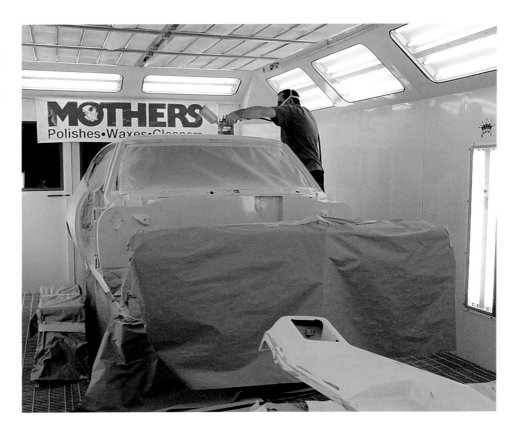

Shaun Spade is applying a nice even medium wet coat of DP200. A well-maintained spray gun helps to cut down on sanding time later.

quality of the compressed air supply. Before you start a show car project, make sure that all airline filters, hoses and spray guns are clean and up for the task. Compressed air typically travels with companions through the lines—those companions are water, particulates and oil. All are problematic to a quality paint finish. Oil contamination and water condensation are a fact of life whenever you compress air in a compressor. Those particles have to be removed from the air supply prior to the spraying process. Any oil that remains in the air stream can create fisheyes. Water that was not removed completely can cause an under-cured finish. Isocyanate is the main component of a urethane hardener. Unfortunately, Isocyanates like to react with water better than they like to react with the urethane resin. Having water passing through a filter, or not filtering the air at all, can spell trouble in paradise.

After the jambs are cut in with basecoat, the doors and fender are reinstalled for the exterior preparation.

The front fender edges have been cut in as well. The headlight bucket will be installed for the exterior basecoat application and two-toning.

CUTTING IN JAMBS WITH BASECOAT

Before you start wet sanding the car's exterior, I recommend that you cut in the jambs with basecoat first. The doors and fenders are off the car from the primer application anyway. It makes it easier to get to every corner of the jamb. Don't clearcoat the jambs though. Keep in mind that the doors and fenders are being reinstalled for the exterior basecoat application. The vehicle will finally be taken apart again for clear coating everything at once later. Back taping the jambs or tapelines of any kind are a no-no on a show car. To prep the jambs, wet sand the DP200 primer with P600–800 grit paper. Use guidecoat to ensure that every nook and cranny will be taken care of. After carefully cleaning all surfaces with AM900, followed by 700-1, apply the first basecoat. Apply two to three coats to cover. Preventing excess basecoat buildup to any non-sanded exterior primer surface is key. Light overspray is OK; it can function like a guidecoat.

WET SANDING THE PRIMER SURFACER

Welcome to a new world of sanding. This is the world where true straightness can only be determined by sight. Should you be able to feel any waves or ripples in the polyurethane primer, you simply rushed the job and primed too early. Having said that, don't be surprised if you need to re-prime a number of spots for a second time. No matter how much attention you paid during the polyester spray filler phase, there are going to be areas that need corrections.

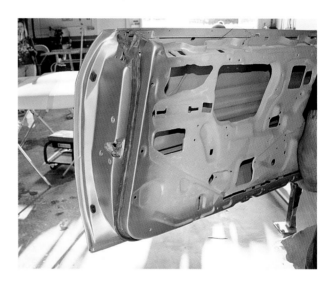

As soon as the doors are jambed, all seals and bumpers are reinstalled. The doors have to be aligned perfectly once more.

If you can take the car straight into the spray booth after wet sanding without additional fine tuning of the body, I promise that you are either not picky enough or you are not looking hard enough. There is always something!

All of the wet sanding is done with balsawood blocks. They are far superior to hard rubber blocks for fine detail work. Again, balsawood gives you the ability to shape the blocks in any way you need or see fit. Being able to round off the edges or cutting them just to the perfect size are

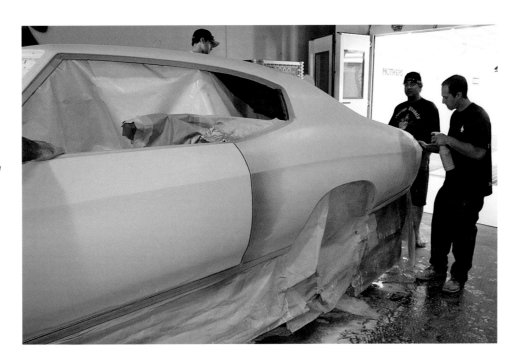

The doors and fenders are reinstalled for the wet sanding process. Every part is properly aligned for the basecoat and later two-tone coats. In the background, "Lil' Daddy" Roth is entertaining the troops. Yes, he's the son of legendary "Big Daddy" Roth and a great artist in his own right.

great options. Cut the sandpaper to size and soak it in water. Soaking the paper in water softens up the backing and helps to eliminate unwanted gouges in the primer during the sanding process.

The common way of supplying water to the surface for the sanding process is to dip the paper and block in a water bucket and quickly return both to the primed surface. People may also use a water soaked rag or sponge to supply the water to the surface. The problem with either method is that a water bucket will start to collect sanding residue and any dust flying around in the shop. These particles can get transferred to the sanding surface and deeply scratch the primer, something you should try to avoid at all cost.

When wet sanding primer and during the color sand and buff process it is paramount that you are in full control of the scratch pattern. Rather than using a water bucket, apply the necessary water with a pump bottle. Pump bottles make it easy to apply just the right amount of water to the area you are working on. On top of that, this method supplies clean, particle-free water. No worries about a possible piece of sand messing you up. Well, besides that, you can also use the pump bottle to spray water at people you work with. It never gets old. But don't dismiss the water bucket and sponge completely; they are used to frequently remove any sanding residue from the surface. Keeping the surface clean during the sanding operation results in a better and finer cut, extending the lifespan of the paper at the same time. After you wash off any sanding residue with a water soaked rag or sponge, use a soft rubber spreader

to squeegee off the remaining water. This technique will remove any unwanted leftover particles from the surface.

Zone blocking technique is a perfect way to attack the wet sanding process. Concentrating on smaller, more manageable areas prevents you from losing sight of what you have done and still need to do. The 3M guidecoat is once again applied to the primed surface prior to sanding. The secret to perfect wet sanding is to cut the primer twice. Make the first cut with a more aggressive P400 grit sandpaper. Cutting the primer with a coarser paper first gets the fat out of the primer and flattens the primed surface better. "Getting the fat out" means creating a look of no excess material left on the car—no orange peel or loaded up edges. Starting out too fine may leave you with a micro texture that just simply will not go away. You can sand until you can sand no more and the surface still has that little rippled look. Make the second cut with P600 grit sandpaper after you have reapplied guidecoat. The P600 grit paper is a happy medium between finesse and great adhesion for the next coat. Anything finer than P800 and you could start giving up adhesion to some degree. A thorough wet sanding job is for patient people. It is all about a critical eye combined with a craftsman who does not give up until it is 100% right.

To get panels 100% straight, you will frequently find yourself wiping down the surfaces with 900 Pre-Kleano and following the surface reflection. Anything that disturbs a perfect mirror-like reflection needs to be corrected. Sometimes you have to take a step back and look from a

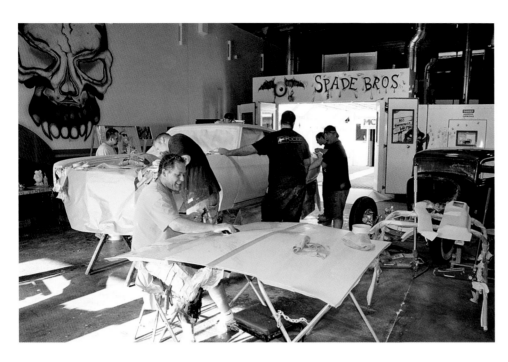

A truly rare sight, daylight hits the project. I don't know why that is, but project cars consume a lot of night hours. All of my personal projects were painted somewhere between 1 and 4 am.

Note that the guidecoat for the first cut was sprayed on. Powder is used for the second cut. There is no particular reason for that other than it was more convenient to spray some on while the car was still in the booth.

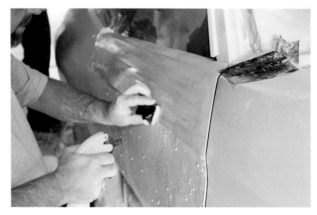

Wet sanding is done with relatively small balsawood blocks. One zone at a time is carefully blocked while the craftsman stays off the edges. All edges receive their final radius minutes before the car goes in the booth for paint.

distance to spot a problem area. It really is all about sight.

The wet sanding process is slow—often double the time it took to sand the polyester spray filler. In terms of steps, you are 90% there. By this point, you're surely tired of what has become a tedious process with degrees of improvement imperceptible to the untrained eye. But don't give up! This is the sprint—or, rather, the glacial crawl—to the finish line. First one to give up and cross the line loses.

Chris and Jake are aligning every part precisely. The design concept calls for a two-tone paint job and the smallest degree of misalignment could be a problem later.

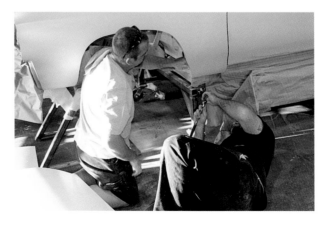

It doesn't matter how much attention you paid while sanding the polyester spray filler, you will miss something.

A close inspection of all edges is a critical step in getting it right. Perfect edges are an integral part of a show car.

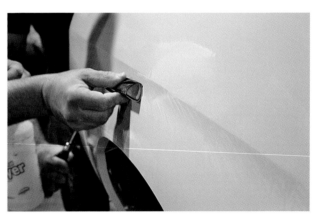

All the small adjustments made earlier turned out nice. The windshield molding will fit like a glove and the drip rail looks perfect.

Using just the right shaped tool for the job is a learned skill. Unless you have done a few of these cars, you may not be aware that there could be a better tool choice. You are not going to find many shops around the nation that have this type of tool in the toolbox.

A show car is only as good as its gaps. You don't want to two-tone a car and have to adjust the gaps later. Your lines are going to be all over the place.

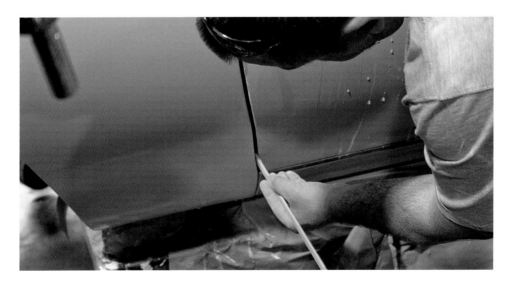

It is a good habit to mark any problem areas as soon as you spot them, helping you remember to fix them.

Corrections are made with two-component polyester putties only. No single component products out of a tube please. They are not up to show car quality or durability.

Left: Any spot that was filled or corrected with polyester putty is going to be re-primed prior to painting. No painting over putty or bare metal areas.

Below: Poor Lance; I am not quite sure how many days he has in this hood. He was almost done and somebody who was careful to remain nameless dented the hood scoop. The metal surface of this hood is rather soft and it did a number to it. He kept smiling while he fixed it—certainly a bigger man than I am.

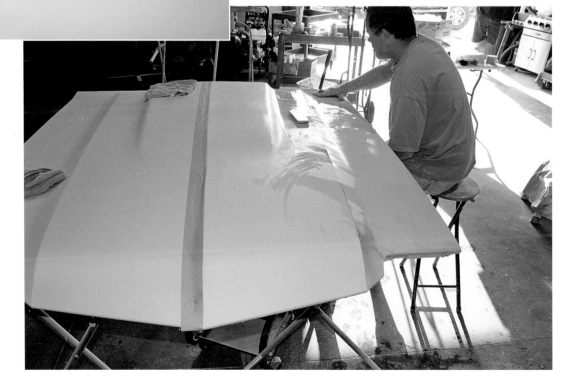

Don't forget the weight load. It has to be in place for proper panel alignment if you are going to two-tone the paint job.

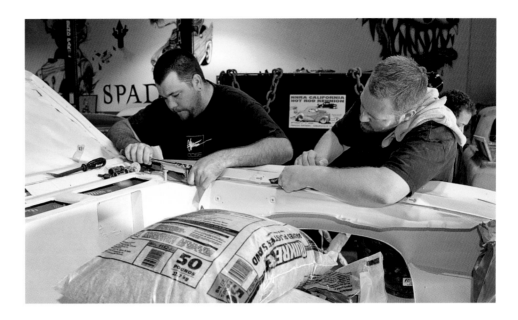

The sanding residue needs to be wiped off as soon as possible. Letting it dry on the surface could lead to problems.

Taking the fat out of the primer.... This is a sanding process that leaves the primed surface looking like it has no excess product on it, mirror straight with no sign of texture or any ripples.

Man, I hope that 3M is going to pay me some royalties. But the truth is, there is simply no better guidecoat around.

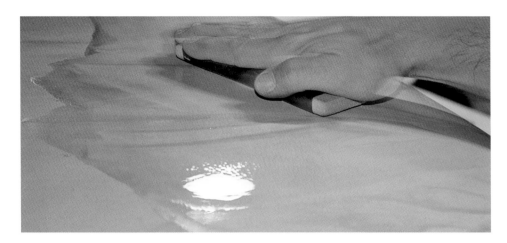

The fine powder of this guidecoat gives you full control over the surface condition during the sanding process. Here you can clearly see the remaining texture of the polyurethane primer. Don't stop until every bit of the guide coat is taken off.

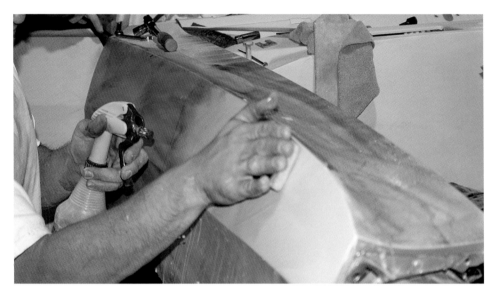

Start the second cut on the fender with P600 grit paper. Staying in the zone and controlling ever aspect of the blocking procedure is key to a perfect surface.

Dave is giving the rocker extensions the same amount of attention as the rest of the car. Simply because it is lower on the car, doesn't mean it requires less detail work.

Bored out of his mind from watching people wet sand a car, "Lil' Daddy" is entertaining himself.

CHAPTER 8
PAINTING

DISCLAIMER

Before I go into the painting part of this book, I would like to give a quick disclaimer. You may have noticed already that the paint supplies featured in this book are mainly Glasurit and RM products. Yes, I can hear the critics cry foul already. Of course BASF is not the only manufacturer of quality paint products and you should be able to produce a great looking show car with other brands as well. Having said that, it is my personal opinion that the products featured in this book are your best choice for this type of work, with emphasis on "this type of work." All leading paint manufacturers produce a product that is more than capable of handling everyday painting. In the show car world, though, you are going to push the envelope of the product's abilities. Odds are that you will use products in a way the manufacturer never anticipated. Trust me, many years of trial and error went into my opinion and some of my learning on the run turned out quite expensive.

I am employed by BASF and that may encourage me to speak well of the company. But I used and appreciated BASF products as a craftsman long before I took a job with them. In fact, when it mattered most in my personal career, producing my masterpiece for the hands-on portion of my Meister Craftsman exam, Glasurit paint was my personal choice. I wrote this book in my free time as a private individual. This book is a labor of love to the only profession I ever deeply cared for. Sure, I understand if you have an issue with my opinion. But I am not the only one—even OEM manufacturers well known for their high quality products have also chosen BASF as a product of choice. Maybach, a subsidiary of Mercedes Benz (lovingly called the über Mercedes), Morgan Motor Company as well as Bentley and Rolls Royce to name just a few also trust the same Glasurit refinish products I do. The Mercedes Benz Classic Car Center in Irvine, California, a facility that is in existence for one reason and one reason only and that is to produce the best possible restorations under manufacturer supervision, also uses Glasurit. By the way, there is a big difference between refinish and ordinary OEM paint finishes. Refinish coatings are for the most part of a higher quality. OEM coatings are not practical to use in a body shop environment. They frequently require

The DuPont Sontara towel is a great choice for cleaning the surfaces for paint. There is very little lint associated with this towel and it holds a fair amount of solvents to keep the surface wet.

a super high baking temperature that is not available in a conventional spray booth.

How about in the show car world, you ask? Well, in the show car world, there is probably nothing more difficult than competing for and winning a Ridler award at the Detroit AutoRama. Five of the past six winners used Glasurit paint. RM Diamont has been featured on many TV shows and was a prominent choice on many cars at SEMA. Honestly, it doesn't matter to me one bit what kind of product you use on your car, but it would be a crying shame if you had to learn the hard way and you repeat the mistakes many of us already made in the past. Discovering later that you didn't get the look and feel you had envisioned, or that the paint will not hold up over the years due to your unconventional use of the product, is all avoidable. Again, you have a choice: educate yourself (talk to a manufacturer's Rep you trust, not necessarily only the paint store employee) and make an informed decision that will serve your own best interest.

PAINTING BASECOAT

When it comes to painting your show car, you need to make a decision about the type of paint you want to use. North America is in the process of moving away from conventional solvent-borne paint and is migrating towards

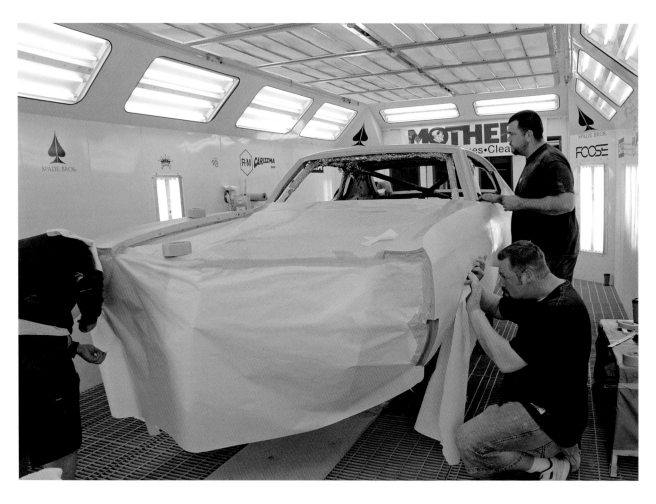

The car has been meticulously cleaned and is re-masked for the first color basecoat.

waterborne paints. The state of California as well as our neighbors to the north, Canada, are both front-runners in this change. Most of Europe has made the change already. The change in technology is driven by the desire to minimize smog-causing air pollutants, namely volatile organic compounds (VOCs). In July 2008 most of California will be using waterborne basecoats. This change in technology is not necessarily a bad thing. Most of today's OEM car production is already painted in the factory with waterborne basecoats. Back in the days when the OEMs switched from lacquer to synthetic enamel, the body shops had to follow if they wanted to repair their cars correctly. Then came the switch to 2K polyurethane on the OEM level. Guess what? Body Shops had to change again. Now it's time for a switch to waterborne basecoats.

Today you can purchase either technology and paint your car. Opting for the older solvent-borne paints may give you comfort if you know this technology well. The problem is that you may need to repair your vehicle at one point. Should you live in California, you couldn't even use any leftover paint to repair your own car after December 2008. The mere possession of a solvent-based basecoat above the 3.5VOC limit will be illegal. Waterborne basecoats cover better and give you much better holdout and gloss retention than solvent-borne basecoats. Technologically, the water based products are superior. They do require a bit nicer spraying environment compared to solvent-borne basecoats and are new and unfamiliar to most painters in this country. The biggest difficulty to overcome is the dry time. For people in high humidity areas or extremely cold parts of the country, a climate controlled spraying environment is important. Waterborne colors are cleaner and more brilliant too. Trying to match a color that was originally made in waterborne paint with solvent-borne paint can be a challenge.

The Chevelle in this book is painted with RM Diamont basecoat, a solvent based basecoat system that has been proven over a very long time. The other two cars

Everything is taped off with great care to prevent unwanted overspray from reaching the inside, as well as keeping anything inside from coming out and landing in the fresh paint.

PAINTING

I talk about in this book later are both painted in Glasurit 90 Line, a waterborne basecoat system that has been around in the US since 1994. Glasurit 90 Line is the most solvent-borne like of the waterborne paint systems I have tried. The application techniques and the majority of its attributes are similar to conventional basecoats.

The actual process of painting a show car is not much different from painting any other nice car. It involves paying attention to the detail and following manufacturer's instructions. Painters really don't like to hear this much, but the prep work usually makes or breaks a show car. I am not saying that painting isn't a highly skilled profession, but a painter has to put his best foot forward every time he pulls the trigger on his spray gun, essentially putting the same effort into every nice paint job. It doesn't really matter if he paints a new car that was scratched, or a Pebble Beach Concourse car; the general mechanics stay the same.

After you have finished sanding the car, it is critical that you remove all masking paper from the body and clean everything very well. Spending extra time cleaning can prevent dust and dirt from falling into your fresh paint. Cleaning is cheap; paint on the other hand is costly. Trying to fish dirt out of your paint during spraying operations is one annoying thing to do. Be sure to blow all dust out of nooks and crannies—you don't want the paint gun kicking it up into your paint. When you're sure you've got it all, wipe the car down with AM900 or 900 Pre-Kleano. Make sure you pay attention to all surfaces masking tape is going to attach to. You don't want to have masking paper move

around on you or come lose during the spraying process. After you've finished masking off the car, wipe it one more time with AM900 or 900 Pre-Kleano prior to pushing it into the booth.

Inside the booth, please wipe the car one more time, this time with water based cleaner Glasurit 700-1. At this point it is a good idea to change to a higher quality paper towel. DuPont makes a super nice towel for this process. According to my information, this towel actually came into our industry from the medical field. Using water based cleaners helps reduce static electricity build up. Reduced static electricity allows for more effective lint removal. Use a tack cloth that is not overly sticky, though. Too sticky tack rags have a tendency to leave some residue behind and that may interfere with your basecoat. The BASF B120 anti-static tack cloth is a perfect choice for lint removal. It leaves no sticky traces behind and removes static electricity as you wipe. After you have applied one or two coats of basecoat color, it is likely that you will find a few spots that are not quite show car quality. Fix every minor scratch. If the surface is not visually perfect, it cannot be clearcoated. You may nip and scuff the basecoat if needed with some P1000 grit paper, in the process eliminating any leftover scratches from blocking the primer and keeping the basecoat totally flat and texture free.

We have been over this before: make sure your guns are clean and well maintained. My recommendation for spraying Diamont basecoat is a Sata 2000 or 3000 series HVLP gun with a 1.5 tip.

Cleaning the surfaces prior to spraying the basecoat is key. A spotless surface is the foundation to any beautiful paint job. Those three parts are going to be sealed first and than painted. Note the body filler and the cut throughs in the primer—you don't want to paint right over these areas.

The B120 tack cloth removes dust and lint from the surface without leaving residue behind. It also removes static electricity at the same time.

Above: *RM Diamont basecoat is mixed up with a medium speed reducer, giving the metallic flakes enough time to orient themselves once sprayed on. A reducer that dries too fast can cause a mottling effect in light metallic colors because the flakes don't have enough time to lay down flat before the solvent evaporates fully.*

Left: *All components are mixed together and the paint is ready to go. This high hiding basecoat achieves full coverage in two to three coats.*

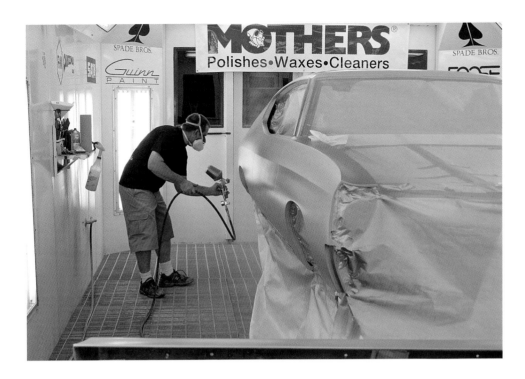

The first coat of basecoat is finally applied to the car shell and parts. Only the lower half of the Chevelle is painted in the nickel color.

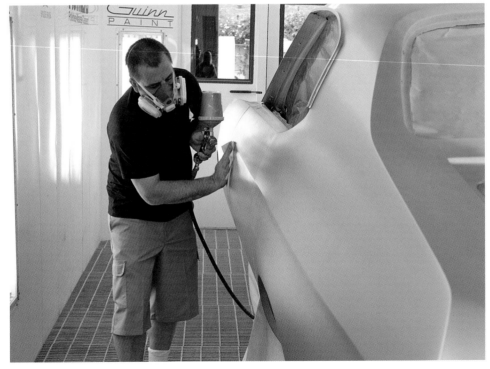

Using the B120 tack cloth between coats removes any dust that may have settled on the surface during flash-off.

When you start playing in the world of show cars, you are likely to run into some very interesting people. Many famous people share the hobby and excitement of owning show cars and they all seem to find each other. You have the potential of meeting automotive icons and celebrities alike. If the right people know about your project, you may even get a visit from the TV studios. Hot Rod TV stopped by to check on the Chevelle. It doesn't happen every day that a camera follows you around but it is fun. For everybody who owns a show car, that is what you build it for. Public and media attention is part of the show car world and it is also why you are spending that much money.

The basecoat highlighted a few spots that are not show car like. Fix everything that catches your eye right away.

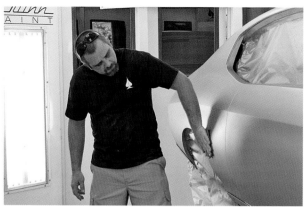

Knocking down the smallest texture in the base is part of what makes the final paint job spectacular. This is commonly called nipping the base and is done with P1000 grit paper.

It is a nice compliment to anybody involved in the making of a project car if it gathers media attention. After all, the car is being built to be shown.

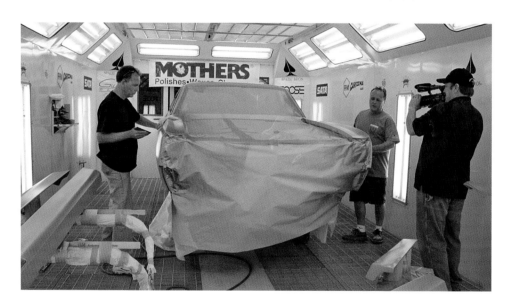

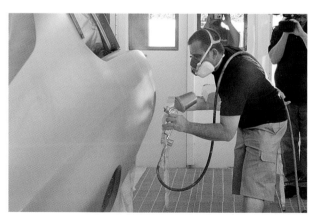

The camera follows Chris Guinn along as he puts on the final coat of nickel base.

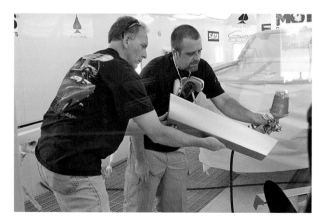

Extra attention is paid to the edges of all bolt-on panels. It is easy to miss a spot or to fail to achieve complete coverage in these areas.

BC00 is used as an intercoat clear. It offers protection similar to a 2K clear without the goofy side effects.

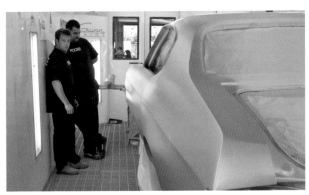

Now that the first color is applied, Chip Foose stopped by to lay out the design work on the Chevelle. Looking at a blank canvas, Chip is visualizing the next step.

By marking the highlights of the backbone, the dominant style line that travels the entire length of the car, Chip creates the break line between the nickel and the white that will follow.

The white and nickel will be separated with a red pinstripe; finding the perfect position for that pinstripe is tricky at times. Being able to see the finished car in your mind is a required talent for the job.

In the back is Jim Holoway, who owns this Chevelle. He enjoys watching Chip at work. Creativity is something you either have or you don't. Chip for whatever reason got a little bit more than most.

It is not easy to be a cameraman around Chip. He is being decorated too. Having fun doing work that you enjoy—can life get much better than that?

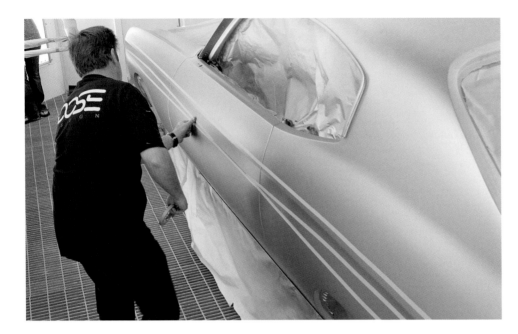

The general outline of the scallops is determined with green tape first. As soon as the designer is happy with it they are redone in blue fine line tape.

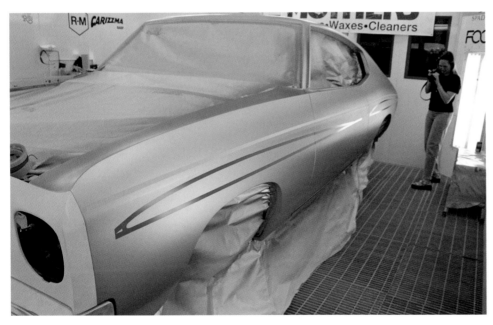

There it is, the break line of the two-tone and the scallops. One side down, one more to go. The headlight buckets are re-installed and will be painted soon; the two-tone goes right through them.

TWO-TONING

After the first color is successfully applied to the Chevelle, a few coats of intercoat clear are applied to protect the integrity of the nickel color. Rather than a urethane clear, this project uses BC00 crystal clear basecoat resin, which sprays, dries and behaves just like any other Diamont basecoat. Using BC00 gives you the same protection as a thin coat of clear would, but without the drying time issues and without any sanding required for the next color. Sandwiching a 2K clear between layers of basecoat has always made me nervous. Dieback (or loss of gloss

over time), wrinkling and adhesion problems have been associated with this practice in the past; staying with basecoat all the way through is less problematic. To ensure that the tape is not going to mark or lift the basecoat during the two-toning process, allow the base to dry properly. You may bake the base if you can.

To tape your design, use a good quality fine-line tape. Some of the cheaper versions have a problem with too tight of a turn. They frequently come loose before you even have a chance to apply your color. Those adhesion problems are an even bigger concern

There are two things you can count on if you work with a popular designer: they always have to go someplace and they always change their mind at least once. Chip had to leave for some time and Shaun was commissioned to reproduce the design on the opposite side.

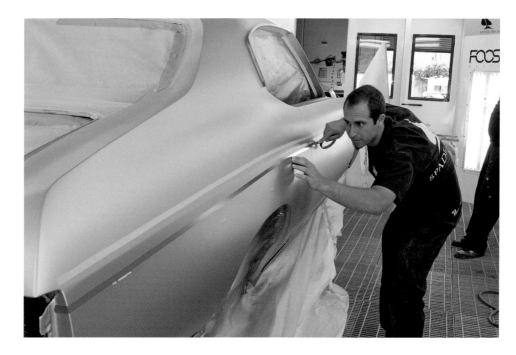

Masking paper is used to transfer the design from one side of the car to the other.

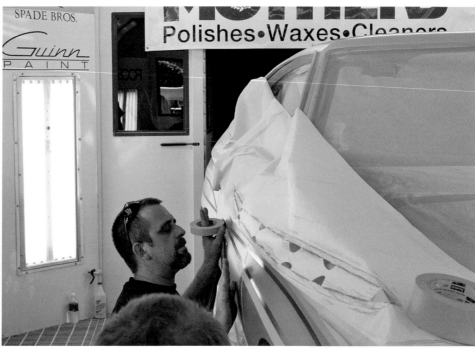

if the tape stays on the car overnight. It is very frustrating to see your work from the day before hanging off the car or being all peeled back in the turns. The flip side to that is a tape that sticks all right but leaves heavy glue residue behind. Removing this residue can be difficult and may damage your paint. I don't have a particular favorite brand for fine-line tape. The 3M tape is good and so are others. It appears to me that the quality of the tape has more to do with its age rather than the manufacturer. Tape that is older generally loses much of its attributes that made it great in the beginning. If a tape is stored in a room that is exposed to solvent vapors, the glue starts to fail much sooner. The only recommendation I can make is to buy your tape fresh and do a test panel to see how well it performs. Another suggestion is to store your tape in an airtight container away from solvents and temperature extremes.

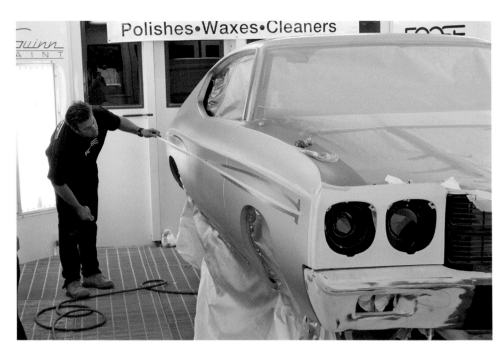

Oh, I mentioned that there are two things you can count on with designers' right. Well Chip changed his mind about some detail of the design when he returned.

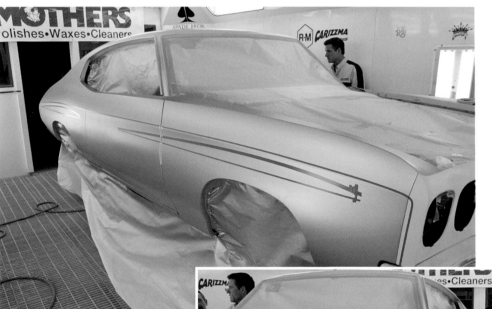

Left: The revised design is now ready to be masked off. Masking off the design requires a lot of attention to every detail. You don't want any white to blow through and hit the nickel.

Below: Have plenty of masking tape in different sizes available. You will be masking for quite some time and having the right products is a big help.

The devil is in the detail; carrying the white into the doorjambs in a clean, professional looking way takes time.

The inner door edge is carefully taped off for paint. It will be painted white as well. The careful tape work allows the painter to spray white safely without fearing that anything may come flying out of the door itself. The wire in the picture operates the door look.

The way we carry the white into the jamb on the quarter panel side matches up with the way it is carried into the door.

The doors are masked such that they can be opened and closed repeatedly during painting.

It is all in the detail work. The inner fender edges are carefully taped off, not allowing any white overspray to stick to the nickel base.

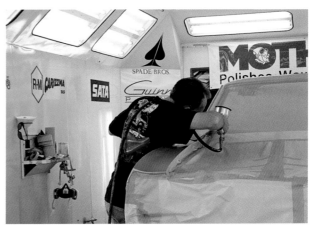

Before the white basecoat can be sprayed, I have to apply a thin coat of epoxy primer over a number of bare metal spots. It is a game of no short cuts.

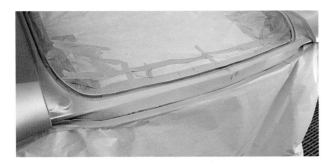

A number of spots around the trunk opening also needed some help from the trusted old epoxy primer. I can't tell you how many times in my professional life I have seen painters simply close their eyes to those little things and go right ahead and start painting. You may get away with it for a couple of years in California, but in a more humid climate you pay the price right away.

Seam sealer may be necessary in some areas around the car. To achieve a perfect factory look, tape off the surrounding surfaces.

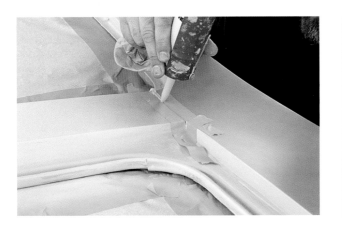

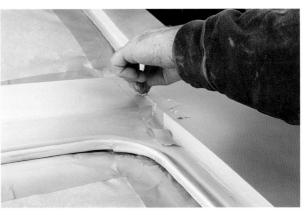

Apply the seam sealer, forcing it deep into the gap. Avoid trapping any air. Air can expand later and the seam sealer may show signs of a bubble.

Smoothing out the surface of the seam sealer with your finger is the next step. Try to keep it off every other surface.

As soon as you are done pull back the tape. Running your finger over the sealer one more time, using AM900 as a lubricant, produces the perfect look.

A little clean up at the end and you are good to go. Allow the seam sealer to dry before you paint over it. The seam sealer may never dry properly if you paint over it too soon.

The headlight buckets are installed and the design is extended into the bucket.

With all the masking done, white basecoat is mixed up. For the Chevelle, Diamont D902 high hiding white is used. To minimize any possible contamination to the white, the D902 is poured through a 200 micron strainer. The Sata RPS cup itself has another strainer built in. Let's not take any chances with white.

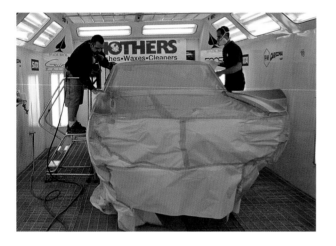

Before we spray any white basecoat, the body is cleaned off one more time.

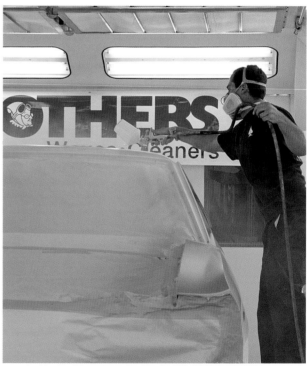

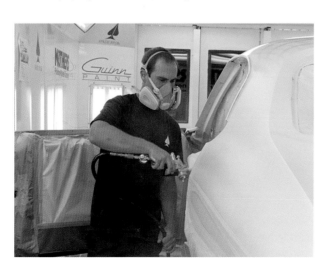

Above: The challenge of spraying white is keeping it clean. The smallest little spec of dirt or a single off color pigment that was still in your gun will show up like you can't believe it. With the car being up that high, having a second person in the booth to help keep the air hose off the car is helpful.

Left: The jamb and exterior are painted at the same time. Achieving full coverage with the least amount of film build is the goal. Overloading the second color creates thicker tape lines that need to be covered up with clear.

The headlight buckets have been taped off and painted white as well.

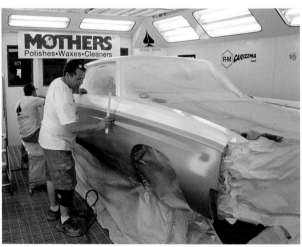

Above: *When you pull off the fine line tape, small amounts of overlapping paint may remain on the panel. This is paint that broke loose from the tape surface and is still attached to the newly painted surface. Rubbing your finger over the loose edge and bending the paint edge back and forth should clean up that line just fine.*

Below: *If the paint edge is too stubborn you may use masking tape to pull off the excess paint edge.*

After the white was completely covered and a few coats of intercoat BC00 were applied, it is time to unmask everything that was involved in the two-toning of the car.

Taking the masking tape off is a critical step in a multi-color paint scheme. Before you do anything, make sure that the basecoat is dry. Pulling the tape too soon can compromise your tapeline accuracy. Fuzzy edges are a possible side effect when you pull the tape too soon. Take your time and keep a close eye on the tapeline as you slowly pull the tape back. Try to avoid pulling the tape in the direction of the freshly painted surface. Have an X-Acto knife handy. You may need to cut the paint surface open on areas that received a bit too much paint. After you pull the fine line tape, paint that was originally attached to the tape's surface may stay behind. To clean up the tapeline, you may carefully rub your fingertips over the lose paint edge. Bending it back and forth until it comes lose. Using some regular masking tape is a very gentle and effective way to remove unwanted paint as well.

Pull the masking tape slowly. You need to be in full control to avoid any damage to the fresh paint film.

PINSTRIPING

Pinstriping is one of the great traditional art forms in the show car world. It blends well with vintage and modern show car projects. If you apply pinstriping in the right way, it enhances the appearance of many different areas of a show car. Pinstriping is a learned skill, I believe only a handful of people will ever be great at it. Looking at the true masters of this art, almost all have been in the striping business for roughly 50 years. The great Bob Spina, or "Uncle Bob" as he is lovingly called by his friends, Dennis Ricklefs of DR Design and Tom Kelly of Kelly and Sons are classic examples of the most influential striping generation. Lucky for me, all three got involved in the Mothers Chevelle project at one point or another. That was like hitting the striping jackpot. It is fascinating to see how effortlessly those artists can create spectacular work that I would never get close to reproducing.

The good news is that this is not the only generation of talented stripers out there. Younger generations have picked up the torch and run with it. The style of pinstriping has changed with the generations. Graphic striping rather than traditional hot rod striping is the clear favorite of the younger crowd. Every striper has his own techniques and style.

There are many different ways to use pinstriping on a project car. Running a stripe over a two-tone tapeline and ornamental striping like you see around lock cylinders are common uses of this art form. For the true masters, there is no limit to their creativity. If you can envision it, they can do it. It takes a good selection of brushes and a steady hand to produce a quality pinstripe. When you consider pinstriping on your show car, you need to ask yourself, do I want the stripe on top or under the clear. Clearcoating over the stripe will protect the stripe from future damage. The downside is that you can't easily change your mind later. Pinstriping on top of the clear gives you the freedom to remove it and do something different if your taste changes.

The choice in striping paint technology changes as well, depending on the technique. Most of the traditional hot rod style pinstriping was done on top of the clear. One Shot is the leading brand of striping colors. One Shot is the ideal product for on top of clearcoat applications. House of Kolor makes a urethane striping color. Urethanes dry quicker and are the preferred choice for under clear applications. With a little bit of practice, you could also use regular automotive basecoat to stripe. Unless you have been striping for many years, hire a professional for your show car project. Don't expect a 100% perfect line either. The beauty of pinstriping is that it is a handmade art form. Taping a stripe may give you the 100% perfect line, but it is many times not as appealing to the eye.

Above: Pinstripers have their favorite unique brushes. Sometimes they are cut or trimmed just to the liking of the individual. Brush brand and style preferences are unique to each pinstriper.

Below: The striping color was matched up to the original design concept. The same red is carried into the interior design later.

PAINTING

Striping paint has to have the right consistency. The brush is dipped into paint and solvents and mixed up on an old magazine to achieve the flow properties the striper desires.

Dennis Ricklefs likes to lay a tapeline down to function as an optical guide, keeping him perfectly on track through the entire side of the car. He told me that some hardcore people in the pinstriping community disapprove of his techniques, but it is hard to argue with the incredible work Dennis has produced during the last fifty years. His work has been published in about every car magazine there is. It doesn't matter how you get there; it is the end result that counts.

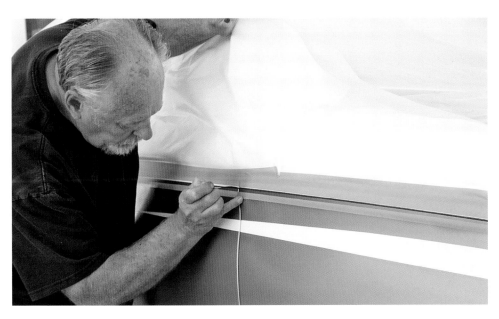

Dennis is laying down an amazingly uniform and straight line. The upper tape functions as an optical guide and the lower tape is a guide for his finger. The masking paper was taped to the car to give Dennis a safe surface to lean on—after all, the car is only in basecoat and keeping the white clean is extremely important.

A different type of brush is used to achieve the desired look. Quality pinstriping comes from experience and practice. Again, masking paper is used to protect the raw basecoat.

The pinstripe is carried into the jambs and door edges with the same precision.

After the pinstripe is laid out on the side of the headlight bucket, the bucket is removed and the stripe is carried all the way through the part—completely ignoring the issue of whether you can see the stripe later.

A good striping job goes around all edges and corners. Keeping consistent line thickness is tricky at times.

After the stripe is done on the outside, the tape and masking paper are carefully removed. The doors and fenders are removed for clear coating and any interior edge pinstriping is finished off at that time.

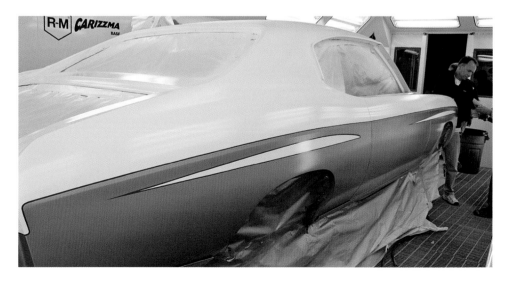

PAINTING

Left: The front bumper really gained a lot of appeal for me. The reshaped nose and two-tone paint scheme flowing through the bumper look beautiful.

Below: The classic hot rod style pinstriping can add a lot to a project. This Bob Spina design is a great example of this art form.

Bottom: Pinstriping offers endless opportunities for a creative mind. Tom Kelly produced this work of art.

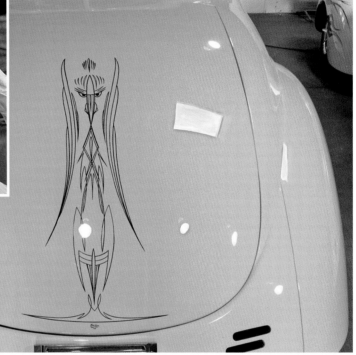

The striping brush may find other uses on a show car. There is a lot of fine detail work that can benefit from a skilled hand with a brush. The brake calipers on this Chevelle are as much a part of the design as anything else. They have been tumbled first and are in need of some fine detail work. The same red is used to fill in the lettering on the calipers. It is funny to see how quickly a professional pinstriper can lose his patience. Bob Spina happened to visit the Spade Brothers shop just in time to watch Chris's attempt to fill in the lettering. Unable to help himself, Bob took over. Being relieved by a top artist in the field is nothing to feel bad about; Chris even bought Bob a nice crab leg dinner for the effort.

Bob Spina, a striping icon, is giving the Chevelle brake calibers that extra detail that sets the best cars apart.

Bob makes it look so easy. If you've never done this, give it a try—only use an old caliper you don't need anymore (and make sure no one's around whose ears you want to protect from unpleasant language).

The final look is very clean and pleasing, tying perfectly into the overall design concept. It's the little things that create the harmony and make the car stand out.

CLEARCOATING

Getting to the clearcoating stage is a satisfying achievement. You've overcome many obstacles to get here. Clearcoating is the final step in the exterior painting process and deserves as much attention as every prior step. Before you can start clearing the car, remove all bolt-on parts and clearcoat them separate from the car shell. Back taping or masking the jambs is not acceptable in the show car world. A show car judge would instantly spot any sign of a tapeline. Wear latex or nitrile gloves during disassembly to keep handprints—which contain salt and oil—and other contaminants off the parts. Be prepared to safeguard the bolt-on parts until you clearcoat them.

Make sure you devote all your attention to cleaning and tacking the basecoat prior to the first trigger pull on your clearcoat gun. If you missed something, it will be embedded in your clear forever. This is a big problem in all colors, but white is by far the most sensitive of all. Clearcoating is a very specialized process that deserves its own spray gun. At all cost, *avoid mixing and matching spray guns between color and clear applications.* Clearcoating a nice clean white or black finish and having some blue metallic specks come out of your gun is no fun at all: your only recourse at that point is to stop and let the paint dry completely, scuff everything and start with basecoat all over again. Many painters have done this; none wants to do it again. Let their learning be yours.

The car will receive multiple coats of clear. If you clear over a pinstripe, apply two light coats first. Pinstriping paint may take off on you if you apply the first clearcoats too wet. Over reducing your clear a bit helps to thin it down. Slightly thinner clear will flash off quicker and locks the pinstripe in. After an extended flash time, proceed with several more coats of clear. Apply a total of five to six clearcoats while extending your flash time between each coat. Adding a couple of minutes to each following application will allow for the solvent to dissipate from the paint film.

Baking the finish after you've applied all of your clearcoat is highly recommended. Due to the extra number of coats required on a show car project, cure time could be slow without heat, particularly when compared to a traditional two-coat paint job. The longer you bake the clear the better off you are. To really get a show car right, you need to "double dip" the clear—that is, spray coats on two separate occasions. (You will do more than one coat each time.) Your first clearcoat job should be fully cured and hard before you re-clear the vehicle. To assist the curing process, cut the clearcoat with 600 grit sandpaper and let it sit for a few days. Opening up the clearcoat surface helps leftover solvents to leave the paint film faster. Bake it again if you can.

But why double dipping?, you ask. Why wouldn't you simply apply ten coats of clear the first time around and call it a day? If you start to think that way, listen up. Overloading the clear as well as rushing it and re-clearing too

Prior to clearcoating the car shell, remove all bolt-on parts. Avoiding tapelines in the jambs is a must in show cars.

PAINTING

Right: Every person who removes parts from the car is wearing rubber gloves. Pay great attention to keeping the surfaces clean and handprint free.

Below: Re-check all of the masking work and replace if necessary. You want to avoid any paper movement during clear-coat spraying. Every time paper moves it has the potential to drop dirt or dust into the clear.

soon can have long lasting side effects. The most common one is an ongoing dieback of the top surfaces. The clearcoat may stay soft for a long time to come and can make assembly difficult. Come on guys, is it really worth it? By now you have invested so much time in your project, a few more days and another gallon of clear is not going to kill you.

As soon as you reach the appropriate level of cure and hardness, it is safe to start the sanding process all over again. Carefully block sand the complete car with 600-grit paper in conjunction with the good old trusted balsawood sanding block. Taking the fat out of the clear and flattening the tape and striping lines in the process is the goal. Be very sensitive on the edges. You don't want to break through the clear and damage the basecoat.

Getting that mirror perfect reflection in your clearcoat without double dipping the car is hard to do—not im-

possible, but hard to do! It is amazing to see how much a second application of clear can improve the quality of the paintwork. Adding more clearcoat will increase the amount of UV protection, improving the coating's durability and longevity. The colors appear nicer too, which is mainly due to the additional depth in the clearcoat finish.

Taking the car around the show circuit exposes it to the risk of minor scratches. Washing the car often and frequent use of that California Car Duster that wasn't quite as clean as you hoped can also lead to further detail work. A show car is potentially buffed more often than any other car out there. Looking good every weekend isn't easy, you know. The extra layers of clear give you the peace of mind that you are able to maintain the look for a long time to come.

There are various 2K polyurethane clearcoats. Often craftsmen don't agree with one another on which clearcoat is the best. Usually it is all about one particular attribute of a specific version of clear that makes craftsmen pick one over the other. It may be the flow of the product during application, the drying characteristic or the way it buffs that makes the difference. It is a personal choice and as long as you stay within a proven system and don't mix manufacturers between your basecoat and clearcoat, you should be fine. Even if you are one of the lucky ones who can use any clearcoat you like, you may want to give the low VOC clears a try. Yes they are more expensive, but they have a level of quality that is hard to beat. The gloss level and flow of these products is amazing.

Small detail work like the white overspray on the door hinge is corrected prior to the clearcoat. No detail shall be overlooked.

We used DC5800 Clear, a 2.1 VOC clearcoat that has superior dry times. This clear was originally designed for small repairs of no more than three or four panels. It is the clear's fast chemical-through cure that was the deciding factor in the choice. Combining it with an extra slow hardener makes it suitable for larger objects like the Chevelle. Chris recently painted a spectacular 33-foot Eliminator boat complete in this clear, demonstrating its adaptability to a wide variety of projects.

Above: Cleaning yourself off is as important as cleaning the car. Wear a nice new spray suit to protect yourself from clearcoat overspray.

Above: Blowing and tacking off every nook and cranny is the best insurance for a clean paintjob. Any extra time spent on this process pays off big time. Not many people like to buff cars and every bit you can do to eliminate dirt is a good thing.

Left: Tack off the surfaces twice using a new D120 anti-static tack cloth each time. Cheap insurance—don't roll the dice.

Finally, there it is—the first coat of clearcoat. To lock in the pinstriping, the first two coats are thin over-reduced coats of DC5800. Mixed 4:1:2 with DH99, the fast hardener, and twice the amount of VR29 reducer, this clear sets up fast and eliminates any possibility for the pinstripe to move.

A total of six coats of DC5800 Clear are applied during the first round of clear; four more will follow when the car is double dipped a week later.

The fenders and doors are cleared separately, following the exact same process used on the car shell.

Just by looking at the reflection in the hood, it is easy to understand why this is the most important panel on the car. Nothing, absolutely nothing, can be cut short or simply overlooked here. The smallest ripple or imperfection will be clearly visible.

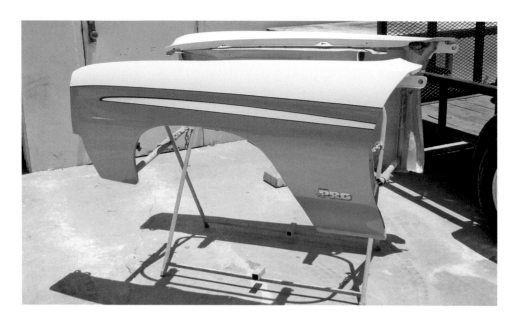

The fenders are double dipped and look like a million bucks. After a couple of days of curing they are ready to be buffed.

PAINTING INTERIOR PARTS

While the exterior is what we see when we approach a car, the interior is every bit as important in a show vehicle. Well-done show cars often carry the exterior design concept and color scheme into the interior. Besides upholstery, the dashboard is a big part of tying everything together. The dash is the one component of your car that you are likely to look at the most. At least that should be the case with show cars you plan to drive around town a lot. Customizing the dash and taking the exterior color scheme into the inside adds another level of appeal to your show car. Metal fabricated and exterior-color-painted center stacks that house an array of gages are a popular addition to many show cars lately. Those center stacks are commonly tied into the factory dash and create a unique and very personal touch to any project. But it doesn't have to be over the top at all. Simply painting the OEM dash makes a gigantic impact on a project. Many show car judges prefer a tasteful and elegant approach over in-your-face modifications. Looking at most of the high profile, contest winning cars over the past decade, grace, beauty, elegance, impeccable build quality and high grade materials are what they all have in common.

This two-component plastic primer filler (uses 929-53 hardener) is some cool stuff. Not only does it build well if you need to repair a plastic surface, it also can be used as a wet-on-wet plastic sealer by simply doubling the reducer. There is no special adhesion promoter needed with this product, just prep and clean the surface well, mix and shoot.

A good show car project needs a name. Jim Holoway decided to go with PRO Pane rather than the original idea of PRO Pain. Both are fitting for a 1000HP propane driven beast.

Painting interior parts can be tricky at times. An array of different types of plastics is found on a single dashboard alone. Picking the correct painting procedure is critical for good adhesion. It is not practical to elaborate on every plastic out there in this book. Scientists introduce new versions of plastic alloys faster then I can type these words. Up to 200 different types of plastics and plastic alloys can be found in a single vehicle today. Some of them are not even paintable at all. Please check your paint manufacturer's technical manual for the proper procedure.

Cleaning a dash prior to any painting is hard work. Years of ArmorAll abuse and other detail products have built up a film of residues that has to come off or nothing is going to stick. Washing the plastic parts in warm soapy water multiple times is a critical step in removing any detail materials, changing the water and washcloth in between each wash. Pick a strong dish washing detergent like the original Dawn. Did you know that Dawn was used to clean up after the Exxon Valdez incidence? Anything strong enough for that task should get the job done here. Never use carwash soap to clean plastics. Carwash soaps may contain additives that help your car shine more; the same additives can mess up our efforts to keep paint on the dash. After you are confident that nothing is coming off the dash anymore, clean the parts with a solvent-based plastic cleaner. RM's AM902 is a strong plastic cleaner that comes in a convenient aerosol can.

Please do not use any solvent-based cleaners other than the ones made for plastic. Plastic parts can build up static electricity during the wiping process. The wrong solvent can easily catch fire if the flashpoint is too low and a spark flies. Severe injuries have been reported and shops have burned down after the use of an improper cleaning solvent that caught fire.

Applying the proper adhesion promoter is crucial, of course. Again, there are more new plastics than I can keep track of, but products like Glasurit's two component 934-70 are likely to fit the bill most of the time.

Above: The original dash is going to be modified and repainted to match the exterior color scheme. The gauge cluster is a custom made unit with special gauges a propane-operated engine requires.

Left: The dashboard components that stay black are repainted in just the right gloss level. Every vent and grill receives the same treatment.

The original black instrument cluster is painted white, intensifying the cool green glow of the gages at night.

The exterior nickel color is used on the face of the dashboard. Tom Kelly skillfully completes the design concept's transition from the exterior to the interior by applying the red pinstripe.

Everything ties together nicely. Not that there would be anything wrong with leaving the dash original and all black, but this is stepping it up a few notches.

Being willing to go the extra mile is what separates the boys from the men, or girls from women for that matter.

A durable, catalyzed black polyester basecoat is used to paint the dashboard and interior pieces. It may seem easier and quicker to go with a spray can, but you will pay the price later. By catalyzing the basecoat, you add a level of durability and a resistance to cleaning chemicals a spray can't match.

The rearview mirror is treated with the same nickel basecoat and a semi-gloss clearcoat finish. Glasurit 923-57 Clear is a flexible semi-gloss clearcoat that has ideal characteristics for interior parts.

After the owner decided to remove the sun visors, the rearview mirror attachment was modified. A urethane filler was used to fill in the visors' attachment point. A layer of fiberglass restores a solid surface.

All the knobs and dials are carefully painted as well. It is obvious that the paint thickness has to stay at a minimum to allow for proper operation.

Above: With a little primer, the piece looks like nothing ever happened to it.

The upholstery is just like everything else—part of the big picture, with matching colors, flowing design and perfect craftsmanship all around.

Right: Custom built center stacks are becoming popular. They are a lot of fun to build and are highly labor intensive.

Left: Do I really need to say anything here? It's beautifully radical and elegant at the same time.

CHAPTER 9
CARBON FIBER

CLEARCOATING CARBON FIBER

Carbon fiber has become common on modern show cars. Its popularity comes from its combination of light weight and super strength. Carbon fiber is widely recognized as a high performance material that adds instant credibility to many show car projects. Walking the halls of the annual SEMA Convention (Specialty Equipment Market Association) in Las Vegas quickly demonstrates that there is no end in sight for the use of carbon fiber in a car. Almost everything you can wish for is available in carbon fiber today: hoods, fenders, mirror housings, spoilers, door panels, engine cover surrounds and rear diffusers are just the peak of the iceberg.

Carbon fiber panels are often used for decoration purposes rather than performance. Putting a carbon fiber hood on a 150HP Civic isn't really dramatically enhancing the car's performance, but it does look cool. Clearcoating carbon fiber is very popular and it is probably the most common way this product is finished and displayed today. The problem with coating carbon fiber, however, is that it likes to map. Mapping is the emergence in a finish coat of the texture of materials below, like body filler or carbon fiber. Shrinkage can cause carbon fiber's structure to appear in your clearcoat. Combine this problem with small pinholes frequently found in the carbon fiber itself and an unsuspecting painter can find himself with a big mess on his hands in a hurry. The natural reaction is to pile on even more clearcoat. In general, this will only partially improve the look. By the time all of the pinholes are filled in with clearcoat, the coating is so thick that it will shrink back and possibly dieback for months to come. Solvent popping is another side effect that can come from applying clear coat too thick.

The nice thing about carbon fiber is that the clearcoat will stick just fine to the surface of your part without any fancy adhesion promoter. Candy colors are sometimes used over carbon and fiberglass fibers to create a different and unique looking surface. This is even more effective with silver colored fibers. The silver colored fibers I have seen on the market today are not carbon, though; they are fiberglass fibers coated with aluminum.

As always, cleaning the panel is your first step of business. Assuming that you didn't build the part yourself, you

It isn't pretty to look at a carbon fiber panel that was butchered. You can clearly see the mapping of the fiber. This particular spoiler must have about half a gallon of clear on it and still looks like hell.

probably don't know what type of mold release agent was used during the manufacturing process. The two common mold release agents are soap-based and oil-based. Each mold release agent requires a different cleaner. Using both is the only way to ensure the surface was cleaned properly. Glasurit 700-1 will take care of the soap-based mold release agent and AM902 handles the oil-based product. When you prep a carbon fiber part for clearcoating, avoid breaking through the thin layer of resin on top of the fiber. Using P320 grit sandpaper, lightly scuff the surface just enough to create good mechanical adhesion between the resin and the clear. Any pinholes should be filled in before you apply the first coat of clear. Squeeze black colored polyester filler into the pinholes using a soft rubber spreader. After the filler has dried, the surface requires a little bit more light sanding. Again, try to avoid breaking through the resin. Some skillfully applied black filler will make the pinholes invisible after you apply the clearcoat. Don't apply more than three coats of clear at one time. Using a fast curing clear and baking it for a long time will lock in the texture of the fiber and allows for almost complete shrinkage. If you have the time to do it, let the part sit in the sun for a few days before you sand and re-clear the piece. If you prepped everything the right way, clear coating your carbon fiber pieces twice should be sufficient.

If everything is done correctly and you take your time, the end result will be as spectacular as the hood in this picture.

PREPPING CARBON FIBER FOR PAINT

Not everybody wants to have his or her carbon fiber clearcoated, though. A car with a complete carbon fiber body is a good example. For a short period of time it may seem to be a cool idea to simply clearcoat the complete vehicle. Reality is that it wouldn't be as pretty as you may think. Most carbon fiber bodies are made out of many different segments that are bonded together to form one piece. The bonding seams mess up the carbon fiber look and it wouldn't be pretty at all if you simply clearcoat them. A tasteful combination of painted and clearcoated surfaces is often the right call.

When I was offered the opportunity to paint a one-of-a-kind carbon fiber body show car, made by General Motors and owned by Jay Leno, it was a challenge I simply couldn't resist. I have met many interesting people in my career and worked on a lot of spectacular stuff over the years. Working at the Big Dog Garage, on a (at that time) secret show car project from GM and having Jay Leno cook me lunches and dinners during the building of the car will be hard to beat for a long time to come. The EcoJet, as this show car project was named, is the result of a napkin drawing.

One day Bernard Juchli, the foreman at Jay Leno's Big Dog Garage, and Jay discussed the idea of building a turbine driven, lightweight carbon fiber car to go along with Jay's jet bike. Ed Welburn (GM Vice President of Global Design) and Jay Leno got together for dinner one night and made preliminary drawings of the EcoJet's design concept on a paper napkin. GM's Advance Design Studio in North Hollywood, California, turned the paper napkin into reality. The end result is a highly attractive, racecar inspired show car that has many amazing attributes. Besides its carbon-fiber-over-Kevlar construction, the car is extremely lightweight and is powered by a 650HP Honeywell LTS turbine engine with 583ft.-lbs. of torque. Bio diesel power and waterborne basecoat technology make this show car project even environmentally responsible. Who said you can't have that much fun without the guilt? Ok, Ok, environmentalists are probably shooting holes into my theory here, but come on, it sure beats the environmental impact this car could have had with a blown 575 running on premium fuel and painted in solvent-based paint.

The problem with handmade one-of-a-kind carbon fiber bodies is that they routinely require more prep work than mass produced pieces. The one of a kind EcoJet carbon fiber body was made by Metalcrafters Inc. in Fountain Valley, CA, and then attached to a modified Z06 Corvette frame. Alcoa assisted the Big Dog Garage crew with the frame modifications and made the billet wheels for the car.

Just like Chris Guinn was faced with a deadline on his Chevelle project, I was given only limited days to complete the paint portion of the EcoJet project. The EcoJet was scheduled to be publicly unveiled at SEMA in 2006 just a few weeks after I started work on this car. The end result was the same, long days and nights. To make matters worse, the carbon fiber work was running behind schedule, chipping away on the precious time available to paint this car. At the end, we had less than three weeks to make it happen.

The carbon fiber shell required a lot of trimming. To ease the production process, areas like the headlights and part of the tail section were constructed as a solid piece and had to be cut out after the fact. The lips of the inner wheel arches had to be trimmed to proper size for clearances and look. Trimming and cutting carbon fiber is a nasty business. The cutting process is slow due to the product's hardness and you will use up more cutting wheels than you normally would with steal. The dust and debris that is a normal side effect of this operation is highly irritating to the skin, eyes and respiratory system. This is not the time to play tough guy or girl and skip your safety gear. If you ever worked on fiberglass, you probably still remember how itchy your skin got after you grinded or sanded the fiber. Well, this is worse, trust me. The fine

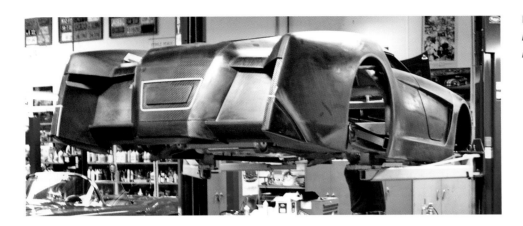

When the car finally arrived at the Big Dog Garage, the body was rougher than I expected it to be.

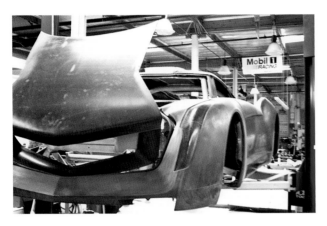

Above: *Cadillac came instantly to my mind when I first saw the front end of the EcoJet.*

Above right: *This body is going to get the royal treatment. Simply by looking at the carbon fiber, it is obvious that mapping is on top of the list of my concerns.*

The first order of business is to clean off the mold release. If you skip this step and start sanding the body right away, you run the risk that you may push the mold release deep into the fiber structure's pores. If left alone, this can create adhesion problems later. Considering all the time and attention Per Blixt, the fulltime body and paint staff member of the Big Dog Garage and I put into cleaning the body, we still missed a few spots. Luckily for us, they showed up early on and could easily be repaired before it was too late. The moral of the story is clear: you simply can't clean any surface too much for painting.

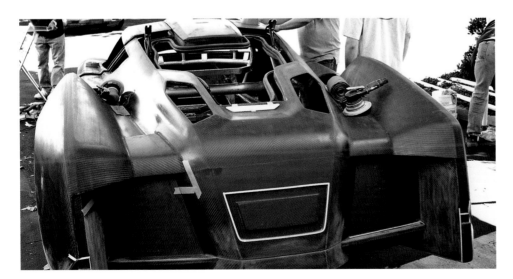

Driven by the tight schedule, many different people and agendas had to compete with each other. The glass guys are trying to fit the windows while we tried to sand the carbon fiber.

Sanding way into the night.... The first day on the job could not end until the polyester spray filler was applied.

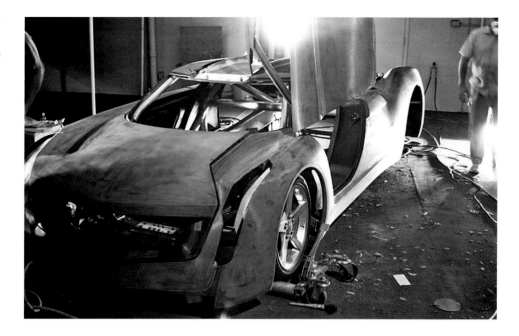

Finally in the booth! It is time to clean and tape the car. Taping is very critical on this car; several segments of the project are planed to remain in carbon fiber. Polyester spray filler overspray could create a lot of problems on those areas and needed to be avoided at all cost.

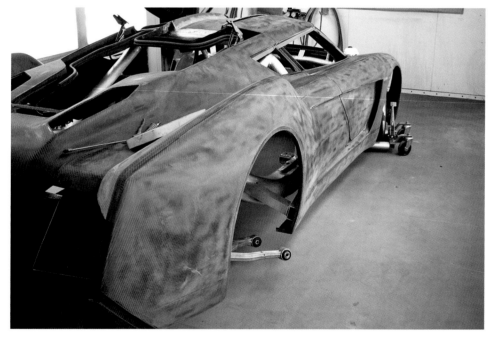

and extremely hard fiber particles are razor sharp and easily penetrate your skin and you can feel them for a week or more, stinging you like little invisible needles. Please wear gloves while you sand raw carbon fiber and protect your eyes and respiratory system!

1006-23 POLYESTER SPRAY FILLER

Rather than attempting body filler work on the raw carbon fiber, we opted simply to sand the shell with P120 grit sandpaper and applied several coats of polyester spray filler from the start. The Glasurit 1006-23 polyester spray filler is the ideal product for this task. It adheres well to carbon fiber and will stop any mapping right in its tracks. Doing body filler work on top of raw carbon fiber is tricky anyway; the difference in surface hardness between the body filler and the carbon fiber surface is so great that it actively interferes with your ability to create true straightness. Polyester spray filler is the great equalizer between the two products, making the body filler work much easier in comparison.

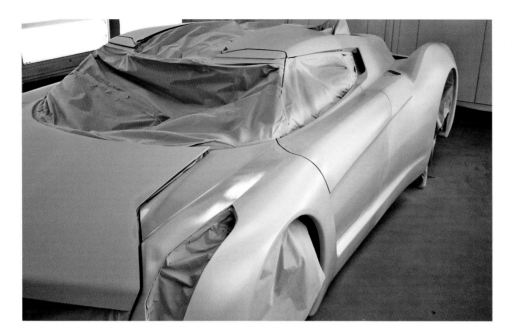

The first coat of 1006-23 is applied. Comparing the primed vehicle to the raw carbon fiber car makes it very clear how much easier it is to see any imperfections in the body.

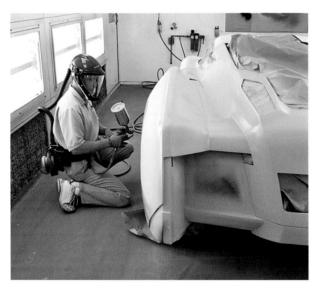

A total of four coats of polyester spray filler are applied to the EcoJet. Application was done with a 2.2 fluid tip on the gun.

To discover the EcoJet's true body condition, we applied 3M powdered guidecoat to the polyester spray filler and blocked the car for the first time. Most areas were pre-cut with P80 grit paper and than re-blocked with P120 grit, which clearly outlined all the high and low spots. Knowing that a second application of polyester spray filler is unavoidable in a situation like this and having that already built into the schedule was very helpful. Sand scratches are not a concern knowing that you reapply 1006-23 for a second time. Polyester spray filler is more than capable of

safely filling P80 grit sand scratches. Plus it is a well-known fact that shaping primed surfaces straight (regardless of the type of primer) is easier with coarser paper and it is needless to say that straight is what we really want. Every area that needs special attention is clearly marked so we won't forget about it. A lot of cutting and trimming was still going on during the first few days and many different agendas had to proceed side by side. At one point I counted seventeen different people working on multiple projects at the same time. Room was at a premium.

For the most part, the body filler and straightening process was similar to the process outlined on the Chevelle: hours of blocking and sanding followed by gallons of body filler and more blocking and sanding. Thinking about it, maybe we should have called this book "How to Prep My Show Car"—after all, you're going to prep the car for about a thousand hours or more and then spend ten hours painting.

Working on carbon fiber does require a few different considerations than working on a steel body car. It is unavoidable to break through the polyester spray filler coating during the shaping process, exposing raw carbon fiber all over again. At this point, due to the repeated sanding action, the carbon fiber is likely stripped of its protective resin surface, making mapping an even greater concern than it was before with the resin still intact. A second application of 1006-23 is the only practical option and necessary to stop this threat. After all the body filler work that was done to the EcoJet, this is really the right thing to do no matter what. Cars like the EcoJet are built for

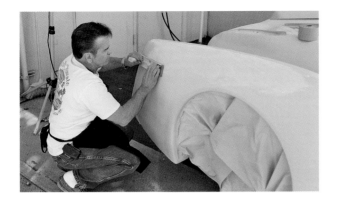

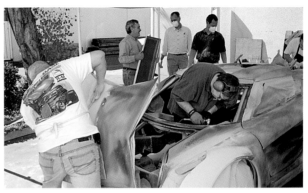

Per Blixt is pre-cutting the polyester spray filler with P80 grit paper on a long board.

A generous application of 3M powdered guidecoat makes it easier to read the surface condition.

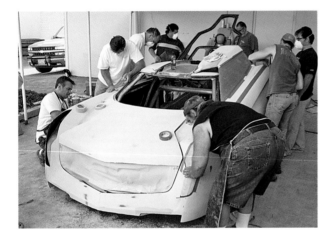

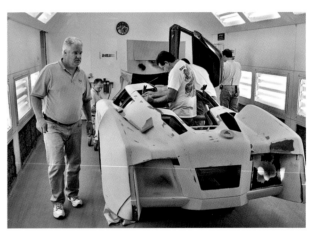

Working around one another was tough sometimes. Everybody had a specific job to do and was scrambling for time.

Masking off the car for its second application of 1006-23. This was one of those welcome moments where we had this car to ourselves.

Taping off this car took several hours. All the jambs and interior surfaces had to be protected from overspray. These surfaces remain unpainted carbon fiber and are going to be clearcoated.

a particular purpose and with a specific venue in mind, but no matter how tight your schedule is, priming raw or exposed carbon fiber with a conventional 2K polyurethane primer would be a mistake. Mapping will eventually occur and you will need to repaint the affected areas sooner or later. Restrain yourself from shortcuts; your name will be permanently attached to the car.

Cleaning the surfaces prior to applying polyester spray filler application is always important. Carbon fiber has a much greater tendency to build up static electricity during the wiping, sanding and blowing operation compared to steel. This build up of static electricity attracts and holds dust particles to the surface. Dissipating the static electricity is easy with water-based cleaners or an anti-static tack cloth. For all you gadget people out there, yes there are high-tech options available as well. If you can't help yourself and money has to be spent, you can always go and get one of those nuclear charged anti-static blowguns. They work really well, just like your anti-static cleaner would, but you look much cooler using it. Then there are electronic gadgets you can hook up to the car and they are supposed to eliminate the static electricity. How well they work on a carbon fiber car, I really don't know. I have always known one thing though: I have to wipe the car clean anyway, and so I never bothered to find out. High-tech or low-tech option, it's your choice.

Here is one important thing to remember: polyester based products are very porous and they will absorb some of the cleaning solvents you apply to them. Please allow for sufficient time between the cleaning and priming process to give the cleaning solvent plenty of time to evaporate out

Andrew Tait is spending a great amount of time blowing and tacking off any dust particles.

of the substrate. Trapped cleaning solvents in your polyester spray filler or the body filler can potentially lead to small blisters or possible corrosion down the road. Time is money and most of us are in a hurry to get primer on the car, but you can see why it would be a bad call to hurry this step or try to make up for some lost time during this process.

One of a kind show cars, particularly if they are built under the watchful eyes of the GM Advance Design Group, require extreme attention to detail. Every bodyline has to be perfect and crisp, all surfaces have to be straight and ripple free, the fit and panel gaps have to be right on the money and the paint needs to be flawless and spectacular. Any show car of this magnitude is going to attract

I am using AM900 to clean any contaminants off the EcoJet's surface. The B120 anti-static tack cloth is used for the final tack before we apply primer.

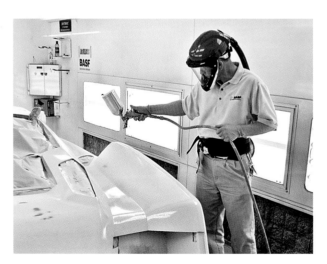

The second coat of 1006-23 polyester spray filler is on its way. Four more coats are applied using a 2.2 DeVilbiss PRI primer gun.

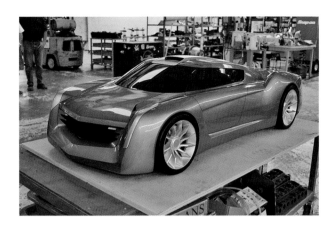
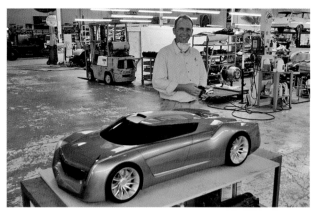

Seeing the clay model was very helpful to get a good feel for the concept. Turning a designer's idea into reality requires good communication. Clay models are about as good as it gets in communicating a vision.

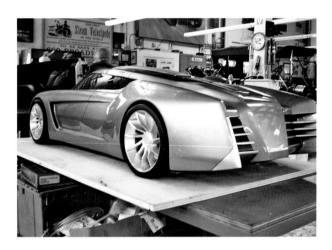

It is obvious that we had a long way to go from the raw carbon fiber shell that arrived at the shop to the completion of the designer's vision.

a lot of attention from the press. No craftsman wants to have his or her name attached to a car that isn't right. For an OEM manufacturer, this is even a bigger deal. Every bodyline and surface is not only evaluated for their looks in real life, they are also evaluated for how they will appear in film, photographs and magazines. Crisp and exaggerated contours and bodylines is the answer for a great camera presence. To ensure that everybody on this project has a clear understanding of the final goal, GM brought the actual clay model to the Big Dog Garage rather than producing drawings for us.

Some readers are probably thinking, well I am not Jay Leno and I will never be able to build a show car like that, so why bother? Ok, you may not exactly get GM to help you build a "one of a kind" carbon fiber body, but I have to give credit where credit is do. I am aware of several show

cars that received significant help, support and assistance from GM and other OEM manufacturers like GM. Not a single one of these owners is remotely as famous as Jay is. You will be amazed about how many of the cars you will see at SEMA every year have OEM backing to one degree or another. It is true, help can be there for you, but your project needs to be fresh and exciting and cannot be a copy of something that was done like that before. The bottom line about OEM support is that nobody is going to help you and sponsor a show car project if there is little in return for the manufacturer. If you want support, think about what is in it for them. We all know what's in it for you. Unless your project has the potential to create nationwide attention and buzz, hold your horses. If your idea is to keep your show car safely in your garage until you feel like taking it out for a ride on selective weekends and only go to a handful of car shows a year, you are out of luck. Sponsorship is based on constant visibility.

Another basic requirement for support from the OEMs is that your car has to make them look really good with significant potential for positive press and public exposure. You also have to be willing to haul your car around the nation on a moment's notice at times. Taking your car to events where the manufacturer likes to use it for promotional purposes is part of the trade. The "free" 575 Crate Motor has a steep price tag, if you know what I mean. Having a few show cars to your credit already doesn't hurt either.

151-70 UV PRIMER

After the second application of polyester spray filler was block sanded and all of the necessary body alterations were completed, areas of raw carbon fiber and small areas of body filler were exposed again. With no time left in the

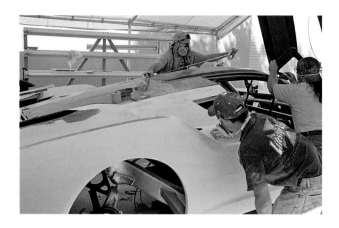

After the designer visited the shop and checked out the car's progress, surprise, more bodywork was needed to move and reshape the line on the roof and quarter panel.

Aluminum tips are fitted to the quarter panels. They are designed to wrap around to the inside and required hours of fitting time by Steve Anderson of GM Advanced Design.

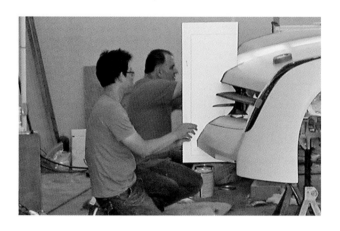

With the help of a template, designer Juho Suh (blue shirt) and Frank Sausedo, head of the GM Advance Design Studio, are aligning the grill blades.

schedule, more 1006-23 primer was out of the question. I was forced to change directions. The schedule required us to move ahead and to switch to a primer that will produce a paintable surface. Faced with the risk of mapping, an unacceptable risk indeed, cutting edge technology was the answer to my problem. UV primer filler came to the rescue.

UV primer is the latest innovation in the automotive paint market. The resin technology in this highly advanced product is similar to what a dentist would use in plastic fillings. The product stays pliable and wet until it is exposed to an ultraviolet light source. Within a few minutes these products achieve a full, 100% cure rate. In comparison, a standard 2K polyurethane primer will be sandable in about 90 minutes, but does not achieve 100% cure for weeks. That ongoing cure process is what facili-

tates the mapping process. With a 100% cure in just a couple of minutes, this product gave me the confidence I needed to feel good about the integrity of this project's paintwork.

Even though the Glasurit 151-70 UV Primer Filler is capable of drying in simple sunlight in only 4–5 minutes, we didn't prime the car completely in this technology. It was the middle of the night when we reached the point to get ready for the next primer application. Of course you can always cure this primer with a UV light, but the UV light that was onsite only had enough capacity to allow spot priming. Priming a complete car and trying to cure it with a light that covers about a square foot at a time is not practical and something you don't want to try.

We decided to spot prime any questionable area and cure it with the UV light. As soon as the UV primer was cured it was sanded with P220 grit paper and prepped for a following application of 285-21 2K Polyurethane Primer. This process eliminated the risk of mapping and kept us on schedule at the same time. For anybody who never used a UV primer before, this technology can be a bit scary at first. The 151-70 is a one-coat product when applied with a 1.7 Sata KLC primer gun. One single coat is the equivalent of three coats of a regular 2K urethane primer. The film build is truly phenomenal. The weird thing for most people is that the coating will be somewhat transparent. That is not a sign of too little film build; it is designed that way. For this technology to work properly, ultra violet rays have to be able to penetrate the coating completely. No cure will ever happen to any layer of 151-70 that is not

exposed to the UV rays. The hard and fast rule is, if you can't see the repair underneath the primer anymore, you applied too much. To prove my point and to give you a better understanding of the do's and don'ts of UV technology and to learn the product characteristics, spray a metal panel with 151-70 and lock it away in a metal cabinet for a month or more. Make sure that no daylight can reach the panel. I promise you, it will still be somewhat wet and sticky by the time you go and check on it.

Proper flash times prior to the exposure to ultra violet light are highly important with a technology like this. Because this product has the ability to achieve a complete cure so rapidly, trapping solvents can be a huge problem. Allow for most of the solvent to evaporate (5–6 minutes under most conditions) prior to exposing this primer to UV light. As impressive as the adhesion of this product is to bare steel and other substrates when used correctly, trapped solvents can easily push the coating off its surface. The sheer physical force behind solvents and their strong desire to leave a coating during cure is highly underestimated. Solvents are in paint products for three reasons: to achieve proper viscosity that makes them sprayable; to function as a transport vehicle from the gun tip to the surface of the car; and to assist flow properties on the surface itself. As soon as those three things are accomplished, the solvent is of no further use. Solvents do not chemically interact with the paint, nor are they necessary for the overall durability of the coating. Removing as much of them as you can prior to the chemical curing process is the way to go.

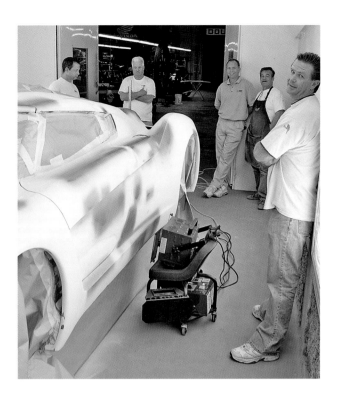

The Motley Crew is watching UV primer dry—from the left are Mike Manion, Mark Northrup, me, Per Blixt and Andrew Tait. The UV light was slowly moved around the car to cure all of the 151-70 UV primer filler spots. And yes, it is about midnight.

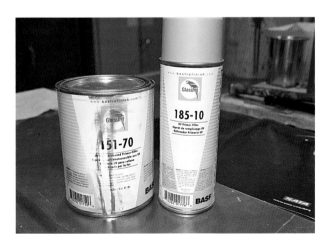

Glasurit UV primer filler comes packaged in two ways: 151-70 is applied via spray gun and 185-10 is an aerosol. The 151-70 is really a one-coat primer if applied with a 1.7 Sata KLC gun. As an aerosol, 185-10 is a two to three coat product. Regardless of which one you use, make sure that the film remains somewhat transparent.

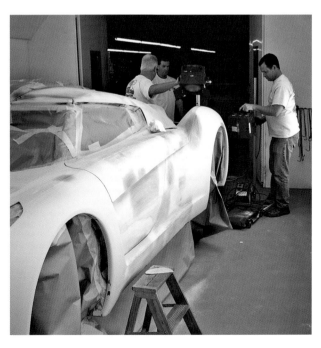

All UV primer spots have been block sanded again for straightness and adhesion. The 2K urethane primer is going to be applied next.

285-21 2K POLYURETHANE PRIMER

A 2K polyurethane primer is the last primer that hits the EcoJet. Glasurit 285-21 2.1VOC primer surfacer is the choice for this car. This high build primer under normal conditions is applied in two to three coats. Needless to say, this is Jay Leno's car; he got four for good measure. This primer dries to a nice smooth and hard surface, just what you want for a show car. No easy sanding 2K urethane primer should ever hit a show car. Easy sanding characteristics generally go hand-in-hand with shrinkage and possible dieback. After days of relentless sanding, your arms turn into noodles and it is hard to believe that anybody in their right mind would have voluntarily picked a hard-to-sand primer.

Well, it is even harder to believe that somebody wouldn't. Temporary discomfort shouldn't make you lose sight of the goal you are working towards so hard. At the end, you are going to spend significantly more time looking at and living with the decisions you made than you would ever do working on the car. Just for clarification purposes, if I say hard-to-sand primer, I don't mean concrete either. Expect the primer to be several degrees harder than lacquer primers used to be. In other words, if just a couple of easy sandpaper strokes significantly flatten the primer's surface, I would be worried about my primer choice. Every show or concourse car and the respective owners of such vehicles deserve the respect and the due diligence of everybody that lays hands on the car. Never lose sight of the fact that if you are not the owner of such vehicle, you are the executor of someone else's high price dream. Ease of use and the price of paint and paint materials should never be on the forefront of anybody's considerations, particularly not while playing in this arena. Product performance and durability are the factors that count.

Following the same procedures outlined on the Chevelle earlier in the book, we wet sanded the EcoJet twice, one pre-cut with P400 grit paper and a second cut in P600 grit.

Sorry, but I skipped the picture showing the 285-21 primer. How many more times does anybody want to look at one more light gray coating being applied? If you just absolutely need to see it, go back to the 1006-23 application and simply pretend. You wouldn't know the difference, promise.

Under normal circumstances, I would have primed the EcoJet twice with polyurethane primer, sanding the first coat of urethane primer surfacer with P220 or P320 grit sandpaper and than reapplied two more coats of 285-21 primer for the final wet sanding step. With no more time left to do the extra step and still a few little things I wasn't happy about, the only viable option was to apply 285-21 mixed 4:1:2 as a sealer and than carefully nip it with P800 prior to the start of the painting procedure. I am not saying that this was a bad way of doing it, but it was just not the best possible way I know of. In my opinion, sealers are for emergencies only and should not be an automatic part of a show car paint job. The main reason for this opinion is that sealers have a tendency to die back a day or two later and produce a micro texture in your clear. If you can avoid sealers all together, do it!

The actual process of wet sanding the EcoJet was similar to the process demonstrated on the Chevelle. The car was pre-cut with P400 grit sandpaper and was followed up with a final cut in P600.

Here is a question for you: If you are not applying body filler or sanding the car, what do you think eats up the next biggest amount of time on a car like the EcoJet? You

CARBON FIBER

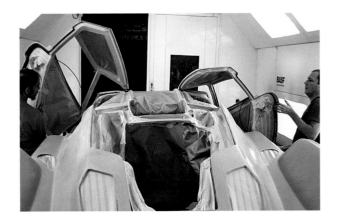

No short cuts here. Taping up the EcoJet was a multi hour operation, something we did four times in total.

Painting a sample panel at the same time as you spray your car makes for a perfect color reference for future use. It is easy to transport anywhere and with a copy of the original mixing formula attached to the back, it can turn into a lifesaver. Five years from now, it will be hard to remember exactly what was done to the car.

guessed it, taping. Keeping any unwanted product off the carbon fiber that is scheduled to be clearcoated only is a time consuming proposition. In order to carry the color just barely into the jambs as the design required, we needed to open and close the doors during the painting operation. Protecting the carbon fiber while at the same time being able to open everything required miles of masking tape. Scissor doors are pretty and cool to look at, but they are a challenge to paint if it is impossible to remove them. Thank God, at least the hood and engine cover were removable for better access. In comparison to other projects, taping cars like the EcoJet requires a substational amount of two- and three-inch masking tape. The door jambs are mainly taped with tape alone. Paper would increase the chance of problems during the opening and closing of the doors while the painting process is in full swing.

WATERBORNE BASECOAT APPLICATION

Waterborne basecoat is the newest topcoat member of our industry. Even though Glasurit's 90Line waterborne basecoat has been around since the early '90s, most painters in the US have not yet worked with it. This technology is the future and is here to stay. With environmental regulations clamping down on the paint industry as a whole, all of the US will be waterborne sooner or later. On top of that, there is really no good reason not to work with this technology. In general, the coverage is superior to solvent-borne materials and the colors are nicer and cleaner too. No worries about washing off the color with water either, once the basecoat has dried; it reacts like any other basecoat. Waterborne technology doesn't mean that the product would be healthy if sprayed without proper protection either. Regardless of the fact that it has a less

offensive odor and is certainly better for the environment, please treat this paint for what it is, a chemical coating!

There are a couple new housekeeping rules with this product too. Leftover paint and the cleaning solution used to rinse out your spray equipment requires a separate waste stream. Mixing water and solvent waste is not acceptable to most waste management contractors. Solvent-borne paint waste is frequently sold as fuel to other industries and mixing water into the waste stream diminishes its burn value.

Most people like to get an extra gallon or so of paint for future repairs. With waterborne basecoats though, shelf life is an issue. Six months to a year is what you can expect from this technology. Rather than stocking up on paint, partner with a paint store that will pay close attention to an accurate mix. If all the mixing bases are properly maintained by the paint store and the paint formula is followed exactly, reproducing the same paint will never be a problem. Please ask for a copy of the mixing formula for your own records. You never know when you may need it. I highly recommend spraying a small metal test panel at the same time as you spray your car. This panel will be your future color reference and should be kept with your paint formula. Spraying the color sample at the same time as you spray your car, following the same techniques, in the same environmental condition ensures that the sample will be true to your car.

SPRAY EQUIPMENT ESSENTIALS

There is a new generation of spray guns out there that were engineered with waterborne paint technology in mind.

Sata, Iwata as well as DeVilbiss all have made changes to their equipment to assist you with this technology. It is important to understand the relationship between air supply, air quality and the final appearance of your paint finish. Though I lean towards Sata's 3000 series guns, I have to admit that there can be valid reasons why you would pick up one of the others. The most obvious situation would be if the compressor would be too limited in its CFM capacity. CFM stands for cubic feet per minute and a spray gun's peak performance depends on proper air volume. Sata spray guns are on the higher end of the CFM consumption scale and with an undersized compressor you may be better of with an Iwata or DeVilbiss.

Please keep in mind that there is a big difference between your PSI (pounds per square inch, also called the force) rating and CFM. You may have 120PSI on your wall regulator and still not have enough volume to operate your spray gun correctly. To make this really simple and CFM easy to understand, picture your garage on fire. There are two water hoses to pick from—your standard 1″ garden hose and a 3″ fire hose. Both hoses have an operating pressure of 100PSI. Which hose would you grab to save your car? The fire hose of course. The bigger diameter hose gives you more water at the same pressure to fight the fire than the smaller hose. That volume difference between those hoses is the equivalent of a spray gun's CFM consumption.

Just like a carburetor, each spray gun is engineered to function at a certain CFM consumption. Some spray guns ask for 8–9 CFM and others want 17 CFM or more for optimum performance. Less CFM consumption doesn't automatically translate into a better quality spray gun either; it simply means that it could be the better choice for your situation on hand. Most manufacturers' spray guns will consistently perform well and do exactly what they are designed to do, as long as you provide them with their basic pressure and volume requirements. As painters, we feel we know what a spray gun does and how it works and therefore don't need a manufacturer's instructions. Yet each gun is different and paint technology is evolving. To get the most from the equipment, I read the manuals and recommend you do to. For a show car, you want to get the best performance possible out of all your painting tools and materials.

How do you know how much CFM you have available? Well, the following is not a 100% scientifically correct answer of course; there are too many unknown variables in every situation, but this is a fairly reliable rule of thumb. A standard two-stage piston compressor produces about 4 CFM per 1 HP and a screw drive compressor generates about 4.7 CFM per 1 HP. To be able to have all of the potential CFM available to you, the air should be delivered to your work area in a 1 ½-inch pipe or larger, and all of your couplers have to be 3/8 inch in diameter. Many shops today are still using the standard ¼ inch couplers or wall regulators with too low a CFM rating and can't figure out why the paint jobs are not as nice as they hoped for. If you are not the only user of compressed air in the shop, deduct the air consumption of the other air tools in the shop. That way you can find out what's left over for you.

Here are some general figures: for a standard DA sander 10–15 CFM and an air buffer 20–25 CFM. A wide-open air blower could use as much as 35–40 CFM. The length of your air hose is also a factor in the calculation; you can lose an additional 1 CFM for each 10 feet of hose over the standard 32-foot length. Depending on the manufacturer, you may lose as much as 7 CFM for each quick-disconnect coupler the air has to travel through. One last comment about CFM—your air supply is only as good as the weakest link in the system. If your air volume is restricted anywhere between the compressor and the gun, your available volume can't be more than the restriction allows to pass through. For example, if the compressor is hooked to the main line with only a ¾ inch diameter pipe, it doesn't matter what you do after that restriction; you can only access the volume that passes through that pipe—100 HP or 10 HP compressor it wouldn't matter.

The quality of the compressed air supply is another aspect you should consider before you jump into your first waterborne paint job. Oil vapors are present in almost every compressed air supply. Conventional solvent-borne paints never were affected by those vapors. Waterborne paint on the other hand may fisheye on you, if the oil vapors are not filtered out. You need a charcoal filter stage in addition to your regular filters to eliminate those vapors. Worried about the expense? Well, you shouldn't be; you are killing two birds with one stone. By adding the extra stage to your filtration unit, you are not only removing a possible paint problem, you are also very likely to turn your air supply into a Grade A breathable air source as well, giving you the ability to run your fresh air supplied respirator off the same airline you use for spraying paint. Please check with your filter manufacturer first and verify local regulations and requirements prior to using this air for breathing purposes. A carbon monoxide monitor will be a minimum requirement for sure.

When it comes to spraying 90 Line basecoat, not much will change. Your spray techniques stay pretty much the

Most shops run a two-stage filtration system to clean the air supply. Adding the third stage, a charcoal cartridge unit, produces a waterborne safe air supply. In most states, this unit meets the requirements for breathable air if it is used with a carbon monoxide monitor. Protecting your health while doing the right thing for the paint.... What a concept.

<div style="writing-mode: vertical-rl;">CARBON FIBER</div>

same, applying multiple coats of color until you have achieved hiding. Most colors are covered in just two coats. Each coat of basecoat must flash off completely before you apply the next coat. Water only comes in one speed though, leaving you with few options to adjust the drying time. To speed up the dry time, you can add additional air-flow devises. Sata, Iwata and DeVilbiss all make inexpensive blow guns that greatly increase the air movement over the panel's surface. Increasing the air movement as well as lowering the humidity is your best option. Of course expensive spray booth upgrades are another option, but in the world of show car painting, time is not as critical as it would be in the collision repair industry. To slow the dry time down, wetting the spray booth floor with water as well as adding small amounts of deionized water to the paint works well. The beauty of waterborne basecoat is that changing dry times will not affect your color match in one way or another. Solvent-borne basecoat's color accuracy, on the other hand, will react to dry time changes. Faster drying times result in a lighter color; slowing the dry time down can darken your color.

The EcoJet was painted in a non-heated side draft spraybooth during the colder part of the year, or whatever you can call winter in California. Because all of the paintwork was done during the cool early morning hours and the EcoJet has some more challenging contours and surfaces, I opted for a 1.2 Sata RP 3000 series spray gun. This would not have been my choice in a temperature-controlled environment, though. If it comes to Sata equipment, the standard recommendation for Glasurit 90 Line basecoat is a 1.3 HVLP gun.

Surface cleaning for 90 Line is the same two-product process outlined a few times before in this publication: AM900 followed by 700-1.

923-200 CLEAR

Prior to July 2008, using waterborne basecoat meant that you could use a higher VOC clearcoat and still be compliant in the state of California. Even with that option available, I opted to go the ultra low VOC clear route. The 2.1 VOC clear option has everything I look for in a clearcoat that is applied to a show car project. Between the flow, the

Glasurit 90 Line basecoat was the product of choice for the EcoJet project. This basecoat has a 2:1 mixing ratio with 93-E3. In extreme heat with low humidity situations, adding 5–10% of 90-VE deionized water may be necessary.

To ensure that I have everything I need for a flawless paintjob, a mobile filter system and new air hoses were installed. This was the first 90 Line paint job at the Big Dog Garage and the third stage charcoal filter was not in place yet.

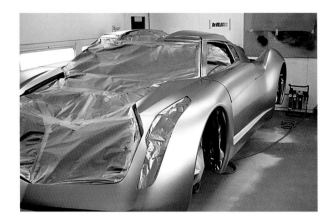

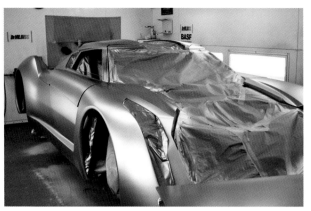

The waterborne basecoat looks just as you would expect a quality basecoat to look—nice and even. A total of three coats of 90 Line were applied to the EcoJet.

As much as I like the looks of the completed EcoJet, there was just something extremely intriguing to me about the way this car looked in basecoat alone. And yes the clock in the background shows 2:35am.

shine, the drying time and the buff ability, it's all there. Glasurit 923-200 Clear has three hardener choices, giving you all the flexibility you may need, based on the size of your project and the environmental conditions you are spraying in. This clear uses no reducer and has a simple 2:1 mixing ratio. Just like most clears you can purchase today, this clear is designed to be applied in two to three coats. Show cars are not your normal kind of paint job and I like to give it a couple extra coats. Please remember that you need to extend the amount of flash time between coats if you are going beyond the recommended number of coats. The thicker the paint film gets, the harder it is for the solvent to evaporate. Solvent pops is the common name of small tiny blisters that appear in your clearcoat finish if you rush the job. Those blisters are the kiss of death to any show car finish. You can sand and buff the clear as much as you want. A watchful observer will still be able to find them.

Above: *Glasurit 923-200 Clear is protecting the 90 Line basecoat on the EcoJet. It was just one more product choice that helped Jay achieve his goal of lessening the overall environmental impact of his project.*

Right: *The EcoJet received five coats of 923-200 Clear. There was no time left in the schedule for double dipping the clear.*

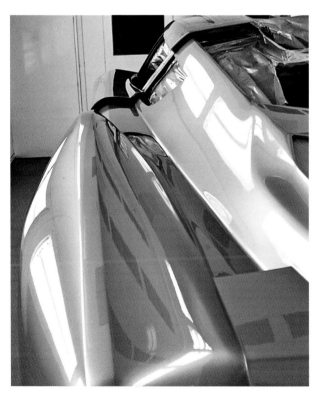

CARBON FIBER

It is extremely challenging to open and close the scissor doors during clearcoating operations. You know what you have done by the time you finish the car. Unfortunately, the way the upper hinge is constructed made it impossible to remove the doors.

The lower lip of the hood was just one part of the project that stayed in carbon fiber. Rather than clearcoating the surfaces in high gloss clear, the design concept called for a semi gloss finish. The job went to Glasurit 923-57 Clear, which is not only flat but flexible too, greatly reducing the risk for stone chips. The semi gloss finish on the exposed carbon gives the EcoJet a more Formula 1 like feel rather than SEMA.

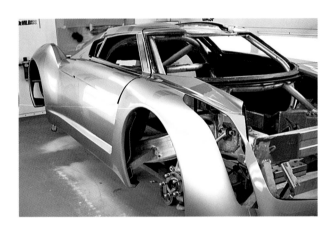

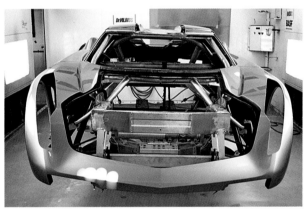

De-masked and ready to go! Picking a fast curing clear was important for the situation. The booth had no baking capability and many people waited in line to get their eager hands on this shell. The clear was about seven hours old at this point.

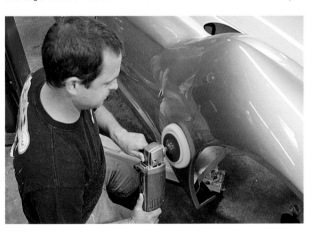

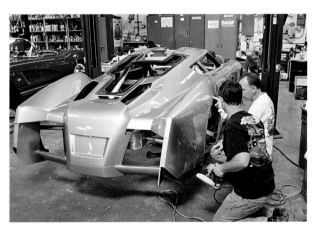

In the interest of time (less then 24 hours later, the car had to be on the truck to Las Vegas), the EcoJet was never completely color sanded and buffed. The overall clearcoat finish looked really good right out of the gun and only small dirt nips were sanded and buffed.

CHAPTER 10
SHOOTING FOR THE STARS

There are a many different levels of car shows you can play and compete in. Here are the three big ones that mean the most to any craftsman in the show car world: the Concourse d' Elegance in Pebble Beach, the Detroit AutoRama, and the Grand National Roadster Show in Pomona. They are distinctively different from one another. "Pebble" as this event is commonly called, is the grand daddy of the vintage car collector world. Competing in and actually winning this event is a game of just a few. The amount of money it takes to bring home the best in show award from Pebble is astronomical to say the least. The money is mainly spent in parts and fabrication of them, if they are not available, and general labor cost. Having four to five thousand hours invested in a car that goes to Pebble is not unheard of. At an hourly rate of about $75–95, it is easy to see why it is a game of just a few. The home built or do-it-yourself cars at Pebble are far and few between.

To win Pebble Beach, you almost need to have a full-time researcher on staff. Being period-correct on parts and features is a big key for this event. Knowing what type of headlight was original on your Duesenberg or if the car was delivered with or without pinstripes is all considered during this event. Knowing all of a car's racing history, in case it was raced at major events in the past, is also part of the game. If it comes to the body and paintwork, most of it is not much different. You do need to be familiar with some vintage paint and striping techniques though. Gold leafing and certain brush painting techniques are also a must in the world of vintage beauty.

And then there are the Grand National Roadster Show in Pomona and the Detroit AutoRama, two car shows that are all about excellence in craftsmanship. For the Detroit AutoRama, about 1200 car are submitted each year in hopes to be invited to the event. A few hundred of them will ultimately make it to the AutoRama. The highlight of this show is the competition for the Don Ridler Memorial Award, Even though the bar is extremely high in both competitions, for many craftsmen this award seems to be a bit more challenging to win then the AMBR Award (America's Most Beautiful Roadster) at Pomona. The Ridler Award is probably one of the hardest show car awards to win besides Pebble Beach. A panel of judges narrows down the field to 30 semifinalists. From there eight finalists are chosen and named the "Great 8." Only one single car will leave this competition with the Ridler award. To make this even harder, this event has to be the first public

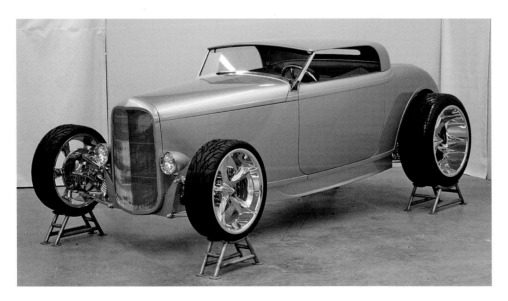

Undisputed, this is a piece of art in any form of the imagination. This car is a perfect example for a statement I made earlier—no over-the-top graphics or screaming colors needed. If a show car is right, it is right in every color.

showing of the car. What is nice about this competition is that it is all about perfection and beauty. Creativity in design and execution is highly encouraged and this is an event a homebuilder and do-it-yourselfer could theoretically win. Don't get me wrong; the level of craftsmanship that is competing in this event will blow your mind. I have seen cars that competed for the Ridler award and didn't win that have been executed nicer than Pebble Beach winning cars. It appears to me that the body and paint expectations during this event are higher then the ones at Pebble. Again, not discounting either event! The reason I feel that a homebuilder would stand a chance at the Ridler Award Competition is that this is about determination, not being vintage correct. No need to find that one missing headlight lens from 1918. The true essence of the Don Ridler Memorial Award is to create the perfect dream.

Some of the greatest names in the show car world have competed for the Ridler Award over the years and not all have won. The few that did win frequently needed more than one try to get it done. People like Chip Foose, Troy Trepanier and Chris Guinn have managed to win at this competition. Being named one of the "Great 8" is something most show car people can't even claim on their resume. But it is my sincere hope that anyone who loves the show car world and believes they have what it takes to get it done would try it at least once. There is a good reason for that too. How about $10,000, a new GM Performance Parts engine and a custom designed jacket? Hey, with a bit of luck, the ten grand could pay for one of your wheels you know, making the whole project a bargain.

PLAYING WITH THE
BIG BOYS

Let me invite you into the world of Alan Palmer. Alan is the owner of Palmer's Custom Paint & Body in Camarillo, California. He was hired to do the body and paintwork on a 1932 Ford Highboy owned by Rudy Necoechea of Sherman Oaks, California. The roadster named "Undisputed" was scheduled to make its appearance during the 2007 AutoRama. It was Alan's first time competing for the Ridler and his project headed straight for a "Great 8" nomination and ultimately won the Outstanding Paint Award as well. In January 2008, Alan won the AMBR Award in Pomona with this car, beating the Ridler-winning car. This is a world where nothing but absolute perfection will do. The tolerances are as tight as humanly possible and your family may not see you for days or weeks during the making of such a car.

This is the world of show cars that are rarely driven. They are built to be flawless in every respect and mostly

transported by covered trailer. Driving them on the road would beat them up too quickly. The owners of such vehicles build them to show them off, collecting as many trophies on the way as possible. When attempting a run at the Ridler Award, everything is built for looks and looks only. It is a competition of beauty not practicality. You may find yourself doing things you would never do to a car that is going to be driven around town over the weekends. The panel fit and all of the gaps are too tight to be driven through dips in the road at sixty miles an hour. After the cars have traveled the show car circuit long enough, they usually become part of someone's car collection or they are drained of their fluids and parked as decoration in

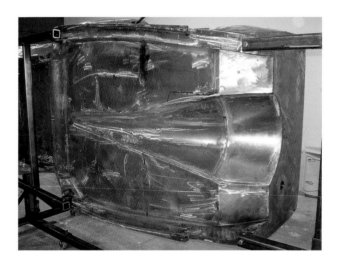

For better accessibility, the '32 was put on a rotisserie after it arrived from Scott's Hot Rod. All fabrication work was done for tight fits throughout.

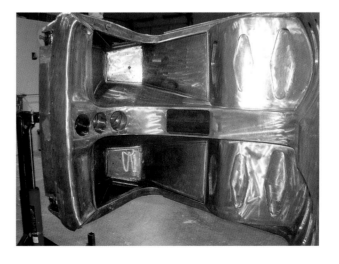

The metal is cleaned and prepped for the magical transformation to a one-of-a-kind show car.

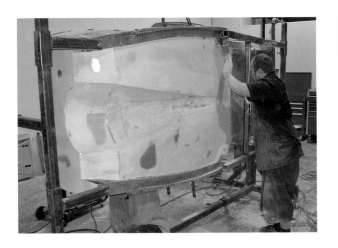

The first round of rough shaping the body.... The same attention is paid to the belly of the car as to the rest of it.

The custom dash is the interior's centerpiece. Every contour and style line is going to be dramatized for the right effect.

the living room of the house. Either way, don't look for the "Undisputed" on the 405 Freeway anytime soon.

The metal fabrication work for this '32 was done by Scott's Hotrods 'N Customs in Oxnard, California. Justin Padfield and his crew hand built 100% of the car's body and they spent thousands of fabricating hours on turning this spectacular car into reality. This is Scott's Hotrods 'N Customs' fourth "Great 8" nominated car. After the completion of the fabricating work, the vehicle was shipped to Alan Palmer in bare steel. Alan and his crew went to work right away to avoid any corrosion issues.

EXTREME BODYWORK REQUIRED

On a project like this one, the body is rough shaped before it will be matched up to the frame. When it comes to the undercarriage of a show car that will compete on such a high level, there is no other option than to paint it. The preparation of the belly has to be equal to or better than the rest of the car. No Line-X or texture coating will be acceptable in this world. Putting the car shell on a rotisserie is the only choice you have to get the belly flat and straight. Work on the exposed surface areas first. Don't worry about the surfaces that need to match up to the frame quite yet. A body filler squeeze will fix that later. Competing in this arena means that you need to get ready for judges who are going to look at things nobody else will. The exterior of your project must be perfect—at least the 30 semi-finalists at the AutoRama will be. Count on it! You may be asked to remove a cover panel so the judge can see how well the car was prepped behind it. Making every single surface of the car top priority is the only way to avoid being caught with your pants down.

Not something you would normally do to a weekend cruiser. The wheel housings are going to be straightened and perfected to the max.

It is obvious that you compete in an entirely different stratosphere than most show cars will. Body filler is going onto surfaces that are commonly left alone. Not a lot of people can claim that they ever body filled the wheel housings of a '32 Ford. They are straightened and body worked to a ripple free mirror finish. Do you really need another reason why you shouldn't drive this around town on the weekend? Nothing sounds more appealing than a $1000 stone chip, doesn't it?

Metal fabricated interior features are gaining momentum. Rudy's '32 Ford project has metal fabricated seats, dash and center column as well as interior door panels. Needless to say, this can turn into a body filler and straightening nightmare in a hurry. It takes days on end and a lot of determination to stay on course and not give

The engine is always a big part of any show car project. That means the firewall has to be up to par. Cars like these will be seen with the hood open as often as closed. Note how crisp and pronounced the bodylines are.

The seats are metal fabricated into the car body. The door hinges are relocated to the b-pillar, giving the "Undisputed" nice suicide doors.

The doors' original interior panels were removed and an all-in-one metal design took its place.

This perspective makes all the changes to the door's interior surface more evident. Hours of detailed body filler work is needed to bring this up to Ridler Award quality.

up. The finished product is going to be spectacular and worth the effort. Looking at all the different surface shapes makes you appreciate the right tools quickly. As always, the devil is in the detail and every change you make will always trigger several other changes that go hand in hand with it. Looking at the pictures here can demonstrate how important it is to find a fabricator who understands what the painter has to go through to get it right. Respect for each other's work is of the essence. A good fabricator can weld up surfaces in different ways. Each way can bring different consequences with it. Protecting the painter's interest by knowing what consequences his or her action can have and acting upon it is priceless.

Matching up the vehicle's undercarriage to the frame's surfaces is super hard work. The final gap size was determined to be one eighth of an inch all around. Some added difficulty was thrown into Alan and his crew's life. For a more dramatic effect, the decision was made to square off the rounded corners of the frame. The custom built frame had nicely rounded edges on the rear section when it arrived at the shop. With not enough time in the schedule to make the changes in metal, body filler was used to get the perfect look. This is one perfect example of things you may do to a show car that will not be driven around much.

In this '32's life, that decision is no big deal. Squaring off the frame of a car that will be driven to every event un-

We should all be thankful for living at this day and age. Fifty years ago, this would have to be done in lead rather than body filler. It is no wonder that nobody saw retirement in those days. Modern high-grade body fillers have no problem handling this work.

The exterior of the door is not yet important. As soon as the interior is finished and primed, the jambs and exterior surfaces need to be matched up. That means primer only for the outside right now.

The frame made it to the shop. Matching up the frame and body surfaces isn't going to be easy.

Finally this frame is being used. It traveled the show car circuit for a while as a display unit. Couldn't have come up with a better use for it myself.

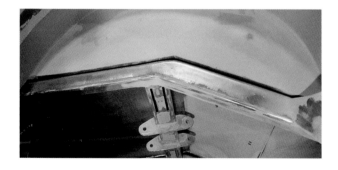

The fit of the frame isn't really that pretty with the rounded corners. Squaring it off is the right call. Producing a clean and crisp look otherwise will be impossible to achieve. If time permits and you plan on driving the car a lot, reshaping the frame by welding metal is the way to go.

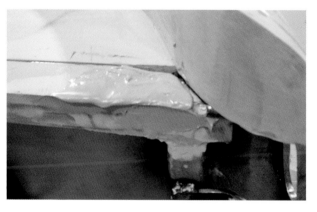

Squaring off the frame while butting up all the surfaces at the same time is labor intensive. If you don't want to do this type of work, don't plan on going to Detroit either.

der its own power, particularly if you throw in a monster horsepower engine, may result in problems quicker than you expect. The twisting and bending of a frame under hard acceleration combined with the constant vibrations of such engines will affect the body filler's durability and may pop it loose. It may be a few years before you notice any problems, but it could very well happen within a month—nobody can exactly predict that. Using the Glasurit 839-90 flexible body filler over an epoxy-primed and sanded frame may be your best choice here and it can help slow this process down, but I still wouldn't use it on my daily driver. You have to be honest with yourself on how you will use the vehicle in the future before you decide on a plan of action.

When it comes to gapping the frame, pick one surface and style line to straighten out first. Paying close attention to the style lines is very important on getting a good start for this task. Unless you perfect one side of the project first, you may find yourself chasing around the car without end. With one side corrected, you now have a guide to follow and everything has a chance to fall in place easier. Take your time to get it right. Show car judges during a Ridler type event are more likely to notice those kinds of things—more likely than a possible flaw on the outside I may add. Again, you are expected to have the exterior right. Nobody in his right mind would show up at the AutoRama with flaws on the exterior panels. If you are going to see flaws during this show car event, they are most likely transport damage. This is where the best of the best come to compete and nobody wants to have their name attached to a poorly executed car. It is about bragging rights and proving yourself as a craftsman.

The bottom line for cars that go to Detroit is that if you or anyone in your shop can see anything, even the most minor thing, fix it.

Spending several hundred hours of bodywork on the frame alone is expected on a car that will go where this one is heading. The '32 will hopefully travel the show car circuit for a long time to come. After the body filler work is completed on the frame, it is time for primer. You guessed it, 1006-23 polyester spray filler was Alan's choice. Numerous heavy coats are applied to the frame, locking in the body filler and filling some of those pesky little pinholes. By this point you should start thinking about your options for temporary storage of the painted frame. Freshly painted frames are sensitive and need to be stored correctly. Making this consideration an afterthought could be problematic. Thinking several steps ahead at all times is what the pros do.

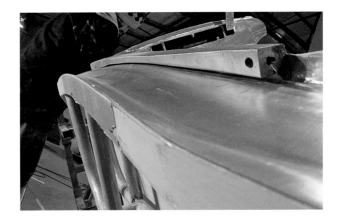

Even though the body matches up to the frame all right, the gaps need to be corrected. One-eighth inch in a perfect line is the goal. At the end, the upper and lower body shell lines have to be harmonious too, which in return will affect how the doors fit.

Straightening the frame surfaces and gapping the frame are next on the list.

Almost there, the surfaces are getting close and line up nicely. The gap itself still has a ways to go. There are waves at the tail end of the gap and close attention will be paid to eliminate all of them.

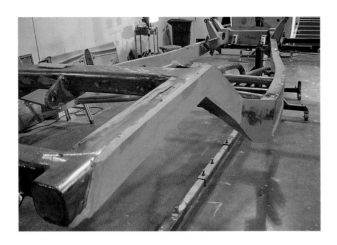

After the frame's rear section was squared off and the surfaces matched up to each other, a body filler squeeze gave Alan a perfect guide for the top frame surfaces.

Amazing what a couple hundred hours can do. The frame is getting ready for primer.

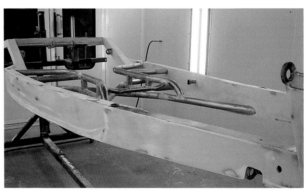

I truly believe that everybody by now understands why you can't do these cars without body filler. Just imagine metal working all those surfaces to perfection. If you try, this is how it would go. "Hey my name is Alan and I painted one '32 Ford in my 60 year career."

The suspension mounting points are highly critical. They remain exposed on this car and everybody will be able to see them.

After the frame is primed, it is time to concentrate on the body. The body has to be primed in polyester spray filler as well. Several frame surfaces have to be block sanded at the same time as the corresponding body surfaces. They all bounce off one another. It is important that you don't jump the gun and move ahead too fast on one part of the project. Most of the time that results in a wasted effort. Remaining open-minded and not losing sight of the big picture requires that you step back and think things over once in a while. Being aware of how every step you do will affect other parts of the job is important and is a learned skill.

The interior of the '32 is opening up a new challenge. Most of the interior's surfaces are exposed and are going to be painted. Extensive body filler work is needed to make the interior flawless. The amount of fabric, padding or carpeting in this vehicle is ridiculously minimal. The style lines are critical throughout the entire interior design and the doors need to be gapped on both sides. On most cars, the interior door gaps are invisible, but not on this car. If you never tried to gap doors on the interior and exterior at the same time, you are in for a treat. This operation is for the most patient craftsmen. Every little mechanical adjustment you make will affect so many areas at once. If the frustration level rises, walk away from it for a while. Hitting the car with a wrench or hammer after you lost your cool is just a bad choice. Always keep in mind, there is plenty of body filler that needs to be sanded and that makes for the most perfect way to burn off steam. As you

The interior surfaces are being straightened with body filler. About 70% of the surfaces are going to be exposed and painted.

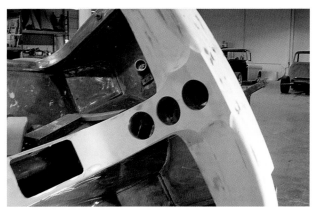

Check out the great lines of the center stag where it meets up to the dash. What an artistic use of body filler.

Metal piping was welded to the floor, functioning as a border for the carpeting. Body filler was used to elevate the surrounding surfaces.

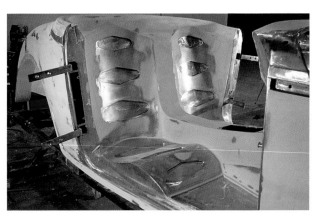

Even the seating area will be mainly painted surfaces. Small pads are going to be the only unpainted section.

On this car the interior gaps are clearly visible and have to be reworked just like the exterior ones. Making mechanical adjustments affects every aspect of the interior and exterior gap. This is very challenging work and the time it takes to get it right is amazing.

It is very tricky to get the gaps as tight as you need them to be and not lose the ability to freely swing the door open. Apply a couple of layers of tape to the inside of the doorjamb, duplicating the thickness of your primers and paint. Nothing can scrape or interfere with the doors.

You cannot afford to lose sight of the exterior gap when you work the inner one. The gaps play off each other and need to be at least looked at simultaneously.

Straightening the inside of a hardtop roof is quite a job. Power or hand tools are only helpful on a small section of the surface. A lot of hand sanding with soft sanding blocks is required. Because the surface is going to be coated with polyester spray filler, stop worrying about sand scratches and go for the 40 grit paper. Anything finer than that is just making it harder on you.

work on the interior surfaces, you learn quickly that your fingertips are often one of the greatest tools to apply body filler. Rounding off tight corners is so much easier to do with your fingers. Wear gloves to protect your skin while you do that.

When it comes to building the ultimate show car, you will find yourself doing things you never thought you would do. Straightening the inside of the removable hardtop roof with body filler is a good example. Most people would simply install a fabric headliner and call it a day. This was simply not good enough for Rudy Necoechea and his car. He opted to do the right thing, the hard thing. Straightening the interior side of the hardtop roof is more challenging than the exterior side. Inverted round surfaces going in multiple directions at the same time are not easy to get right. The end result of taking these extra steps is highly rewarding. The look of a flawlessly painted interior roof can blow your socks off. When it comes to the inside surface of this hardtop, not a lot of the area is suitable for the use of power tools. Here is a lesson I hope you never have to learn the hard way. With hand sanding and shaping as your primary option, cutting the body filler as early as possible is the only way to go. Under no circumstances should you allow the body filler to cure completely before sanding. Don't answer the phone or walk away from the job until you have sanded the body filler. Letting it cure too far would minimize your ability to get it truly straight and properly shaped. Use aggressive sandpaper to cut the body filler. P40 grit is a good choice here. Getting the optimum surface condition with the least amount of body filler is the goal. Only cover as much surface with body filler as you feel comfortable can be sanded in time. Don't try to be a hero, be smart.

This hand-fabricated roof is one beautiful piece. But in typical show car fashion, the surface is going to be covered with body filler completely.

The interior surface is ready for polyester spray filler. Even so there is quite a bit of body filler involved in straightening out this roof.

The exterior is also ready to get primed. Close attention was paid to not overload the lip with product where the small window will go.

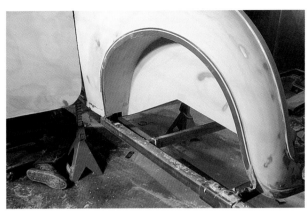

The lower body contour wraps around the whole car and is a major part of the overall appearance. There is no room for errors.

This door surface is not straightened or adjusted yet. The surfaces will be adjusted with the engine covers and hood in place. The engine covers are designed to overlay the front section of the body. Both surfaces have to be perfect without a chance of rubbing. The cover will be removable.

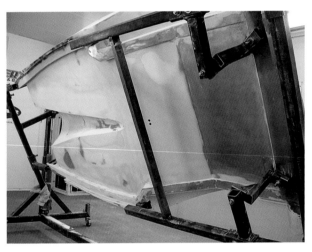

The floor panel is reworked to a quality standard many cars don't even have on the exterior. It is ready for polyester spray filler.

There are so many style lines and contours that need to be perfected on this '32, all while trying to get the gaps right at the same time.

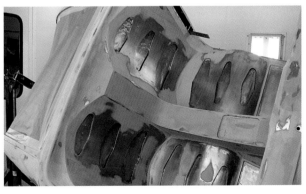

The interior surfaces are ready for primer. The trunk is masked off to avoid overspray onto the not yet completed surfaces there. The trunk is getting the same makeover as the passenger compartment.

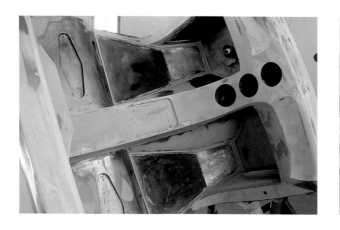

After countless hours of body filler work, the dash is finally ready for primer too.

The lower body contour has been perfected and dramatized for the desired effect. As soon as the primer hits the surface, you will know if you succeeded.

To boost morale, Alan and his crew opted to prime the body and frame before completing the doors, engine covers and hood. There comes a time when you get tired of looking at the same body filler surfaces and priming the areas that are good to go can be motivating. Yes, you may need to rework a few spots here and there, but that can be well worth it. Being able to see your work after the primer is applied gives you a better visual status report. Any area that requires extra attention is going to stand out. Also making decisions about lines and surface alterations is easier with primer on them.

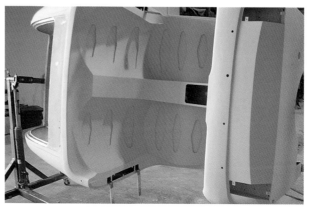

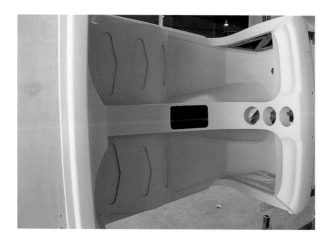

Above left and right: I have seen it a million times and it still amazes me how much impact the first layer of polyester spray filler makes. Everything takes on a new dimension and the guesswork is over.

Left: The interior surfaces really show their true face now. They don't need paint for us to be able to recognize that this is going to be a spectacular interior.

Job well done. You can see that the lower contour has what it takes to grab your attention. Typical '32, just crisper and more pronounced.

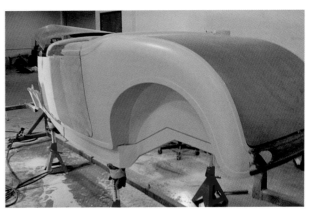

Back on the frame, the remaining parts are installed and will get the attention they deserve. The rear section of the door was already matched up to the quarter panel surface and all the attention is focused to the front section.

All of the hard work is starting to pay off. The fit between the frame and the body is dramatically improved. A few more adjustments here and there, but it is about where it needs to be.

Everything is coming together nicely. Some detail work is still required on the edges but we are just in the first primer stage here. Remember the bare metal picture of this section earlier? What a dramatic improvement all around.

The familiar zone blocking technique. The door and engine cover surfaces are corrected and floating body filler over both surfaces at the same time creates the desired panel flow.

The front-end is taking shape little by little. The objective is to create the illusion that the car is made from one solid piece.

The original frame design (look at the big round opening) was missing the little contour that would extend the lower body line. Ignoring those little details is risky business on a car like this.

After the body filler work was completed on the doors and engine covers, 1006-23 was applied to those surfaces as well.

You can never leave your guard down when working on a show car. The smallest details can easily take away some of the appeal. Making and creating solutions on the fly is often necessary. After the body and frame were reunited, Alan spotted a small section between the suspension mounts that was missing something. The round frame opening was missing the contour of the lower style line. Without it, the flow of this line around the car would be interrupted right at that spot. A couple of hours later, the frame segment now has the contour. Seeing, recognizing and correcting the little things is what makes a great show car craftsman.

This '32 Ford has two major style lines and nothing has been given more attention than those two lines. Functioning almost like double backbones, they are of equal importance. The upper one is a bit more in your face while you are close up to the car, but as soon as you step back and look at it from a distance, the lower line is the one that grabs my attention more. Understanding the key features of your project car is important. You need to channel your attention and effort to the correct areas.

Stepping back and walking around the car for 30 minutes or so after it is uniformly primed may be the best time you will ever spend. As soon as you start blocking, your focus returns to isolated areas only. Besides that, it is a rare window of opportunity to see an undisturbed surface and you should take advantage of it if you can. As soon as you break through the primed surface with sanding and blocking operations or apply more body filler, this window of opportunity is gone until the next primer application rolls around.

To get the best results you possibly can, you should approach every show car project like it is your last. Think as if the rest of the world is going to judge your life accomplishment on that particular car. Having that attitude can help you stay on track when you hit a low. And you will hit a low! What has helped me the most over the years is asking myself if a special person in my life that really knows cars would be proud of my decision. Doing the right things all the time is tough. Walking away from your project on a day nothing seems to go right is tough too, especially if you have a deadline, but it just may be the right thing to do. Both Alan and Chris laughed and agreed with me that we all spent "stupid time" on our projects—burning all nighters on a task we would have accomplished after a good night of sleep in just a few hours.

Looking at this Highboy, it is of the utmost importance to get the lines perfect. In comparison with the EcoJet,

Looking at the lines, it becomes clear that all the time invested is paying off. Needless to say, more than one application of 1006-23 hit the surface of this car.

It is all in the detail! You miss a spot and you are dead meat.

As the polyester spray filler is being blocked, the upper and lower style lines are put under a microscope. Those two lines are like a double backbone for this Ford. I couldn't clearly say which one is the more important one.

there are not a lot of dramatic shapes that catch your attention on this car. The ones that are there have no other option but being flawless. I am sure that it comes to nobody's surprise that it took more than one application of 1006-23 to get the car right.

My favorite feature of this car is the free-floating roof. There are no obvious signs of any attachment point as you walk around the car. The roof simply appears to hang there in the air not supported by anything. It is a spectacular look that required great engineering skills. I am not giving away how it was done; instead I'd like you to pack up the kids and attend the next car show where the "Undisputed" is scheduled to appear. Check it out for yourself. You are not going to regret it.

Having just the right gapping was critical to the overall appearance of the roof design. A boatload of time went into this part of the construction. The smallest difference in gap size would be obvious to almost anybody. Looking at the finished car, there is no sign of a hinge, locking mechanism or fastener anywhere to see, inside and out.

One other consideration on a show car like this one is the fit and finish of its hinges. The look has to be perfect and complementing to the project. Simply mounting them to the surface would be so OEM like. Who wants OEM looking things, on their ultimate show car? Certainly not Rudy and Alan. The hinge design calls for tight fitting flush mounted hinges on the trunk lid. It is the little things, the well thought through things. that make for a great show car. Looking at every aspect of the car and finding tasteful ways to improve the things that count most is an art form by itself. Don't change simply for the sake of change; do it to improve the status quo. Done tastefully, little things can go a long way. Doing them not so tastefully on the other hand can be a waste of money and a turn-off for the viewing public. For the most part, show cars are about tastefully pushing the envelope rather than smacking viewers in the face. "Apocalypse Now" would be seeing a monster truck conversion of a Willys Pickup rolling into Pebble Beach. Time to find a new hobby. Just for the record, I do like monster trucks—just not at Pebble Beach.

"Undisputed" is finally ready for 2K polyurethane primer surfacer. Glasurit 285-21 primer was used for the task. The paint products used to paint the '32 are the exact same primer, basecoat and clearcoat that went on Jay's Eco-Jet. They were applied and wet sanded with very much the

The most important gap on the car wraps around the hard top roof and can't be anything but perfect.

When the car is completely finished, there will be no visual signs of any attachment points inside or out.

Recessed hinge mounting points allow for a flush surface finish.

Filling in the areas around the hinge attachment points with body filler gives you the tight fit desired.

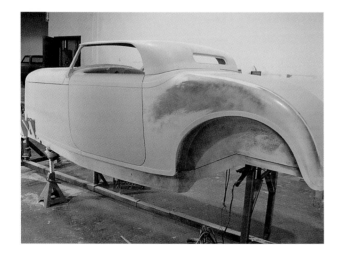

The car is nearly ready for the first coat of 2K polyurethane primer surfacer. Alan's shop has made major headway by this stage of the game.

The gaps are there and one by one the radiuses are being put back in place.

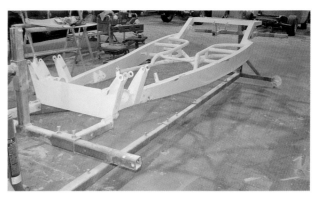

Until you have done this type of work you may not understand, but seeing this picture and knowing what it takes to get here can bring tears of joy to your eyes. No car ever left a factory looking this tight and sharp.

After applying 1006-23, Alan test fitted the frame to the body and block sanded the primer. You can see that several spots needed more body filler work. The frame is ready for re-priming.

same techniques addressed early in this book. I don't wish to bore you to death, but I will reiterate that you will likely have to prime your car twice. No matter how much attention you paid to the little details, there is always something that requires a re-prime. You will be better off if you plan for this eventuality from the start. The closer you get to the final stages of a show car project, the less patient you are go-

ing to be. The sweet smell of the finish line can cloud your judgment. Doing the right thing, especially if the weather and calendar suggest it is time to take your project out for a cruise, can be tough. All the important details remain the same. Corrosion protection when and where needed, flash times between coats, not overloading the product and proper drying times are the key factors to success.

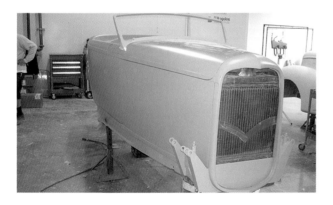

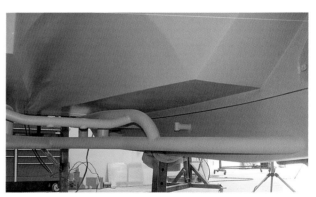

Above: *Finally primed in 2K Polyurethane primer—Glasurit 285-21 was the product of choice at Palmer's Custom Paint and Body.*

Above right: *The frame and car belly are primed in 285-21 primer as well. Days of wet sanding are ahead.*

Right: *Simply looking at the primed undercarriage is a delight. There are not a lot of cars out there that have surfaces, shapes, gaps and lines like this. You are lucky to see those on the outside of cars, but seldom underneath.*

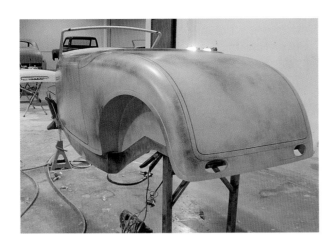

Guidecoat has been applied to assist the wet sanding process.

Sanding the same surfaces hundreds of times can get old after a while. Sorry, but it needs to be done.

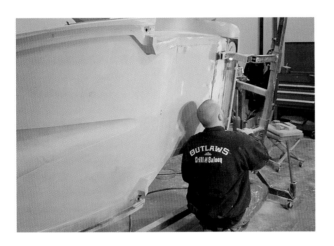

More small areas emerge during the wet sanding process. Polyester putty and additional primer is needed to correct them. The fact that you still find things wrong is not a problem—not correcting them would be.

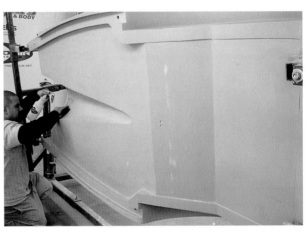

Block sanding the primed surfaces with the exact same standard of quality on all sides is time consuming. Once again, a pump bottle is used to supply clean water in the right amount to the desired area.

Sometimes things can go wrong on your car. A weld may fail during the eleventh hour, or the car shell may slip off a stand. You may dent a panel and not notice it until you start cleaning it for paint. Reality is that things do happen and you need to deal with them. It is up to you on how you will react. It is never fun, but if you get upset you may not make a smart choice. Experience has taught me that in situations like that, it is best to walk away from it for an hour if you can tell that you'll get mad. Alan was faced with a few things like that very late in the game and making the correct choice isn't always easy. If you add Alan's time constraints on top of it, you can see that it takes a strong character to not simply mask things over. A weld failed, which was not discovered until the car was in the booth to get painted. Then several small areas appeared

It is amazing to see how much surface area there is to block sand in a painted interior scenario. Many different shapes of sanding blocks are required to get a perfect ripple free surface.

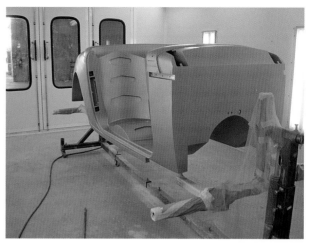

This is Alan's favorite picture. His guys are cleaning and prepping the car shell for paint and he is welding at the same time. This is not what you expect, but it is reality. It is the same dedication to excellence that will not let you leave well enough alone that prevents you from choosing the caulking gun rather than the welding gun. Going back to welding at this stage of the game is what needed to happen and it was done.

Remember how I stressed the fact that tapelines were unacceptable in the Chevelle's door jambs? Well, on this type of work, it's even worse. You can't have any tapelines on the entire car shell. The paint finish has to flow flawlessly from the exterior into the interior. Even the belly has to be painted at the same time. Taping anything would be a mistake. Attempting this type of paintwork without putting the car shell on a rotisserie is playing with fire. I don't care how well you think you can tape and later buff those lines, trust me, they are still there. An experienced show car judge will find them.

The first coat of Glasurit 90 Line waterborne basecoat was applied to the body. I know I am repeating myself, but if you don't have a rotisserie, you shouldn't be doing this type of work. No tapelines anywhere, not even on the transitions from the exterior surfaces to the belly.

Alan found a few areas he didn't like. Rather than closing his eyes to the fact, he stopped and fixed them.

that needed corrections after the basecoat was applied. To round it all up, the car was then damaged on the way to Detroit and needed to be fixed just before the show started. Every single one of those things can drive you nuts. If you mentally prepare yourself for things to happen, your reaction to them will most likely be better.

After the final application of 90 Line waterborne basecoat, allow for the proper flash off time before you start applying clear. We discussed earlier that trapping solvent in your paint film leads to problems down the road. Well, it is no different with waterborne basecoats either. Trapped water has no way to escape after you have applied the clear and the paint film remains soft indefinitely. Picture putting a sheet of plastic over a puddle of mud. The water can't evaporate and the mud will never dry. In the end, the clear will lose its gloss and may even turn white. The bottom line is that regardless of the type of product you use, don't rush it.

All parts on this '32 were painted separately from the car shell itself. This technique makes many show car painters nervous. There is a potential for color match issues between the shell and its parts. To ensure that all surfaces match up at the end, it is important that you never change your spray technique during the painting process. Maintain constant distance from the panel, reducer speed, and pressure setting. Make sure that you use the same batch of color all around. Painting cars complete, inside and out, requires more than one gallon of basecoat. If you didn't mix the paint yourself and you are not sure if somebody may have made a mistake, intermix the containers with

Two areas in the trunk got extra attention and are ready now for the final basecoat application. By the way, the gray product you see is 285-21 primer.

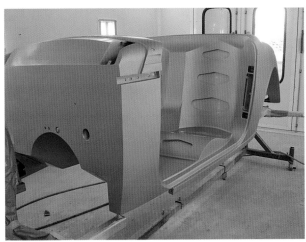

After the final application of 90 Line basecoat, the shell is now ready for 923-200 clearcoat.

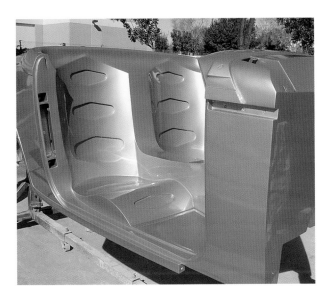

The first look at the finished paintwork in the sun.

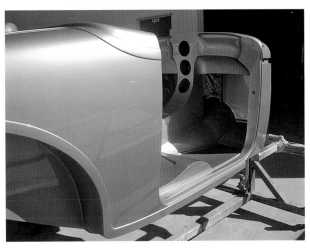

This finish is straight out of the booth; no color sand and buff work was done yet.

each other. That will give you the peace of mind that every container contains the exact same color.

Running into color match problems during a "parts off the car" application is more likely with solvent-borne basecoats than it is with water. Waterborne basecoats like 90 Line or Onyx HD are not as affected by changes in spraying techniques or environment. Most of the color match and metal control is achieved during the actual drying process of the waterborne coating. Please don't misunderstand me: spray style, techniques and gun settings have an impact on your color match. The impact is just not as big as it would be in solvent based basecoats.

There were many more loads of parts to paint. Using the same batch of paint and spraying everything the same way ensured that there were no color differences.

Next in line is the frame. Painting a frame looks easier than it is. Not missing anything or leaving a dry spot in the clear requires a lot of attention to details.

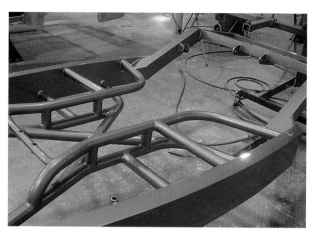

Looking at this section clearly illustrates the level of difficulty involved with painting a frame. Getting a texture free clearcoat finish without a run is not easy to do. After all, you don't want to buff the frame more than absolutely necessary.

You have done well, if all your bolts still fit. Anticipating the paint film thickness is part of the job.

PAINTING THE ENGINE AND TRANSMISSION

Engines play a big role in almost every show car project. Naturally performance is the controlling factor on engine modifications, but it is closely followed by visual upgrades. Painting the engine and transmission is a powerful enhancement to any show car project. It takes the whole quality level of your car up a couple of notches. As always, there are no quick fixes or shortcuts either. Attempting a run at the Ridler award can mean that you may do things a bit differently. As a rule of thumb, the paint film on an engine that is built to run should be kept as thin as possible. Engine heat can have a negative impact on the paint

finish, particularly if the film is too thick. Expect some burn off around the cylinder heads where the headers are attached. The heat is just a bit too intense at that junction. For the most part, automotive paint holds up pretty well on an engine. The way the engine looks, painted with automotive paint rather then the typical heat resistant rattle can paint, is absolutely worth the small risk of minor heat related paint damage. On a top-notch competition show car like the "Undisputed," looks are more important than the worries over film thickness. Worst-case scenario, when you are done traveling the circuit with your car and you finally decided to drive the thing around, you may have to fix a spot here and there. After all, owning a show car is like owning a house, you keep working on them.

Even a brand spanking new engine and transmission is not clean enough for paint. Clean the parts multiple times. Use a fresh paper towel as often as possible. As soon as you are convinced that nothing is left on the surfaces, clean it one more time. The price you have to pay if you didn't remove all the grease and oil is steep. Can you imagine the mess it makes if you have to strip down the paint? It is Murphy's Law that the paint will come off only in areas that are the hardest to get to and the rest remains with just good enough adhesion to be a pain in your you know what if you need to remove it. In comparison, cleaning a few times too many is a small price to pay. Tape off all of the openings to prevent any foreign material from entering the engine. Looking good but seized up is not very appealing either. Good quality tape and paper go a long way here.

Here it is, the new engine arrived and it was attached to an engine stand.

The matching tranny, also attached to a stand for better access.

The oil pan is not very show car like and will be overhauled.

The engine surface is smoothed out as much as possible. A Dremel tool is a good choice for the task.

The transmission oil pan is body worked and ready for some primer.

The engine's oil pan was sanded and body worked to remove as much texture as possible.

The transmission got a 360° makeover as well. You can see how much detail work goes into one of these cars. Nobody will ever be able to see the upper portion of the transmission when it is installed. Regardless, every surface is treated the same way, just like it was the most important surface on the car.

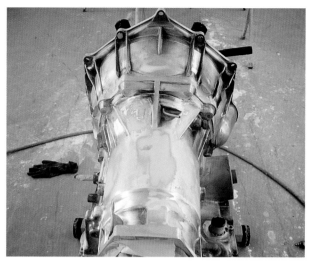

It may not look like much, but the amount of work that went into these parts is amazing.

To get the uncompromised look required for a show car of the highest level, you can apply polyester spray filler to all engine and transmission parts. This is the ideal method for "display only" model cars. If you are planning to paint your engine and don't plan to tow your vehicle around, stay away from this procedure. The coating's overall film build will be greatly increased and the usability as well as durability for a weekend cruiser would be compromised. I am not only worried about the paint here; heat buildup inside the components or a diminished heat transfer from the engine and transmission walls can be a factor on longer runs too. Stay with a couple of coats of epoxy or urethane primers for engines that get used. My favorite scenario is one coat of epoxy sealer, followed by two good coats of 285-21 primer. Depending on the color you have chosen for your engine, you may also benefit from either 285-10 or 285-20. These are direct-to-metal primers. They are white and black in color. Being able to use a white primer on an engine that will be painted in a white pearl color, for example, is the perfect crime. In reverse, priming the engine black makes for a great foundation for a dark blue candy. Both products can be mixed with each other to achieve any shade of gray you may desire.

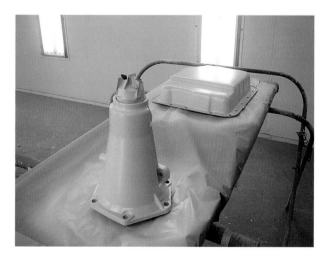

Several coats of 285-21 primer are applied to give Alan a chance to perfect all surfaces on the drive train.

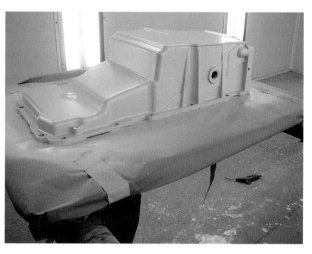

You can still see all the waves, dimples and imperfections after several coats of primer. A clear sign that high fill rates are needed for perfection.

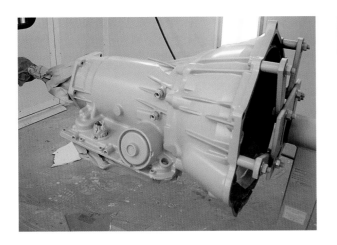

The transmission turned out really nice after just a couple coats of primer.

The cylinder heads are molded onto the engine. Giving the engine a billet look.

In this picture, the engine is turned upside down. Spark plugs have been broken off and installed to protect the cylinder heads. Breaking off the ceramic portion of the spark plug gives you improved access during the paint application.

Tape off any critical area or opening before you apply body filler or primer. Pay extra attention to any mounting surfaces.

It is quite a drastic change from its original condition. Sanding all of those nooks and crannies is work you wish you could pass on to others. No really, it is that exciting!

Try not to get too carried away spraying primer. Having to sand out a primer run around the bolts or any other hard-to-reach spot is no fun.

After you've sanded through the skin of every one of your fingertips, the engine is finally re-masked and ready for paint.

Even the transmission's oil pan is now nice and straight. A light coat of corrosion protection and this piece is good to go.

No stone remains unturned—the valve covers and oil pan are equally well prepped. The valve covers are very critical; they are easy to see all the time.

There are not a lot of engines out there looking like this. This is a good example of what show car painting is all about.

Ready to unmask and bolt on the chrome parts. . . . Looking at this, when it's all done, you would never believe how much time is invested in this finish.

It is hard to imagine that there is anybody out there who wouldn't like this look. Granted, somebody may not like the color choice, I buy that, but the overall finish? Stupendous (my favorite Calvin and Hobbes expression) comes to my mind.

Who wants to be the guy who has to change the oil? One slip up with your wrench and you potentially owe your customer a thousand bucks. There is only one way to go, top-notch on everything for this car.

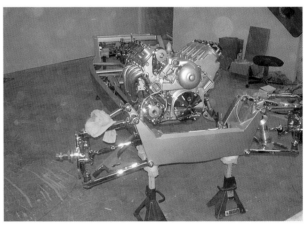

One other part that gets the royal treatment is the gas tank. It is completely irrelevant if you can or cannot see its surfaces; they are all body-filled and ready for some primer.

Above, and below left and right: It sure is a pretty sight when everything comes together. It doesn't take an expert to see that this is something special.

If you are more into the OEM looking engine compartment, this is a good example of that style of engine painting. Not as labor intensive and not as impressive as the engine on the '32, but still light-years ahead of what left the factory.

Not everybody needs or wants to put that much effort into an engine. Painting an engine in a more traditional way is still the most exercised option today. Clearly, this option will not excite a show car judge at Detroit, Pebble or Pomona enough to give you a best in show award, but it may just do on a more local level.

You still need to clean the snot out of the engine and yes the Dremel tool will be your best bet. Priming and sanding remains the course of action, but what is nice about OEM-style engine painting is that almost everything you do looks better than the original engine did.

Not painting the engine at all can be a great option for an all aluminum engine block. Clean it up and polish every inch of it for a really cool look. Either way, you cannot produce a spectacular looking show car without paying great attention to the engine one way or the other.

The final result after all the work you have invested is spectacular to say the least. Alan and his crew have all the right in the world to be proud of what they have accomplished. My guess is that less than ten cars a year are built nationwide to this quality. What's even more amazing to me is that Alan didn't hesitate for a second to say yes, when I asked him if he would be ready or would like to build another car that could compete in Detroit. Many people feel a bit burned out for a year or so after going through all the trouble of building a compromise-free vehicle. More power to him!

The finished interior is spectacular. The seats are more comfortable than you may think, but they sure are not forgiving if you carry hard or sharp objects in your pants pockets. No key rings please! This is show car styling all the way. Looks will supersede practicality every day of the week.

Left: No stone remained unturned; the trunk is equally impressive as the outside.

Below left: Every time I look at this photograph I understand why somebody would build a car like this '32 and never take it on the road. Parking this work of art in my living room, on top of a mirrored floor, would make me very happy for the rest of my life.

Below right: No clutter or spaghetti wiring in the engine compartment will impress show car fans. Custom crafted "Undisputed" name plates are a tasteful addition to the engine covers and it completes a spectacular design concept.

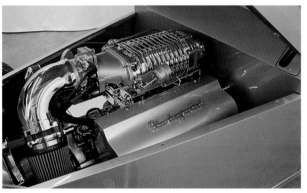

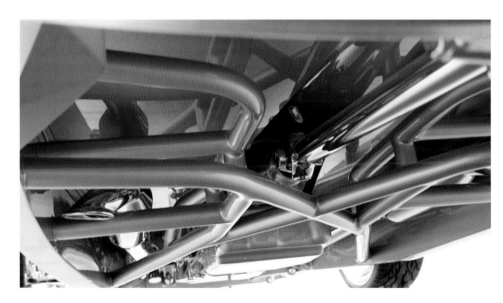

Left: If you feel you could produce a car like this, the Detroit AutoRama is just the place for you. If you could come close to it, I tip my hat to you. You would be in a very special league.

Not very practical, but unique and beautiful. Trying to keep everything pristine while you take the vehicle around the show car circuit is a job by itself. Bragging rights are sweeeeeeet!

Above: Take a close look at this picture; it is a perfect example of a point I made earlier about colors. This vehicle would be spectacular in almost any imaginable color and graphics would not improve this car's statement in a dramatic way.

Right: Nice! The paint finish is flawless—absolutely texture free and as glossy as humanly possible. Having such large, relatively flat panels would make the smallest imperfection stick out like a sore thumb. There is no question about the fact that the devil is in the detail.

CHAPTER 11
DETAILING YOUR PAINTWORK

DETAIL YOUR NEW PAINT

In a perfect world, every paint job turns out flawless and requires no further work. In reality though, the perfect world is hard to come by. In my 26 plus years of painting, so far, I met the perfect paintwork maybe a dozen times. This is not to say that some of the work wouldn't be perfectly acceptable in the collision repair world, but not in the show car environment. You want a mirror like texture and imperfection free, highly glossy finish without any signs of shrinkage or prep related sand scratches. Every single one of these criteria is hard to achieve by itself; combine all of them into one single paint job and you have your homework cut out for you.

Luckily for all of us, most paint related issues could be corrected with some fine sandpaper, a buffer and a quality buffing compound. Just like everything you do to a show car, it is all about making the right choices combined with the proper techniques. The many detail product options today appear endless and I wouldn't be surprised if at least one new product hits the market almost every month. A great number of companies compete in this market segment and I am the first one to admit that I am not able to try or evaluate every single one of them. I am sure that most products will work fine, if used as intended by the manufacturer. For me personally, there are three major manufacturers that come instantly to my mind when nothing but perfection is required. Meguiar's, Mothers and 3M are the most prominent products in my market area. When it comes to buffing compounds, I have only Mothers and 3M in my personal garage. For the record, Meguiar's compounds were not left out due to their product's performance—I have never tried them; I rely on the other two simply due to my familiarity with them and the repeated success I have enjoyed over many years with Mothers and 3M. If it isn't broken and your projects are exactly as you like and expect them to be, you have the tendency to not mess with it. But remember, you have choices—educate yourself and make your own pick.

When it comes to quality buffing compounds, I have learned that one particular attribute is the most important feature of all—the absence of filling materials. There are a

This picture shows you one of the worst-case scenarios you could find in show car painting. Metal flakes like this "Roth Flake" are very intriguing to look at, but due to the amount of clearcoat required to smooth the surface, shrinkage and very long cure-through times are an issue.

number of compounds on the market that contain filling materials and they will make your buffing job look like a million bucks in no time. The problem with products like this is that rather than fully removing your sand scratches, they fill in part of the scratch, making the surface appear as if you completely removed your scratches. But eventually the filler will wash off, exposing sand and swirl marks all over again. Unfortunately, there is no easy way for you to tell by simply looking at the bottle if a product contains those filling materials or not. Trial and error is the only way to find out, unless you are chemically inclined of course—then you may be able to tell by looking for those ingredients on the MSDS (Material Safety Data Sheets). The bottom line with buffing compounds is rather simple—they need to remove the scratches completely and not fill them in.

By the way, most manufacturers have MSDS available on their web sites for public viewing. If you ever wondered what a material is made out of, or you like to learn about their dangers and proper cleanup after a spill, MSDS will give you all the answers you are looking for. Go and check it out one day; you'll be surprised to learn how dangerous some of your most common products in the garage really

If you cured the coating long enough, there would be no reason for the paint finish to shrink or do any other weird thing later.

An array of buffing pads is required to handle any possible situation you may run into. Buffing pads come in all kinds of materials and sizes; sooner or later you are going to need them all.

are. As a parent, having that information handy—and I mean printed out in a binder for super fast access, is critical. MSDS give first aid instructions in case of an accident. I still remember being a kid and all the troubles I managed to get myself into while playing in the garage (and of course I made sure my parents didn't know I was doing that; no fun in that). Having MSDS handy could turn out to be a life saving exercise.

Well, compound is only one part of the equation in quality buffing. Besides the compound, the choice of buffing pads is important too. The choices range from traditional wool pads to numerous foam and waffle pads. It is the combination of both products that make or break a buffing job. Last but not least, the techniques you use and the sandpaper choices you make prior to the buffing procedure determine the pad and compound's ability to do their job correctly. Over the years, more attempts to buff a surface correctly have failed due to sandpaper and sanding procedure issues rather than compound or pad related reasons.

A successful buffing job depends on a number of criteria. Besides proper compounds and equipment, the paint itself is of great importance. Trying to buff fresh paint too early can create problems that are irreparable and would require repainting. Your paintwork should be thoroughly cured for several days before you attempt to buff it. If the clearcoat is still soft, it may buff really easy, but the problem is that the surface is still curing and solvents continue to evaporate. Until most of the cure is completed, the final surface appearance/texture may not be in place yet. As result of sanding and buffing too early, you may find yourself having to redo all of your work for a second time a month or so later. Having to sand and buff a surface twice exposes

you to the potential risk of burning through the clearcoat surface the second time around, requiring you to paint parts if not the whole car all over again.

Another serious risk you run into buffing very early is that you may overheat the still sensitive clearcoat film. The buffing pad can generate quite some heat due to the friction between the pad and the paint surface. Overheating the clearcoat can permanently damage the finish. If that happens, you most likely experience a dullness to the surface of your clear that won't go away, regardless of what you do to it. Re-sanding, more buffing, wax, it wouldn't matter. Again, repainting is the only recourse you have at that point. As a rule of thumb, the thicker the coating, the longer you should wait before you buff the car. I like to give it a minimum of one day of cure at about 72°F for each two coats of clear applied. The longer you wait the harder it may be to buff the paint, but the better the long-term results.

If your show car is painted in an old school metal flake finish for example—one that historically requires several gallons of clear not quarts—letting the vehicle sit for a month or more may be required for true perfection. In situations like the flake jobs, cure times may benefit from opening up the clearcoat surface by sanding it. The coarser the sanding grit, the faster the solvent evaporation and the hardening of the paint surface. Don't overdo it though; at the end, you have to be able to remove those aggressive sanding scratches without removing too much clear. If you don't have enough clearcoat left on the surface for the needed UV protection, the overall paint finish may fail.

The more traditional paintwork requires a little less wait time compared to the flake or heavy graphics paintwork.

Don't expect instant results. Buffing is a slow and controlled process that has to be done right. Move your pad around to avoid overheating the paint surface. Remove all buffing residue on the surface prior to applying more compound. Keeping it clean pays off.

For the most part, buffing is best done with a lower RPM setting. RPMs equal heat and heat is not always helpful.

Micro fiber towels are an essential part of the buffing operation today. As long as they are clean, those towels will not scratch your paint. In the event that the towel comes with a tag on it, please remove it. Tags are normally not made out of micro fibers themselves and they can scratch your paint. Micro fiber towels are the ideal product to remove any buffing residue.

Most single or dual color show cars receive anywhere from four to six coats of clear. Hopefully you opt for double dipping the clearcoat (that is, applying it in two different sessions separated by a curing period) for a truly spectacular finish. If you do, you could have up to eight or nine coats of clear on your car by the time it's done. This gives you ample opportunity to create that mirror like finish your car deserves. Please let your car sit for at least four days prior to the first sanding operation. If you don't have the time available to let the car sit that long, you could repeatedly bake the vehicle to speed up the cure time. A 45-minute bake cycle at 140°F surface temperature followed by a complete cool down of the vehicle's surfaces is about a

day's worth of wait. Don't underestimate the value of the cool down portion of this procedure; baking your vehicle for three hours straight wouldn't be as effective.

The first and most important step in creating that perfect look is the correct sanding procedure. You will be required to block sand the complete vehicle several times, stepping it up to finer sandpaper grits each time. My recommendation for the first cut on a double dipped car is P600–P500 if you really know what you're doing (experts only please)! P800 is my starting recommendation if you didn't double dip the car. Sanding is ideally done with a small balsawood block that has rounded off edges. Larger blocks have a tendency to create gouges or sanding lines. Block sand all of the surfaces completely flat while staying off the edges as much as possible. Paint doesn't build up on sharp edges as much as it does on flat surfaces and burning through the paint on edges is easier done than you think. Reducing sanding and buffing in these areas to the bare minimum required is key.

For the most perfect results, sand only one grit-size per day. This allows for additional solvent evaporation and cure time between cuts. I perfectly understand that I ask you to turn this into a very long and time-consuming process—but believe me, when you are done, it's well worth it. There are machine-sanding recommendations for the color-sand and buff operation out there and for most collision repair and commercial paintwork they are great. For true show car perfection, particularly if you plan on playing in Ridler Award territory or in the Concourse world, nothing has come close to hand sanding yet. After you've finished the first cut, you may benefit from applying powdered guide coat between sandings with the different grits; it will help

A small balsawood block should be used to sand most of the car's surfaces. Larger blocks have potentially unwanted side effects and may work against you. Lightly rounded edges are very helpful.

you to avoid any accidental leftover scratches from the previous day. Take your sanding grits from P600 through P800, P1000, P1500, P2000 and finally P2500. I spoke to other experts in the industry and some believe in taking it all the way to P3000, which I personally have never done. Make sure you supply clean water via pump bottle. Any contamination in your sanding water could have negative effects on your ability to get the desired finish.

After you finish block sanding the clearcoat, it is time to start buffing. Trust me when I say that there are probably a million different opinions out there on how to buff your car. Most are likely to work in one way or another. Some people still use wool pads; others solely believe in foam pads. Some believe in a single compound solution and others use multiple compounds to get where they want to go. Depending on your final choice of manufacturer and compound, I highly recommend that you follow the manufacturer's instruction very closely. But a word of caution is in order: most manufacturers' instructions are only based on normal (industry standard) two-to-three coat paint applications. You may have to use some common sense and alter the instructions a bit to fit your situation. Manufacturers can't possibly predict what you may have done to your show car paint project. This is a situation where you can benefit from the experience of manufacturers like Mothers or Meguiar's, who have made themselves at home in the custom car world. They are more likely to have been there and done it before.

My personal preference for everyday buffing requirements is 3M's Perfect-It III compound. It is a quick and easy to use product that will please most consumer expectations. The 3M system works great with a combination of different foam pads. The 3M compound is engineered to be sufficient without the use of a wool pad, but some stuck-in-the-past craftsmen still use it anyway. It works! When it comes to going all out and getting the full show car finish though, my choice has been Mothers over the last several years. This company's whole existence centers around the detailing requirements of the car hobbyist and the show car world. Over the years I learned that shine is what they do for a living and I could only benefit from their expertise. When it comes to using the current Mothers buffing compound lineup, I like a combination of wool pads followed by foam pads. An additional personal preference is to use a little bit of water-spray during the first step of the buffing operation. This step incorporates the use of the cutting compound and the wool pad. A small amount of deionized water (free of minerals) helps the surface to stay cooler and keeps the compound from drying up under the pad. This technique is probably as old school as it comes, but it still works well today.

Have you ever been in a situation where you worked with something for years, but you never realized how great it was until you accidentally change it? To me that was the case with small packaging sizes. As a paint rep, I frequently receive product samples to try and those samples are routinely packaged in small bottles. It wasn't until I had to use the original packaging size one day that I realized just how great and convenient those small containers really are. From now on, I will repackage my compounds into smaller containers whenever practical before I start a buffing job. My favorite packaging size allows me to store the compound in my shirt pockets rather then setting it on or close to the car. As a result, I don't have to look for it anymore, it is always with me in the same spot until the job is done—plus I don't set the container on top of the car's painted surfaces anymore. Granted, everybody knows that you are not supposed to set the container on top of a freshly painted surface—but somehow, someway, that darn bottle of compound always finds its way right where it doesn't belong. Bad habits are hard to break. An additional problem I found with large containers is an increased risk of drying up at the lid, clogging up the bottle's small hole. Forcing the compound out of the bottle the next time you use it can loosen up dried compound. A small dried-up piece of compound can scratch your paint, even damaging it, if you get it between the surface and the buffing wheel.

Let's talk about a major mistake many people make when it comes to the detail work after paint. It is a standard procedure for many to apply a coat of wax to the car when the buffing procedure is completed. Waxing a new paint

My favorite workhorse for everyday buffing needs. If you follow 3M's instructions, you will not be disappointed with the look.

For my top of the line stuff, Mothers is what I come back to all the time. It just works for me.

finish is dangerous if you do it too soon. Most paint manufacturers don't want you to wax your new paint finish for at least 90 days. Keep in mind that this recommendation is based on a normal paint finish, not a show car finish with thicker than average layers of paint. To be safe and not compromise all of your invested money, time and efforts, I strongly recommend that you do not wax your show car for about a year. Waxing the paint finish too soon can cap off and trap solvent traces in your paint. Those trapped solvent traces can permanently damage your paint over time. Wax free show shine products like Mothers Showtime or Meguiar's Final Inspection are fine and you don't have to worry about them, but every product that claims to seal the paint could be a potential problem.

There is another new trend in the show car world that fits into the same category as wax. "Clear bras" (a clear

I like to repackage my compounds into small containers, allowing me to put them in my pockets rather than setting them down on the car's surface. It also prevents the top of the larger container from drying up too fast.

A mirror like reflection is the goal for the perfect show car finish. Removing every bit of sanding scratches and swirl marks is paramount.

It is a little hard to see, but a clear bra protects the leading edge of the fender. The fact that they are relatively stealthy makes them appealing to car owners.

The California Duster comes in multiple sizes. This is a smaller version designed for the dash. Larger versions are ideal for a quick daily removal of dust from the paint surface.

The fibers of the California Duster are chemically treated to hold onto the dust you removed from the surface. Strangely enough, the dirtier they get, the better they seem to work, but there is a time to clean them of course. Too much debris inside the fabric can also scratch your paint.

plastic protection film that adheres to the paint surface) are a choice for a lot of show car owners who routinely drive their car from show to show. Those bras are commonly installed on the leading edges of the hood, fenders and bumpers. They are relatively stealthy and give you good stone chip protection if applied by an expert. Just like with wax, those plastic films can potentially trap solvents that are still lingering around in your paint finish. Small blisters as well as a loss of clearcoat adhesion are side effects I have noticed if not enough time has passed.

Speaking of bras, I hope that nobody is considering one of those black strap-on plastic bras for your show car. They are a surefire quick way to damage your paint. Regardless of how careful you are, sand, chemical fallout and other debris will find their way between the bra and the paint. The constant vibration of the car while operating creates that perfect sanding action between your supposedly protective surface and your paint. Moisture is another problem with strap-on bras. It may take days or weeks for moisture to dry up behind that bra and we all know what kind of damage water can do if left alone and it is allowed to remain in place just long enough. It is spelled R-U-S-T.

Please be gentle to your new paint job for a while. The paint's adhesion as well as its chemical and impact resistance improve over time. In the early stages of the paint's cure (a day or two), chemicals like cleaners, antifreeze and gasoline could, under certain circumstances, hurt the paint. Brake fluid on the other hand can potentially damage the paint at anytime, if not removed and neutralized as quickly as possible. The same is true for battery acid.

MAINTAIN YOUR PAINT FOR YEARS TO COME

Washing your car is something you are likely to do often and a bit of common sense goes a long way. Rinse off as much dust and dirt with a strong stream of water from the garden hose prior to scrubbing the surface with a sponge or carwash mitt. Pressure washers should be used with the appropriate respect. Too much pressure and not enough distance from the surface may damage your paint. Any debris that still remains on the surface of the car when you start to wash it mechanically has a potential to scratch the paint. Wash the car from the top down, taking full advantage of the dirt softening and cleaning power of the soapy water run-off. Most dirt is found on the lower portion of the car

Clay bars can come in different grades. Some are made for light colors others are for dark and they may be more or less aggressive. Some manufacturers make one type for every color. In general, they are individually wrapped to keep them clean and prevent them from drying out.

This Mothers Microfiber Towel has a highly absorbing foam center and it will not scratch your paint if used correctly. If you are used to using a chamois, the microfiber towel may take a bit of getting used to at first. This towel option is most important if your paint is a dark color.

and you don't want to pick it up with your sponge or mitt and spread it around over your roof and hood. Swirl marks are quickly noticed on your paint surface if you don't pay attention. The daily use of a "California Car Duster" can help you to stay ahead of too much debris buildup on your car. Please maintain your duster in a good clean condition to prevent unintended damage to your paint!

One side effect of taking your show car to a lot of open-air car show events is the possibility of a build up of chemical fallout on your paint's surface—well at least that is the fact in major metropolitan areas like Los Angeles, Phoenix, Miami or New York. Chemical fallout is the common term for airborne particles that settle and attach themselves to the paint's surfaces. If left alone, those particles can oxidize on the paint's surface and greatly reduce the gloss level and the appeal of your car. Chemical fallout is easy to detect. Simply run your hands over the freshly washed horizontal surfaces of your car. If it feels rough or your skin doesn't smoothly glide over the painted surfaces, you have chemical fallout on your car. Thankfully, the detail industry is ready to help you with this problem.

Synthetically engineered clay bars are a great and gentle way to remove chemical fallout from the paint surface. Clay bars are used in conjunction with special lubricants and the risk of any real paint damage is little as long as you follow the instructions. How does clay work? In simple terms, it's called dragging traction. It is the same dragging traction you would encounter when drying your vehicle with a chamois. By the way, I don't necessarily recommend using chamois for drying. The chamois can develop large amounts of friction when you pull it across your paint surface. Combine that with little nap found on a chamois

The surface difference between a microfiber towel and a traditional chamois can make all the difference in the world. The traditional chamois has no nap and particles left on the car after a wash have no place to go.

and particles not washed off have a higher chance of being rubbed directly onto the paint and causing scratches and swirl marks. Micro fiber towels are a much better choice to dry your car nowadays.

The same dragging traction I don't care for in chamois is what makes the clay bar so effective in a positive way. Washing first is key though; otherwise the bar will choke on all the dirt and probably scratch the paint finish. When lightly rubbed with little pressure, the clay bar will pick up embedded particles in your paint that would otherwise remain after washing. Clay bars pull out and shear off embedded particles and surface-born contaminants with a safe and effective lubricated mechanical action. For this to work properly, the clay bar must be sliding on a film of lu-

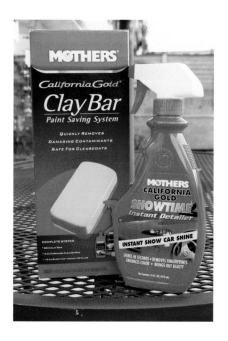

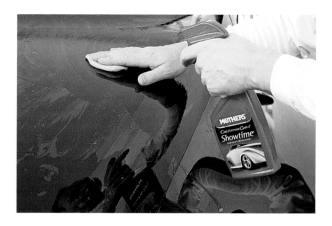

Mothers Clay System uses Showtime Instant Detailer as the lubricant. Any residue that stays on the surface can easily and safely be removed with a micro fiber towel.

After a thorough wash, slide the clay bar over a film of lubricant. Don't use much pressure while claying. You can hear and feel the changes as the surface condition improves. Avoid dragging the clay over dry surfaces as this may harm your paint. Make sure that your surface is cool and don't attempt this operation in the sun.

After you clean a small section of your car, knead the clay well to expose a new clean working surface before you move on to the next area.

After you finish claying your vehicle, remove any swirl marks and minor scratches prior to waxing the car. A random orbital buffer is a good choice for the task.

Removing swirl marks is relatively easy this way. Again, work around your car in sections and clean the surface with a microfiber towel prior to moving on.

After you have finished polishing the surface, repeat the same process with the wax, using a fresh foam pad of course.

bricant. While using a clay bar, knead it regularly to expose a fresh working surface (the more you knead, the better off you are). All right, here is something nobody wants to hear: if you drop the clay bar throw it away. Because things happen and you could easily drop your clay if the situation is right (remember you have slippery lubricants involved), I recommend that you don't use all of it at once. Splitting the bar in half or even thirds is a good idea.

There are a couple things you need to know about clay. Clay will remove the wax from your vehicle's paint surface. Consequently you have to be prepared to reapply wax or sealer to the entire clay-barred portion of your paint. Consider the brand of clay you use—some are very hard and aggressive. I have been very successful with Mothers California Gold Clay Bars as well as with Meguiar's C2000 Mild Detailing Clay; they are more malleable and not as stiff as other clays. When it comes to reapplying wax, as always, you have choices. Carnauba Wax is a frequent favorite amongst car enthusiasts. Carnauba dries to a nice and hard surface and it is a good choice for applications by hand, but technology hasn't stopped here either. Mothers Power Wax or Meguiar's NTX TechWax are more liquid in consistency and are great if used with a random orbital buffer. Call me new fashioned if you will, but I am too lazy to wax my car by hand. Some guys enjoy tinkering around their car for hours; I prefer driving it.

SPOT REPAIRING PAINTWORK
Paintless Dent Repair
Here is something you may not expect to hear from a paint rep. Should you find yourself in a situation with minor damage to your show car, try paintless dent repair as your first option. Granted, not every type of damage is suitable for this repair technique, but if it is, it is by far the most preferred method to restore your show car's appearance. Why? Paintless dent repair eliminates the need for flawless color match and saves you from a lot of sometimes-unnecessary work. Every time you start painting individual portions of your car, perfect color match or ample room to blend-out your color is required for an undetectable or invisible repair. In general, painting makes the affected area bigger than it has to be.

Paintless dent repair is something best left to highly trained experts. The technique basically works by putting pressure on the bottom of a dent with specialized tools, while controlling the upper surface at the same time with soft hammers and other unique tools. Reflection tools are attached to the car to help the technician to read the surface conditions during the process. The technician needs

Damage does happen! No matter how careful you are it is likely you will have to fix your dream at one point. Following the proper steps may help you to avoid the big one—headache that is.

to be able to get access to the inner panel for this to work. Most dents are not really small and most have some kind of crease or a sharp point that stiffens the surface area (if you see any signs of cracking in the paint, stop right here; you will need to paint your repair). The crease is making the metal surface resistant to pressure. A ton of experience is needed to fix these types of dents without painting. With a hard edge present in your dent, it is very easy to cause poke marks if you use the wrong tools or techniques.

"If the moon and the stars align just right," or you simply hire a qualified pro, your baby may be as good as new in about an hour. Oh, did I tell you that many paintless dent repair people would actually come to you, rather than you driving all over town to get to them. Convenience is everything

Spot Repairing Your Show Car
Unfortunately things do go wrong and you could find yourself faced with necessary repairs to your show car's paintwork. Repairing the paint on a show car that was painted by you or under your supervision is one thing; repairing the paintwork of a show car you purchased as is, is a completely different story. Repainting parts of your own paintwork is easy because you know exactly what was used on your car. You know every product and the procedures that made your car. Based on the severity of the damage, creating the appropriate plan of action is simple. You basically redo any necessary steps and processes you went through making this car the first time around, just in a very small area, minus the stripping of course and some other operations you won't need to go through.

But if the paintwork isn't yours and you don't have all the critical information on what was used on the vehicle, the ball game entirely changes. There is great potential for all sorts of problems if you are not aware of what types of products have been used. The age of the paintwork and the state in which the car was painted can have a big impact in your ability to properly repair the paintwork on a purchased-as-is show car. Let me explain that a bit. The age and the state in which the car was painted are good indicators of the quality or paint technology used on the vehicle.

Let's compare Texas with California as an example. As a direct result of long time environmental pressures in California, paint technology and its quality have significantly improved in this state over more than a decade. Texas on the other hand didn't really have much of a regulation to speak of and technology improvements were almost at a standstill. Prior to the introduction a few years back of what is called the "National Rule," a basic regulation on VOC compliancy for all of the US that is not otherwise governed by stricter local regulations, Texas was still able to use lacquer products. Lacquer primers are notorious troublemakers and are the number one cause of premature paint failure on a show car. Even though I understand that nobody enjoys change, I never could figure out why so many people in the show car world would voluntarily continue to use inferior products on their projects when cutting edge technology was readily available to them. Investing so much time in a show car and not opting for the best available technology seems short sighted. Yes, lacquer primers are easy to use; yes, they sand like butter; yes, they are cheap to purchase—and no, they are not worth your money or time. The sad truth is that there are plenty of show cars out there today (I call them ticking time bombs) that are not up to par with cars built in highly regulated areas. Regulating VOC was not a welcome occurrence in the paint industry at first, but the end result speaks for itself—much better product quality. When it comes to repairing a show car whose paint job you are unsure about, there are a few things you can do to make an educated guess on the best approach.

It is a good idea to start by finding out how many paint jobs are already on the car. A normal factory finish measures at an average of 4–5 mil, while a show car that was stripped and completely redone is more likely in the neighborhood of 9–12 mil. In the event that you measure a thickness above 15 mil, I would strongly recommend that you sand through the paint layers to see if you have more than one paint finish on the surface. The chances

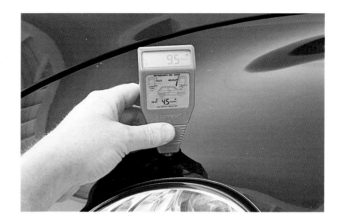

One of the first steps is to measure the thickness of the paint film. OEM paint thickness is about 4 to 5 mil; show cars measure higher film thickness. An Elcometer reveals that this paint film is 9.5 mil, typical for a show car finish that was done from the ground up. Coatings in excess of 15 mil could be problematic unless most of it is body filler.

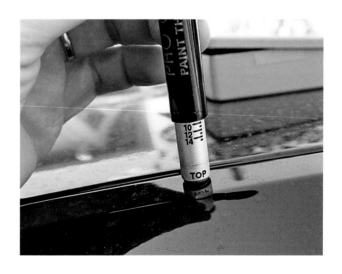

The Pro Gauge II is a magnetic, less expensive, but less accurate way to measure the thickness of your paint. Is it sufficient? Yes, but not nearly as much fun.

for problems increase each time the car is painted. Please keep in mind that you may measure on top of a thick layer of body filler. Always check four or five different spots on the panel for better accuracy. To measure the paint thickness, you have two options—an electronic devise like the Elcometer or a magnetic devise like the Pro Gauge II. The Elcometer is more precise and easier to use, but it also has a price tag that makes it less desirable for most people. My Elcometer was in the neighborhood of $600 and unless you deal with vintage and show cars all the time, the expense may be hard to justify. The less costly Pro Gauge

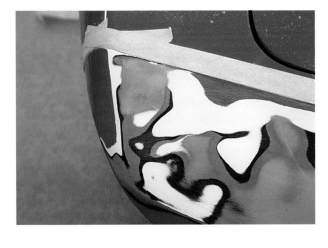

UR50 is one of those all-time great solvents, aggressive enough to do the job without being destructive on the other hand. This solvent has never let me down when testing the integrity of a questionable coating.

After exposing all layers of the coating, you are ready for the solvent test. This picture shows the ideal feather edging condition for a solvent test, but be aware of your substrate please; polyurethane bumpers like the one on this Corvette may not tolerate long-term exposure to some strong solvents. Common sense goes a long way. If the substrate is solvent sensitive, treat the entire repair as if it is questionable.

II on the other hand can be found in a more affordable $60–80 range. I personally prefer the Elcometer of course. I like precision. My guess is that most of us in the show car world like precision; otherwise we wouldn't be playing in this arena. So spoil yourself and get one.

The next step in evaluating a paint job you are unfamiliar with is a solvent test. The solvent test will show you if any layer of the paint job wasn't catalyzed, or is lacquer based. To get the most out of this test, you need to sand through all of the layers of the paint finish down to the body filler or substrate if no body filler is present. Feather edge the paint layers nicely, exposing as much of each paint layer's surface as possible without artificially increasing the size of the repair, of course. Now place a solvent soaked white paper towel on top of the exposed paint layers and wait about ten minutes. Make sure the towel is not drying up though. After ten minutes, start rubbing the towel with moderate pressure over the exposed paint layer edges. If you have paint transfer to the towel, you have a problematic coating on your hands. For best results use a quality solvent. Some solvents are not aggressive enough to expose potential problem layers. My all time favorite solvent is UR50. It is a very clean solvent that will tell you the truth every single time.

If the solvent test reveals a problematic paint finish, you have some choices to make. Obviously stripping the car down and redoing it completely, just because you have minor damage, is out of the question, but ignoring the fact is

equally bad. Solvent sensitive paint finishes can give you a run for your money when you try to repair them. Lifting and wrinkling during the repair process as well as other post repair problems like repair mapping and shrinkage are common side effects associated with those situations. Hopefully, the sensitive portion of the paint finish is in the undercoat section where most of them are commonly found. (Please keep in mind that even modern basecoat colors that are not catalyzed will transfer some color to your test towel, but they don't constitute a real problem.)

Solvent sensitive clearcoats or single stage finishes are nearly impossible to spot repair with paint products legally available in the US today. That situation may call for a trip to Mexico, where the required products are still in use. When dealing with questionable paintwork, some basic steps can help you to minimize potential paint problems. Never apply polyester body fillers on top of solvent sensitive coatings. The fact that it is solvent sensitive is a sign of poor or no catalyzation. This makes that product layer the weak link and not suitable for body filler. They are not suitable for a two-component solvent-based primer surfacer either.

Remove all of the paint from the area you need to apply body filler to first. After you straighten the surface and feather edge the paint, I would recommend a high-quality water-based primer. Water based primers will build a neutralizing bridge over the questionable coating without the risk of wrinkling, swelling or lifting. But the empha-

This is what you hope to see! If nothing but a trace of sanding residue is found on the paper towel after you soaked the paint for ten minutes in solvent and then rubbed the surface repeatedly, it is safe to assume that you can work on top of the paint you have.

Glasurit 76-71 is a ready-to-spray waterborne primer surfacer that is ideal for repairing solvent sensitive coatings. It is a direct-to-metal product that doesn't require any additional corrosion protection. Used correctly, this product can save you a lot of headaches.

Running the wool pad over your paint finish is quick and easy and it will show you without any damage to the paint if you are working with a single stage coating or a basecoat clearcoat finish.

sis is on high-quality primer. The waterborne primer you choose has to be an everything-in-one product to be successful. It has to be a direct to metal primer, with excellent corrosion protection, adhesion and fill. Due to the sensitivity issue, solventborne etch or epoxy primers are not suitable in a situation like this. The product that fits the bill better than any other product I know is Glasurit 76-71 primer. It combines all the attributes I am looking for to get me out of trouble. After you block sand the primer, you are safe to paint right over this product, but don't be a fool though—keep your coats light if you paint with solvent based basecoats. You don't want any surprises or

to push your luck. The 76-71 is a ready-to-spray product that comes in a one-liter container. It is not the cheapest primer you have ever purchased, but after several painstaking, unsuccessful attempts to repair questionable substrates with solvent based products, you may find yourself willing to give your first born for this product.

Should you have a solid colored car to work with, you may also want to do a quick buff test as well. The buff test is just like sanding the surface lightly, but without damaging the paint. All you really look for is paint transfer to the pad, indicating the presence of a single stage or a non-clearcoated paint finish. Why is it important to know? Repairing single stage finishes with basecoat clearcoat will be obvious a few years later. Single stage finishes age faster and a clearcoated surface will outlast a single stage coating hands down. This is precisely why you should never try to spot repair a single stage paint job within a panel using clearcoat. Logically it may make sense at first and it would be the easier way to blend (no pigment flotation issues that way), but the final outcome is always the same. It is not a matter of if—it's a matter of when—the repair will become apparent. Traditionally, reds, orange, yellows and whites are the most likely paint finishes you will find in single stage. Increased hiding power is the most likely deciding factor for a painter to choose single stage over base-clear. Even though single stage is less expensive to use, I don't see cost being a deciding factor on any true show car. Paint experts may opt for the additional hiding power of a single stage coating, but they routinely turn around and clearcoat the single stage too, getting the best of both worlds.

FINAL THOUGHTS

There are different ways to reach a superlative auto finish and show-quality painters take slightly different paths, based on their experiences, training, material and tool choices and the circumstances of each particular project. What I have put together here is the best way my friends and I know of today to paint your show car and make it last. Other experts' opinions are likely as valid as mine in their own rights. The bottom line is that the techniques and materials shown in this book will work, and if you follow all aspects correctly you will turn out really nice cars. Naturally, nothing stands still in the automotive aftermarket world. Technology is likely to change over the next years and it pays to stay on top of the product developments. For example, 3M is one of the best manufacturer examples I can come up with in our industry. Their inventive wheels never stop turning and without a doubt, they will have at least one new product on the market that I will wish I could have added to this book by the time it goes into print. Then there are craftsmen like Chris Guinn, Alan Palmer and myself all over the world who are going to continue to improve the ways we do things. Every new show car project is unique in itself and therefore likely to produce at least one improvement, if not a completely new way of achieving certain tasks. The learning never stops.

If you do know of a better way to do things than the guy next door, please further the hobby and the spirit of excellence by sharing with others in this very specialized community. Sharing knowledge elevates all of us and it improves progress that benefits generations to come. Even if we would double the amount of craftsmen in this line of work over the next decade, the future demand for show cars will still be higher than what we can all together handle.

SPECIAL THANKS!

It is obvious that writing a book like this is almost impossible to do without the help of other people. And help is what I received everywhere I turned. The level of information sharing and general support came as an unexpected surprise to me. It is not uncommon for skilled professionals to try to keep their hard learned lessons to themselves. After all, it is people's livelihood and growing competition in the interest of the greater good of this craft is unfortunately not on everybody's mind.

Well, I feel that the first thanks are really due to you, the reader. The fact that you made it to this part of the book and the fact that you are still reading must mean I did all right. Besides you, there are a number of great individuals who truly deserve recognition for their help in turning this book into what it is.

The number one supporter of this book is also the biggest ambassador of the show car painting world I've ever met. Chris Guinn is an exceptionally skilled craftsman who possesses all of those personality traits you hope for in order to be on top of the show car painting profession. Today, he is, as far as I know, the only person to ever win the Ridler Award and Best Paint Award at the Detroit AutoRama in the same event. He also won the AMBR (America's Most Beautiful Roadster) the same year. Chris's greatest gift to this industry is his willingness to share his knowledge with anybody who is truly interested in taking this craft to the next level. I am looking forward to many more mind-blowing projects with you. Thank you for everything and thanks for being such a good friend!

Thank you, Jay Leno. Taking time out of your busy schedule to write the foreword was more than I could have hoped for. Being able to work at the Big Dog Garage for three weeks and painting the EcoJet is an experience I will cherish forever.

The Spade Bros. have been another great supporter to this book. They held up the fort and took some critical pictures when I couldn't be there. Without those, the story in this book would have been harder to tell. Thanks for your hospitality and friendship. Nothing but good times and good memories at the Spade Bros.

Thank you to Alan Palmer! Without your generous contribution, it would have been much more difficult to paint a clear picture about what is really involved in the chase for the Don Ridler Memorial Award. What a great car you have built. I am sure this award will be yours one day; in the meantime, enjoy your AMBR and I am looking

forward to many more creations by Palmer's Custom Paint & Body.

Thank you Jim Holoway. Being able to follow your Chevelle that closely from start to finish made this book.

To my parents, thank you for teaching me good work ethics and allowing me to follow my dreams. I know it must be hard for you to believe that I actually wrote all those words in this book by myself. Yes we are talking about the same son that didn't write a single greeting card or e-mail in the last decade and a half. Sorry!

Thank you Dave Brez. It would have been hard to take some of the photos myself while working on the EcoJet. Thanks for sharing.

Thank you Paul Gonzales, I know I have been in your way a couple of times, but you never complained.

Of course, thank you Stephanie Barakos! If it wasn't for you, I would have never thought about writing this book in the first place.

The most important thanks come last. Thank you to my wife Anette! I know that spending your summer weekends and countless nights by yourself was not your most favorite thing to do. If it wasn't for you taking over most of my tasks and clearing out the schedule, this book could have easily turned into a multi-year deal. Thank you for letting me do what I needed to do and for all of your support. You are a good trooper and partner in crime.

SOURCES

BASF Corporation
Automotive Refinish Group
26701 Telegraph Road
Southfield, MI 48034
www.basfrefinish.com

Guinn Paint
1515 S. Parker
Amarillo, TX 79102
www.guinnpaint.com

Spade Bros.
15831 Chemical Lane
Huntington Beach, CA 92649
Phone: 714-898-2927
www.spadebros.com

Palmer's Custom Paint & Body
1031 Avenida Acaso
Camarillo, CA 93012
Phone: 805-383-4020
palmerscustom@verizon.net

Mothers Inc.
5456 Industrial Drive
Huntington Beach, CA 92649
Phone: 714-891-3364
www.mothers.com

Foose Design Inc.
17811 Sampson Lane
Huntington Beach, CA 92647
www.chipfoose.com

Dennis Ricklefs Design
26664 Pierce Circle, Suite E
Murrieta, CA 92562
Phone: 951-600-9493

Paul Gonzalez Custom Cars
14582 Goldenwest Street, Unit E
Westminster, CA 92683
Phone: 714-891-2203
www.pgcustomcars.com

3M Global Headquarters
3M Center
St. Paul, MN 55144
www.3M.com

Scott's Hotrods 'N Customs
3421 Galaxy Place
Oxnard, CA 93030
Phone: 805-485-0382
www.scottshotrods.com

Crazy Painters Kelly & Son
10512 Trabuco Street
Bellflower, CA 90706
Phone: 562-867-0511

Bob Spina
15831 Chemical Lane
Huntington Beach, CA 92649
Phone: 714-898-2927

DAN-AM Company (SATA)
One Sata Drive
P.O. Box 46
Spring Valley, MN 55975
Phone: 800-533-8016
www.sata.com

DuPont Performance Coatings
11215 Brower Road
North Bend, OH 45052
www.dupont.com

Meguiar's
17991 Mitchell South
Irvine, CA 92614
Phone: 949-752-8000
www.meguiars.com

INDEX

The Best Tools for the Job.

Sheet Metal Fabrication
- Forming Compound Curves
- Building Forms and Mock Ups
- Preparing Metals
- Choosing and Using Tools
- Identifying Types of Metals

Eddie Paul

101 Harley-Davidson Evolution Performance Projects 2nd Edition
- Engine mods for Evolution Sportsters and Big Twins
- Chassis and Suspension Upgrades
- Home Customization
- Aftermarket Exhaust and Fuel Delivery Projects

Kip Woodring and Kenna Love

How To Rebuild Corvette Rolling Chassis 1963–1982
- Brakes and Wheels
- Suspension
- Differential and Frame
- Fuel System, Exhaust, and Cooling
- Engine and Transmission

George McNicholl

How to Paint Your Car
- Modern Paint Technology
- Custom Painting Tips
- Bodywork and Prep Techniques
- Safety Advice

Dennis W. Parks and David H. Jacobs, Jr.

Other Great Books in this Series

How to Paint Your Car
136261AP • 978-0-7603-1583-5

How to Paint Flames
137414AP • 978-0-7603-1824-9

How to Master Airbrush
Painting Techniques
140458AP • 978-0-7603-2399-1

How to Repair Your Car
139920AP • 978-0-7603-2273-4

How to Diagnose
and Repair Automotive
Electrical Systems
138716AP • 978-0-7603-2099-0

Chevrolet Small-Block
V-8 ID Guide
122728AP • 978-0-7603-0175-3

How to Restore and
Customize Auto
Upholstery and Interiors
138661AP • 978-0-7603-2043-3

Sheet Metal
Fabrication
144207AP • 978-0-7603-2794-4

101 Performance Projects For Your
BMW 3 Series 1982–2000
143386AP • 978-0-7603-2695-4

Honda CRF Performance Handbook
140448AP • 978-0-7603-2409-7

Autocross Performance Handbook
144201AP • 978-0-7603-2788-3

Mazda Miata MX-5
Find It. Fix It. Trick It.
144205AP • 978-0-7603-2792-0

Four-Wheeler's Bible
135120AP • 978-0-7603-1056-4

How to Build a Hot Rod
135773AP • 978-0-7603-1304-6

How to Restore Your Collector Car
128080AP • 978-0-7603-0592-8

101 Projects for Your
Corvette 1984–1996
136314AP • 978-0-7603-1461-6

How to Rebuild Corvette Rolling
Chassis 1963–1982
144467AP • 978-0-7603-3014-2

How to Restore Your Motorcycle
130002AP • 978-0-7603-0681-9

101 Sportbike
Performance Projects
135742AP • 978-0-7603-1331-2

How to Restore and Maintain Your
Vespa Motorscooter
128936AP • 978-0-7603-0623-9

How to Build a Pro Streetbike
140440AP • 978-0-7603-2450-9

101 Harley-Davidson Evolution
Performance Projects
139849AP • 978-0-7603-2085-3

101 Harley-Davidson Twin Cam
Performance Projects
136265AP • 978-0-7603-1639-9

Harley-Davidson Sportster
Performance Handbook,
3rd Edition
140293AP • 978-0-7603-2353-3

Motorcycle Electrical Systems
Troubleshooting and Repair
144121AP • 978-0-7603-2716-6